A RotoVision Book
Published and distributed by
RotoVision SA
Route Suisse 9
CH-1295 Mies
Switzerland

RotoVision SA, Sales & Production
Office
Sheridan House
112/116A Western Road
Hove, East Sussex
BN3 1DD
UK

Tel: +44 (0)1273 72 72 68
Fax: +44 (0)1273 72 72 69
E-mail: sales@rotovision.com
www.rotovision.com

Copyright © RotoVision SA Autumn 2002

10 9 8 7 6 5 4 3 2 1

ISBN 2-88046-738-1

Book design by Scott Witham and
Traffic Design Consultants, Glasgow.

Photography by Xavier Young and
individual agencies

Production and separations in
Singapore by ProVision Pte. Ltd.
Tel: +65 6334 7720
Fax: +65 6334 7721

DESIGN / AFTER HOURS CREATIVE /

PASQUALE / STOCKS TAYLOR BENSON / R DESIGN /

MOEBA / TOP / FRONT PAGE / SIBLEY PETE

DESIGN / HEATHERWICK / DI CREW

IESEL / EYE II EYE / THOMPSON / GS / SUKA AND FR

RICKETT & WEBB / HM&E / BIG GROUP / MINALE TATTERSFIEL

ANCER / KRAFT & WERK / MAX & CO / VIRGIN / PHILIPP UND

EUNTJE / PLUS ONE / SUTTON COOPER / SJI / ID2 / METHOD

ICK CLARK / THINKING CAP / WPA / CENTO PER CENTO

HERRY / HOLLIS / BD-TANK / THOUGHT / DEAF EY

MAGINATION / BLATMAN / GRAPHIC PARTNERS / WILLIAMS &

HOA / ACTUAL SIZE / METHODOLOGIE / INKAHOOTS / MOTIV

ORRIS / ONE O' CLOCK GUN / KBDA / BUREAU GRAS / 99

REATISCOPE / STILL WATERS RUN DEEP / SAYLES / PC

PEN / SHAPIRO RIORDON / FOUNDATION 33 / SINCLAIR LEI

YSIWYG / FRCH / GRAY / AID / ZEN / CUTTS CREATIV

YRAMID / HEAD TO HEAD / NOFRONTIERE / TWIST / FIEL

LUE / KYSON / PENTAGRAM / DEVER / CATO PURNELL / GB

NIO / WHY NOT / 344 / LABEL / CDT / HOWDY / HEARI

ODDS / SELBY SPRINGETTS / TAXI / BOBS YOUR UNCL

LAZER / CORE / IDENT / NAME / APART

B STUDIOS / LEWIS ABBERLY / THE CHASE / RICKABAUG

RENEAU / NLA / SAVAGE / HOOP / TRAFFIC / THIRD PERSON

LOK / VANILLA / BELYEA / CONRAN / STATICREATIV

AND / PREJEAN LOBUE / SAATCHI

TOMLIN / DUFFY / WASSCO / CHECKLA

PEMBERTON AND WHITEFOO

FESTIVE

The art and design of promotional mailing

RotoVision

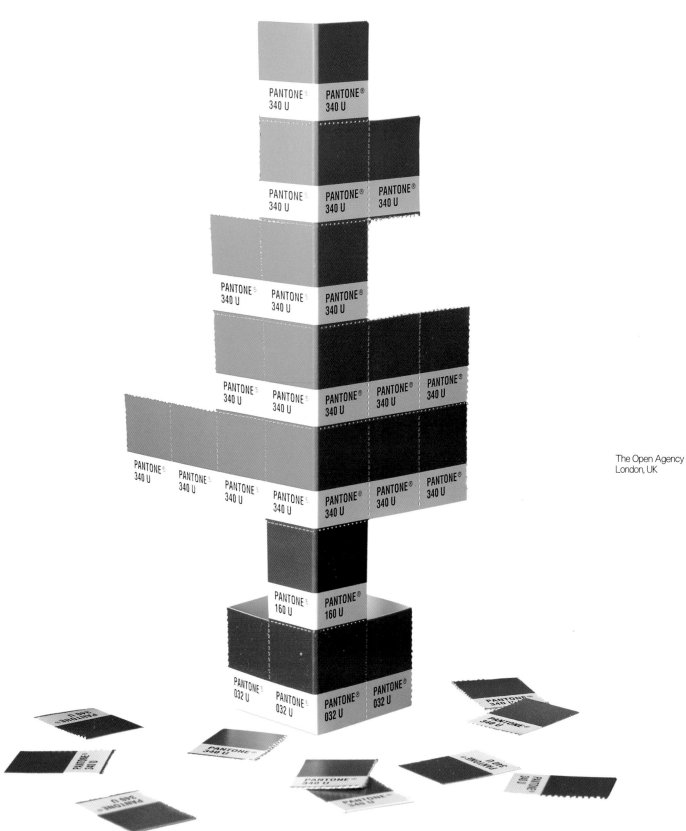

The Open Agency
London, UK

CONTENTS

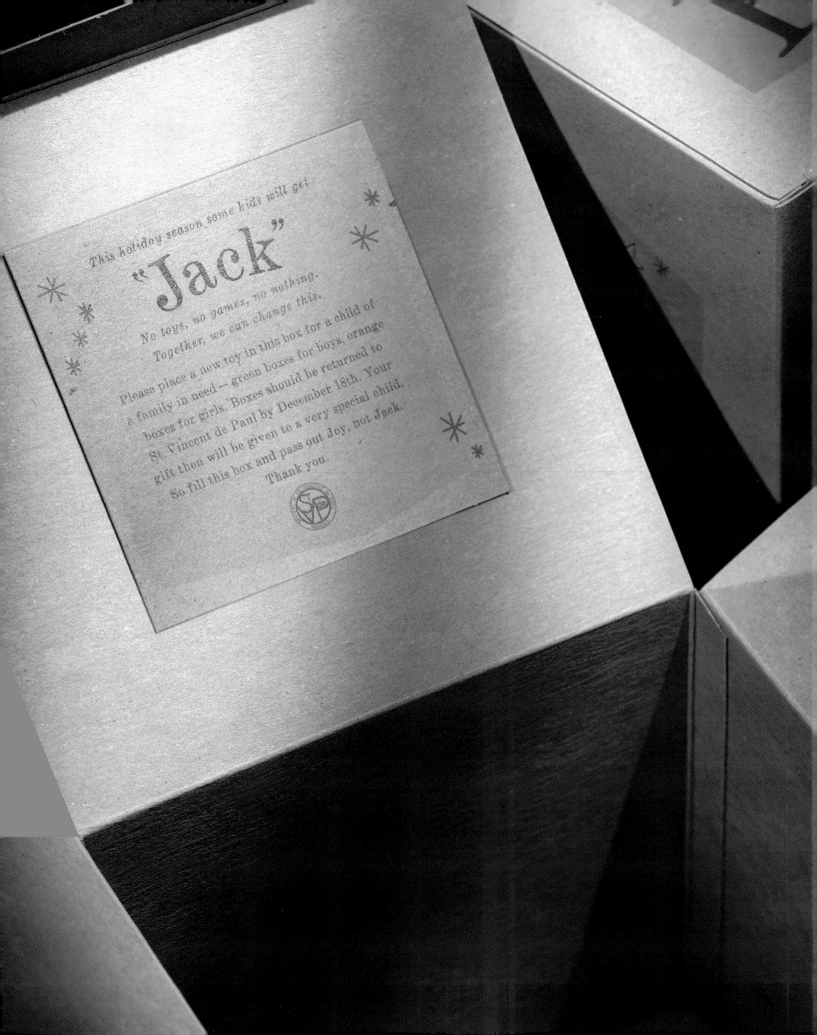

EVERY YEAR DESIGNERS ARE FACED WITH THE SAME PAINFUL DILEMMA – WHAT SHALL WE DO FOR THE AGENCY FESTIVE MAILING? IT MUST BE HIGHLY CREATIVE, IT MUST DEMONSTRATE OUR ABILITIES... AND ALL OUR COMPETITORS ARE DOING THE SAME THING AT THE SAME TIME

INTRODUCTION

Looking at the vast array of astonishingly imaginative ideas produced on one simple and very repetitive theme – Christmas, or its non-Christian counterparts – I had long harboured the desire to produce a book containing nothing but the best creative solutions from agencies worldwide which use the festive mailing as a vehicle to show off their talents. Designers use reference material covering the range of the creative spectrum. Why not a collection of self-promotional festive mailings from the best agencies in the world?

After contacting only a handful of agencies, it became clear not only that there was a wealth of work waiting to be showcased, but that the creative industry was willing to support such an idea. Word soon began to spread.

After two years of exhaustive collection and mailing campaigns, an estimated 8,000 agencies had been made aware of the quest to gather

material for the book – a project that, however unlikely it may seem, was the first of its kind.

The submission rate and enthusiasm shown by the global design community left me speechless. Work arrived by the vanload and letters of support and phone calls of interest came daily. The quality and variety of the samples submitted – from the USA, Russia, Australia, Argentina, Europe, India and the Far East – was breathtaking.

As a work of reference, this book was created to be a tool for designers: to demonstrate the use of humour, materials and pure imagination when creating an agency mailing.

I hope you share my enthusiasm for this exceptionally creative selection.

Scott Witham
Creative Director
Traffic Design Consultants
Glasgow, Scotland
scott@traffic-design.co.uk

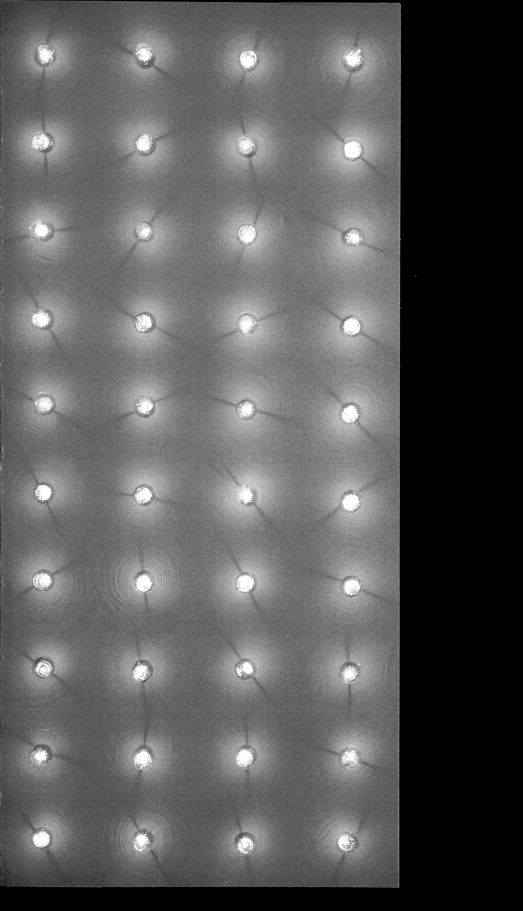

[Opposite]
CDT
London, UK

[Below]
The Open Agency
London, UK

The holidays are pure torture!

Family obligations, strapped budgets, not enough time and unrealistic 'goody goody' feelings combine to send everyone to the brink of insanity. We thought if we could distract our clients and those around them with humorous activities and an irreverent thought or two it might be a good thing. If they actually ended up with something they could give as a gift, play with or just enjoy, then so much the better. And hey, if it was actually designed nicely, why then suddenly the day would be brighter, the snow would be cleaner and the world would be a happier place. Really. Especially the snow part.

Russ Haan
After Hours Creative
Phoenix, Arizona, USA

Creating a totally different Christmas card every year gives us the chance to send our best wishes in an original way and show off our design skills to our clients and colleagues.

I never sit down to create a Christmas card; the ideas for them simply crop up in the strangest places. Our card for 2001, the plant-inserter and Christmas tree seeds, came about during a holiday in Greece while basking with my sketch pad in the sun. Every year I develop more Christmas ideas, so we have some in stock for the future. I hope to create another great Christmas card for 2002, perhaps during my holidays in France! After all, there is nothing more beautiful than the development of a brilliant idea.

Ruud Winder
Bureau Gras
Alkmaar, Netherlands

Jumping on the festive bandwagon as we do at the back end of every year, the perennial creative spectre raises its ugly head. As if we haven't got enough on our minds, the annual creative challenge creeps up on us, bearing with it the opportunity to flex our creative muscle within a boundless seasonal brief that takes its roots in the arena of the humble greetings card.

At worst, the creative process offers thinly veiled and highly inappropriate promotional sales messages often (thankfully) to hilarious effect. At the tip of the creative iceberg, though, some brilliant ideas break the surface, proving that this is a time to lay down the creative gauntlet and show what you can really do.

Stuart Gilmour
BD - Tank
Glasgow, UK

FOREWORDS

The process of design is a constant flow of gathering and outpouring. Many thoughts and ideas don't seem to fit within the straitjacket of a project. Nevertheless, they are worthy of a home. Some ideas are saved, and, if they stand the test of time and scrutiny, they become our seasonal card. Our seasonal piece has always been used to draw attention to, or raise money for, a charity. A founding principle of Lippa Pearce was that we would donate design time and energy freely every year to Human Rights. Our seasonal card is one small aspect.

Harry Pearce
Lippa Pearce Design
London, UK

For me, creating a self-promotional piece of work is a job like any other. It always starts with the same three simple questions: who am I talking to; what do I want to say; and how will I say it? How does it differ from work for any client?

The main difference is that in self-promotion you have also to play the role of the client – and an ideal one at that; a client who is brave, open-minded and who you know well. In short, the road to your creativity lies wide open. And that is a challenge I am always pleased to take.

Damijan Vesligaj
Kraft & Werk
Maribor, Slovenia

The 21st century saw huge revolutions in communication and today we persist in giving one another cards and heartfelt mailings. We impart our humour and thoughts several times a year in these massive migrations of cards and souvenirs all over the world. Therefore it gives us great pleasure to produce our agency festive mailing year after year. It's both a creative challenge and a great source of fun.

In each holiday mailing we send out, we like to think our thoughts and hopes for the New Year travel with it.

Dmitry Pioryshkov
Direct Design Studio
Moscow, Russia

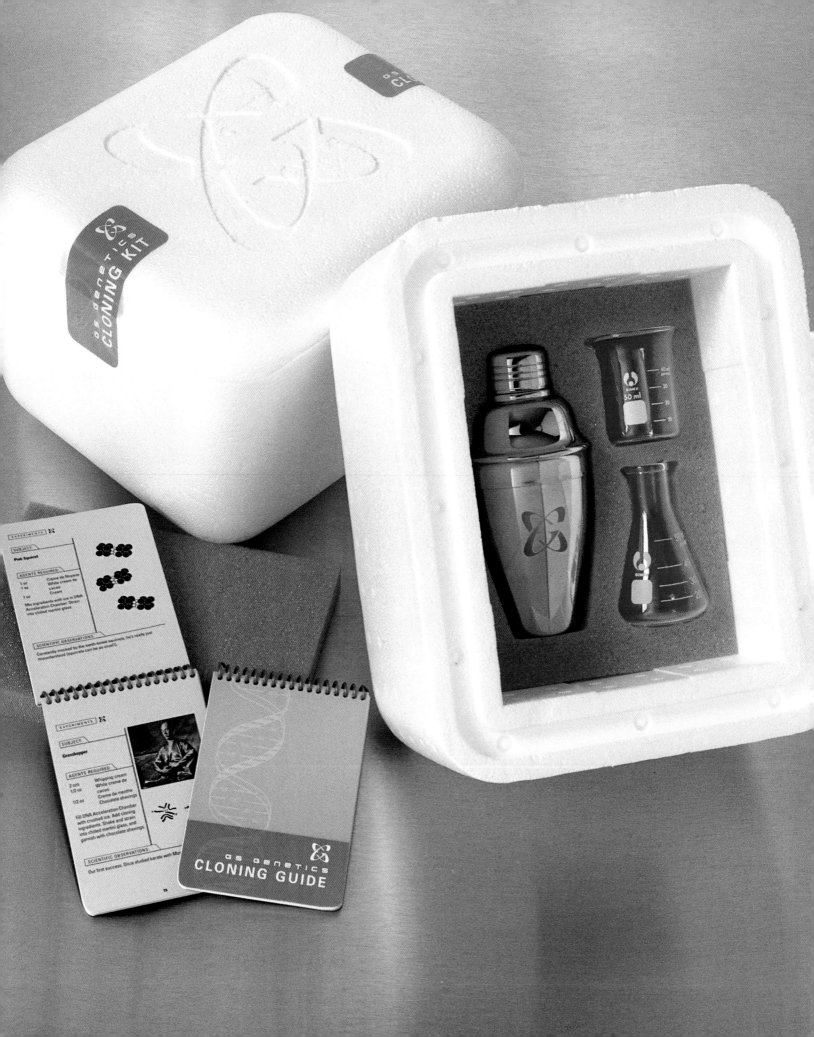

The agency Christmas gift. It's the hardest brief of the year, but in a strange kind of way, it's the one we enjoy the most. Truth is, we love to give, and we love to create things of beauty. Maybe it's because we have a culture that is very family-like; maybe it all comes from our Italian heritage. The gift is a small token of thanks to our alliance partners – our clients and our suppliers. We love having them around, and we love working with them. Yet we acknowledge that our gift is comparatively small in relation to their contribution to our business success, so we try to make it heartfelt. We look for gift ideas that are sincere, that celebrate the spirit of Christmas and that reflect our agency's personality.

Nic Harman
De Pasquale Advertising
Brisbane, Australia

India – colour, design, exuberance, a blend of tradition and modernity. Modern Indian work blends individual style with heritage to create a whole new tradition. We like to put our greetings cards into a design that fuses the reality of our present with the rhythms of India's past.

While India is in our blood and bones, our designs reflect today's satellite TV world, a world that flashes by at the speed of light. Our holiday mailers, by their design, catch the moment when one year dissolves into another. As our name suggests, what you seek is what you get: we seek the opportunity to express wishes and welcomes in our own very special way.

Nidhi Harlalka
WYSIWYG Communications
Calcutta, India

By the time we get round to thinking about our own Christmas card we are usually punch drunk and looking forward to the New Year. We might well have been thinking 'Christmas' for some of our clients since spring! It's quite hard to get Christmas mailings right. You can't be sentimental, but it's not a good idea to be offensive. If a Christmas card is based on humour, the joke needs to sneak up on you, rather than shout in your face. My own favourite was from a Dutch design group. It was a very simple postcard of a group of absolutely miserable people, 'celebrating' over their pints in a nondescript bar. I was sure they were Dutch – it turned out they were Irish! Truly, we are all Europeans now.

Lynn Trickett
Trickett & Webb
London, UK

FOREWORDS

Festive client gifts are essential self-promotion pieces that offer an additional opportunity to communicate with your clients. The creation of these gifts can open many doors and expand the client's vision of what you are as a company. The gifts showcase work that goes well beyond what clients have already seen. For instance, if you don't normally do much packaging work, highlight your creative strengths in package design. Or, if your company would like to do more interactive work, include an interactive CD .

Consider developing a piece with the participation of all staff members. Allow junior designers, account executives and PR staff to add their ideas. Demonstrate the wealth of creativity in your studio and how instrumental each staff member is to the success of your company – a side often not seen by your client.

Rarely is the financial investment as important as the creativity. Small studios are just as able to impress a client as large ones. Your goal should be to create a gift that is memorable, that leaves a lasting impression. It should be seen by many and displayed in offices for months afterwards. People like to see their name beautifully rendered – it makes them feel special and important. And no matter how humble we like to think ourselves, we all enjoy being recognised. Take the opportunity to make someone feel good.

Although Christmas is a holiday widely celebrated it is also a hectic time when gifts can go unnoticed.

You may choose to give your gift at a different time, to demonstrate that your agency embraces, values and recognises diversity while also standing apart from the many gifts received at Christmas.

Find a holiday that appeals to you and to your company's philosophies. You don't have to limit yourself to traditional holidays – remember, gifts will be welcomed at any time of the year. How about a gift for Burns' Night, Groundhog Day or the Solstice?

Be creative, enjoy the process and let your clients know that they make your business a success!

Valerie Elliott
iD2 Communications Inc
Victoria, Canada

RECT DESIGN / AFTER HOURS CREATIVE / LIPPA PEARCE /
RSW / AMOEBA / TOP / FRONT PAGE / SIBLEY PETEET / THE E
YE II EYE / THOMPSON / GS / SUKA AND FRIENDS / TRICA
ANCER / KRAFT & WERK / MAX & CO / VIRGIN / PHILIPP UN
CK CLARK / THINKING CAP / WPA / CENTO PER CENT
MAGINATION / BLATMAN / GRAPHIC PARTNERS / WILLIAMS
ORRIS / ONE O' CLOCK GUN / KBDA / BUREAU GRAS / 999 /
HAPIRO / RIORDON / FOUNDATION 33 / SINCLAIR LEE / WYSI
EAD TO HEAD / NOFRONTIERE / TWIST / FIELD / BLUE / KYS
OT / 344 / LABEL / CDT / HOWDY / HEARD / DODDS / SELBY
RESCENT LODGE / IDENT / NAME / APART / NB STUDIOS / L
AVAGE / HOOP / TRAFFIC / THIRD PERSON / BLOK / VANIL

NTERBRAND / PEMBERTON AND WHITEFOORD / BROWNS
NEW ENGLISH / MELTON / PROCTOR & STEVENSON / IRIS / C
F PAINT / BALENA CORPORATION / CPD / CAHAN / GUNTE
DE PASQUALE / STOCKS TAYLOR BENSON / R DESIGN / CITRU
GG / INTER DESIGN / HEATHERWICK / DI CREW / PYLON
RICKETT & WEBB / HM&E / BIG GROUP / MINALE TATTERSF
ND KEUNTJE / PLUS ONE / SUTTON COOPER / SJI / ID2 / ME
HERRY / HOLLIS / BD-TANK / THOUGHT / DEAF EYE / IMAGI
CTUAL SIZE / METHODOLOGIE / INKAHOOTS / MOTIVE /
CREATISCOPE / STILL WATERS RUN DEEP / SAYLES / PCI /
WYSIWYG / FRCH / GRAY / ABM / ZEN / CUTTS CREATIVE /
YSON / PENTAGRAM / FDEVER / CATO PURNELL / GBH / ON
SELBY / SPRINGETTS / TAXI / BOBS YOUR UNCLE / GLA

/ THE WORK /

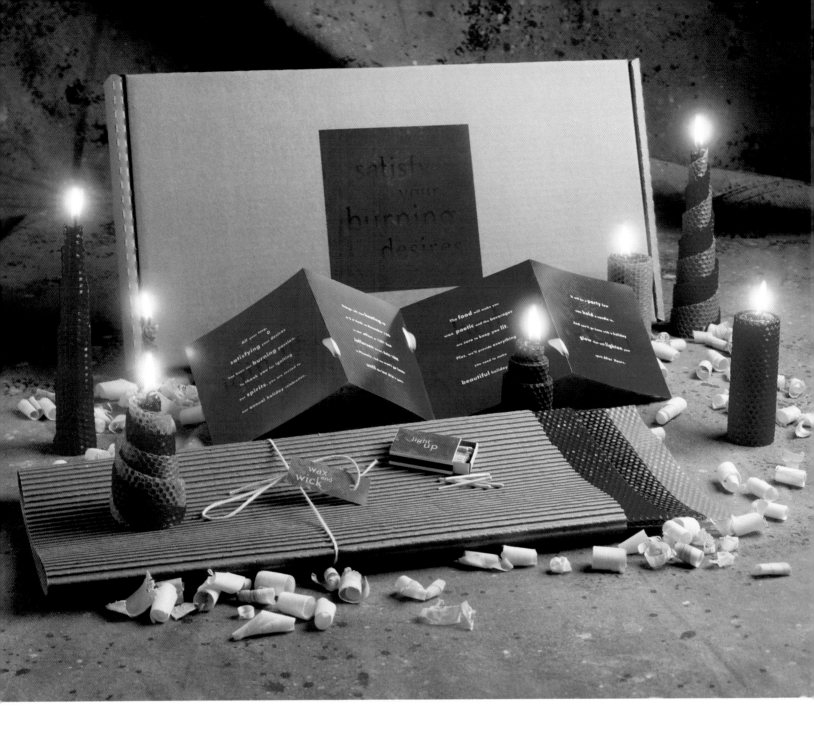

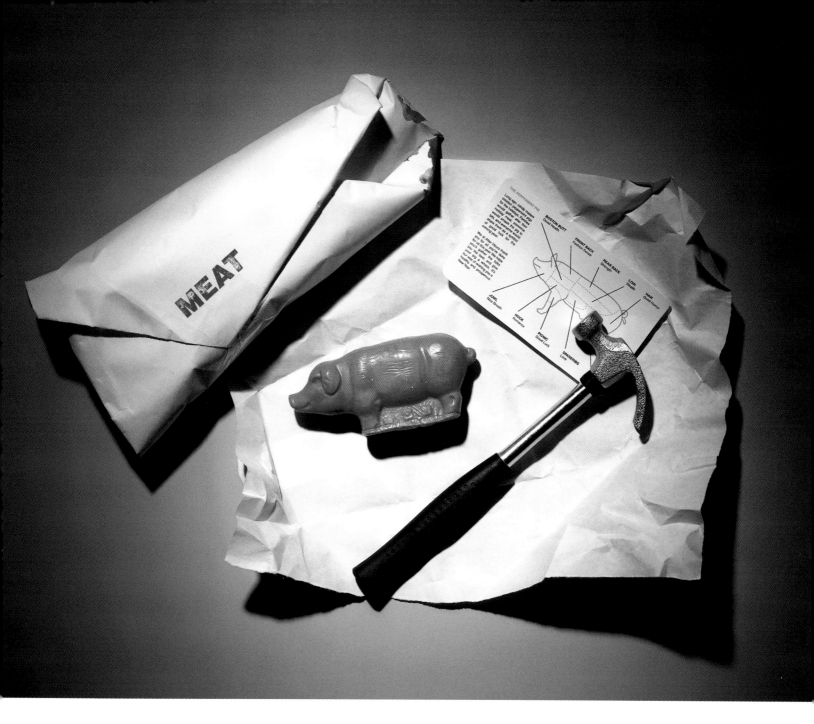

DESIGN
AFTER HOURS CREATIVE
LOCATION
PHOENIX, USA
CREATIVE DIRECTOR
RUSS HAAN

"For an idea to make the cut as an After Hours holiday mailing, we apply the following criteria: it must involve an activity; every component of the activity must be able to be included in the piece; it must be something that can be done with kids; it must not be about Christmas only; it must have potential for politically incorrect copy; and it must be able to be mailed."

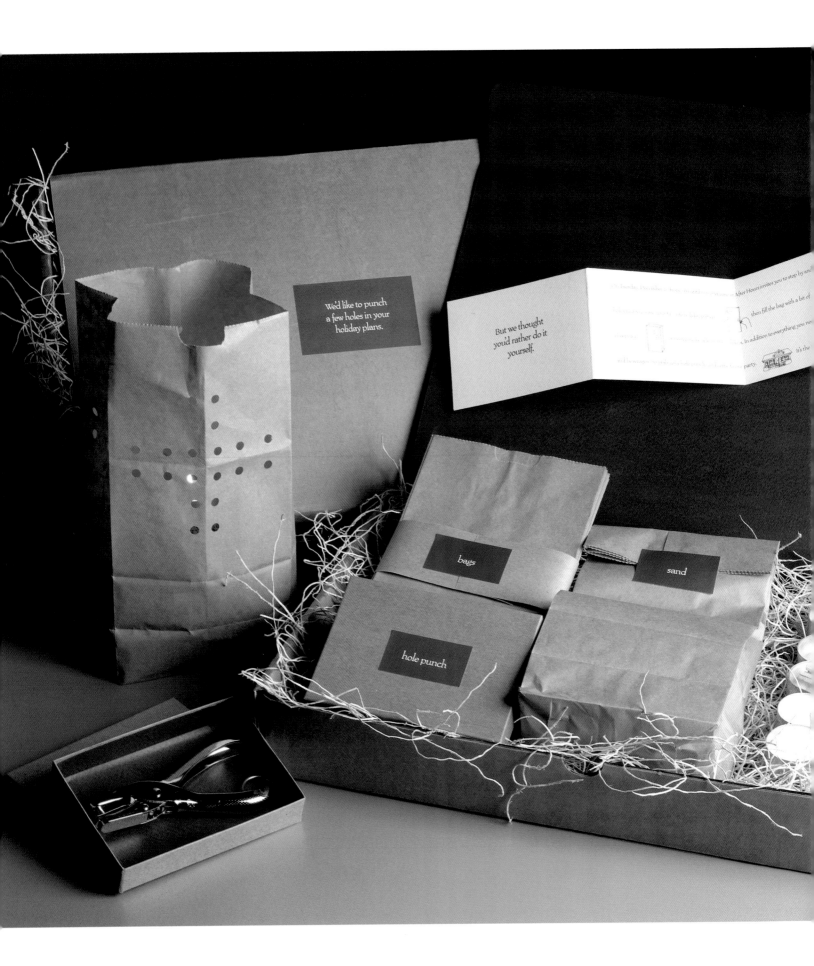

We'd like to punch a few holes in your holiday plans.

But we thought you'd rather do it yourself.

bags

sand

hole punch

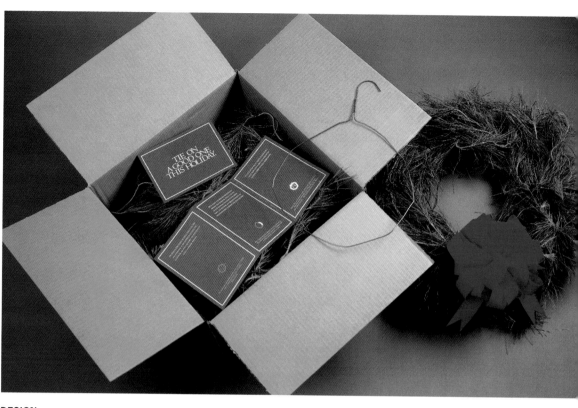

DESIGN
AFTER HOURS CREATIVE
LOCATION
PHOENIX, USA
CREATIVE DIRECTOR
RUSS HAAN

DESIGN
DE PASQUALE ADVERTISING
LOCATION
BRISBANE, AUSTRALIA
CREATIVE DIRECTOR
NIC HARMAN
CREATIVE TEAM
LUCAS WILD, CHARLES BARRON,
STUART ROYALL, VINCENT LANG

Pasta Gift
"As a firm with an Italian heritage, we have a real belief in traditional values such as family and friends. Christmas, to us, is the perfect time to celebrate humanity. We love to give, so gifts such as this are our way of expressing wellbeing and generosity. We chose the 'pasta' theme because we love it as well as the fact that our competitors call us the 'spaghetti brothers' – if you can't beat 'em, join 'em!"

Bocce Gift
"The Bocce Ball gift concept followed on from the previous year's gift of pasta. Again, it was meant to symbolise a time when friends and family get together. Bocce is true to our Italian heritage and a hell of a lot of fun to play. Our Christmas party was held at a local Bocce court where the entire agency learnt to play (it gets easier after a few vinos, by the way)."

De Pasquale

DESIGN
BAER DESIGN GROUP
LOCATION
EVANSTON, USA
CREATIVE DIRECTOR
TODD BAER

"A twist to the season! This holiday
promotion for the Baer Design Group
spread holiday cheer and promoted our
corporate identity services."

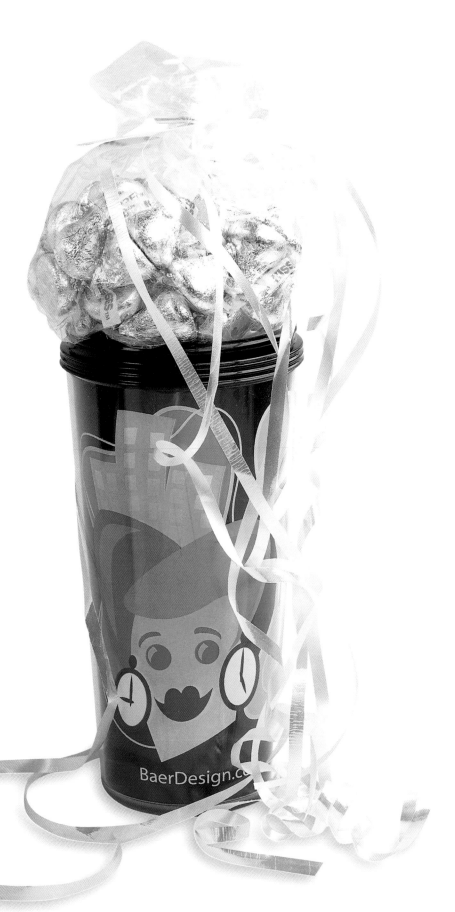

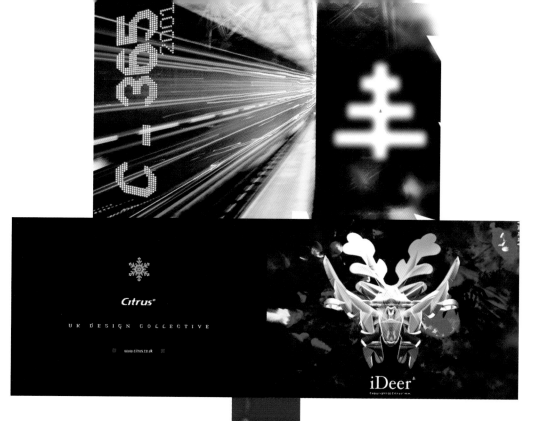

DESIGN
CITRUS
LOCATION
LEICESTER, UK
CREATIVE DIRECTORS
STEVE MEADES, JIM COOPER

"We produce a festive mailing because there is a challenge in taking a very traditional theme and creating something that is not only 'different' but acts as a great self-promotional item."

DESIGN
R DESIGN
LOCATION
LONDON, UK
CREATIVE DIRECTOR
DAVID RICHMOND

"It's a great excuse to keep in touch
and also remind people you're
still around."

DESIGN
FRONT PAGE DESIGN
LOCATION
GLASGOW, UK
CREATIVE TEAM
JOHN TAFE, FELICITY JOHNSON

"We wanted to put a smile on our clients' and suppliers' faces with a fun and memorable gift that they could enjoy over and over. Jingle balls delivered with impact."

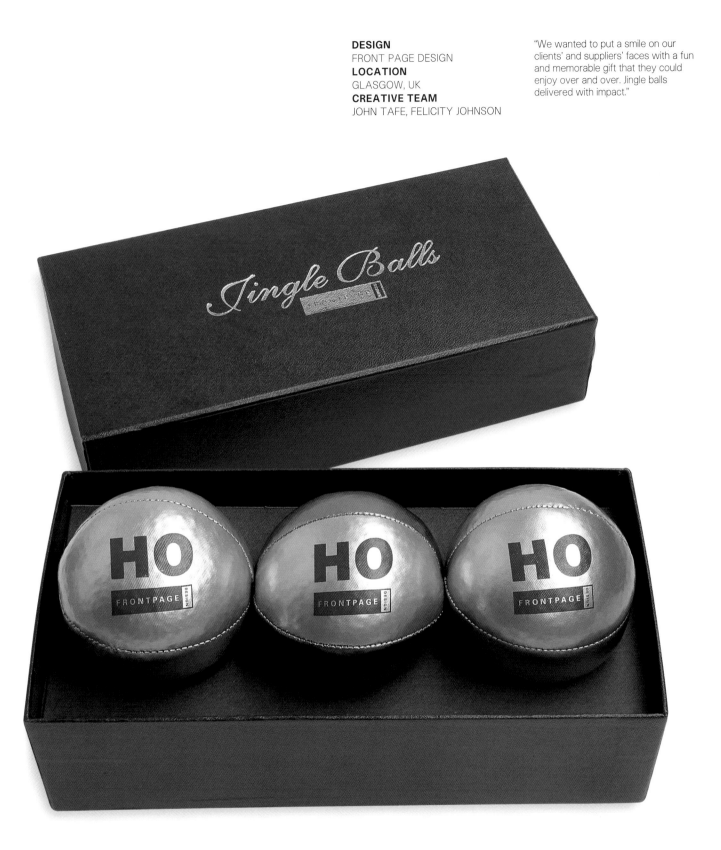

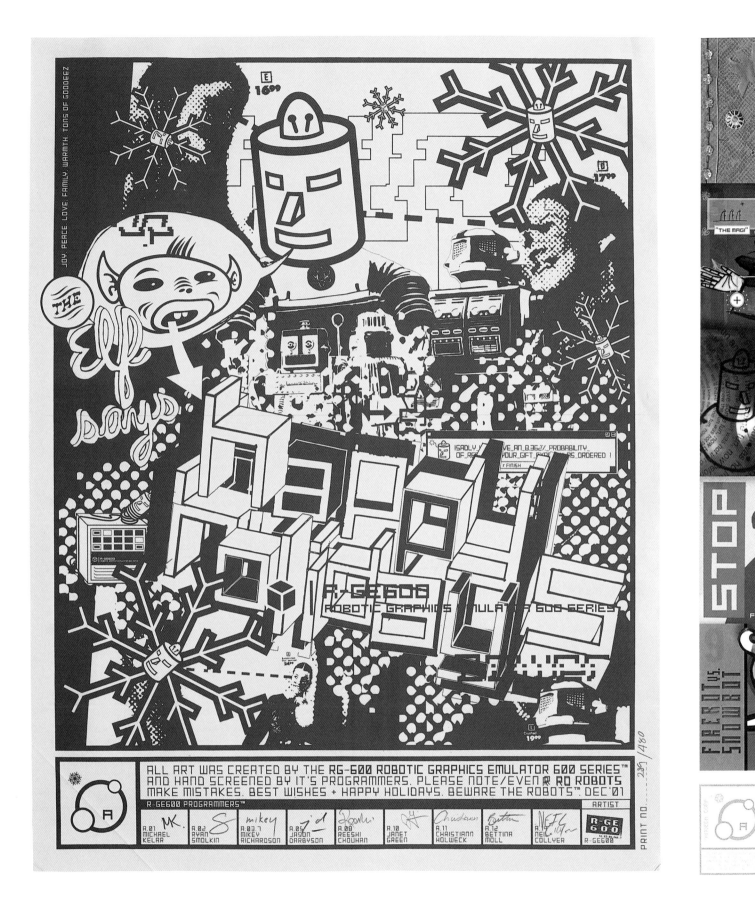

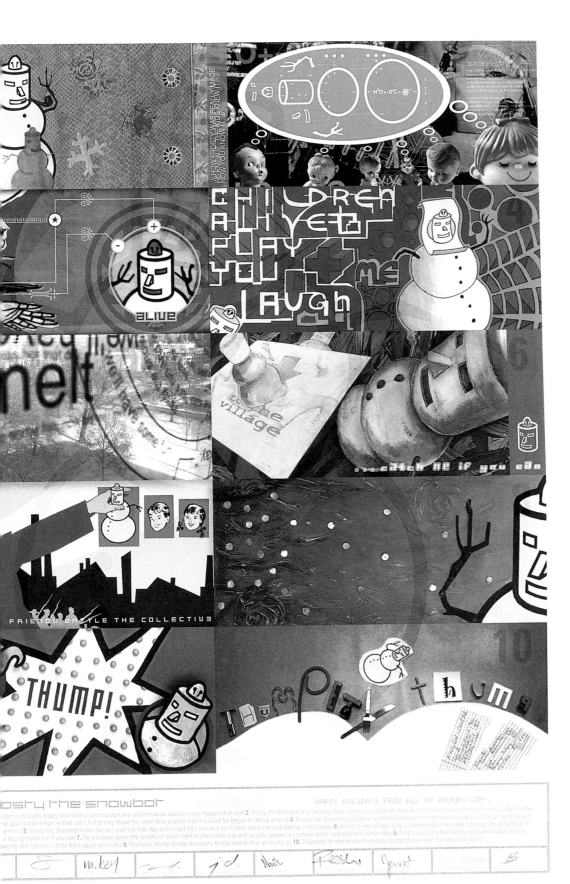

DESIGN
AMOEBA CORP
LOCATION
TORONTO, CANADA
CREATIVE DIRECTORS
MIKEY RICHARDSON,
MICHAEL KELAR

"We wanted to produce something fun and collaborative to give recipients the idea that the message was from all of us – our entire staff. The robot is our 'mascot' so we're constantly having fun with new projects involving it."

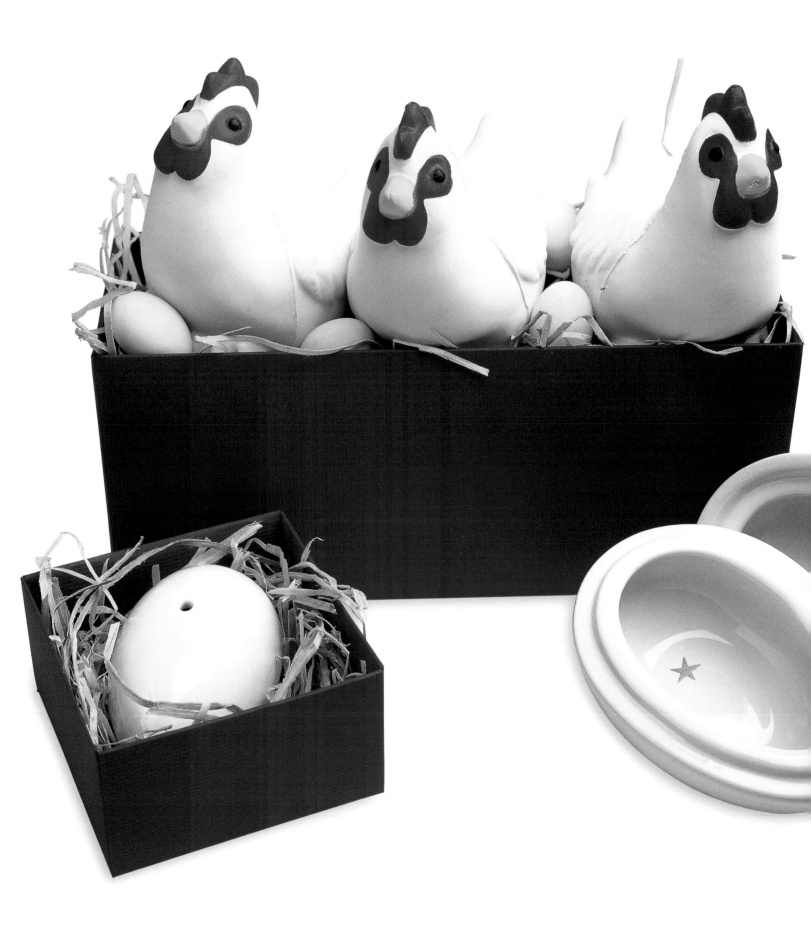

DESIGN
EGG DESIGN & MARKETING
LOCATION
LONDON, UK
CREATIVE DIRECTOR
CHRIS PERFECT
CREATIVE TEAM
SARAH BLACKBURN

"Every Easter, our clients enjoy receiving our chocolate Easter eggs. But Christmas is a challenge – thinking of new ideas each year that involve an egg is lots of fun."

DESIGN
INTERDESIGN
LOCATION
PARIS, FRANCE
CREATIVE DIRECTOR
MARC PIEL

"Our end of year mailing is a way of saying thank you to all our past clients, suppliers and friends. We are a product design office, so we try to add a third dimension to the 2D paper. We always get tremendous feedback."

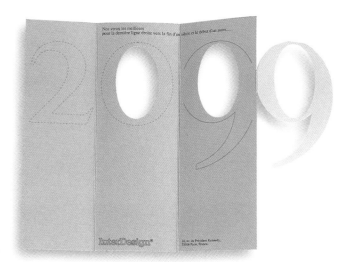

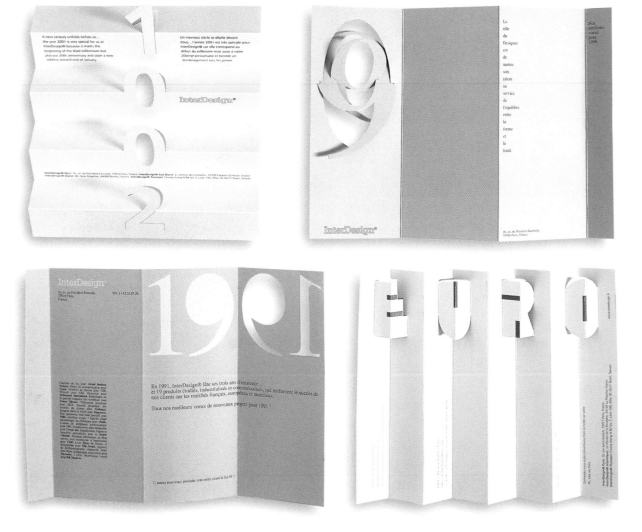

DESIGN
PYLON
LOCATION
TORONTO, CANADA
CREATIVE DIRECTORS
SCOTT CHRISTIE, KEVIN HOCH
CREATIVE TEAM
GILL AIKEN, JOSH THORPE

"People get a lot of Christmas cards so we try to do something a little out of the ordinary each year. These promotions give us a chance to have a bit of fun, experiment with unusual methods and materials, and help maintain our reputation for creativity."

Reserved Parking for the Last-Minute Christmas Shopper

Happy Holidays from the gang at Pylon

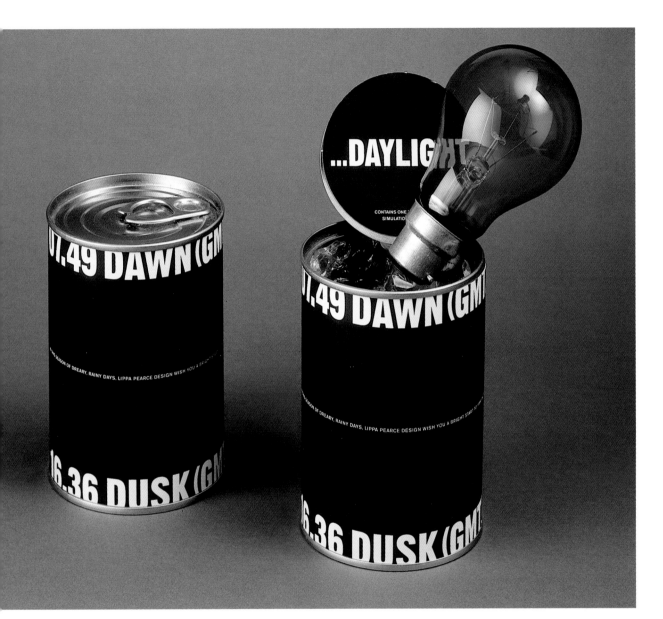

DESIGN
LIPPA PEARCE DESIGN
LOCATION
LONDON, UK
CREATIVE DIRECTORS
HARRY PEARCE, DOMENIC LIPPA

"All our festive mailings explore typography, humour and wit. Each has a unique approach defined by the changing subject matter for each year."

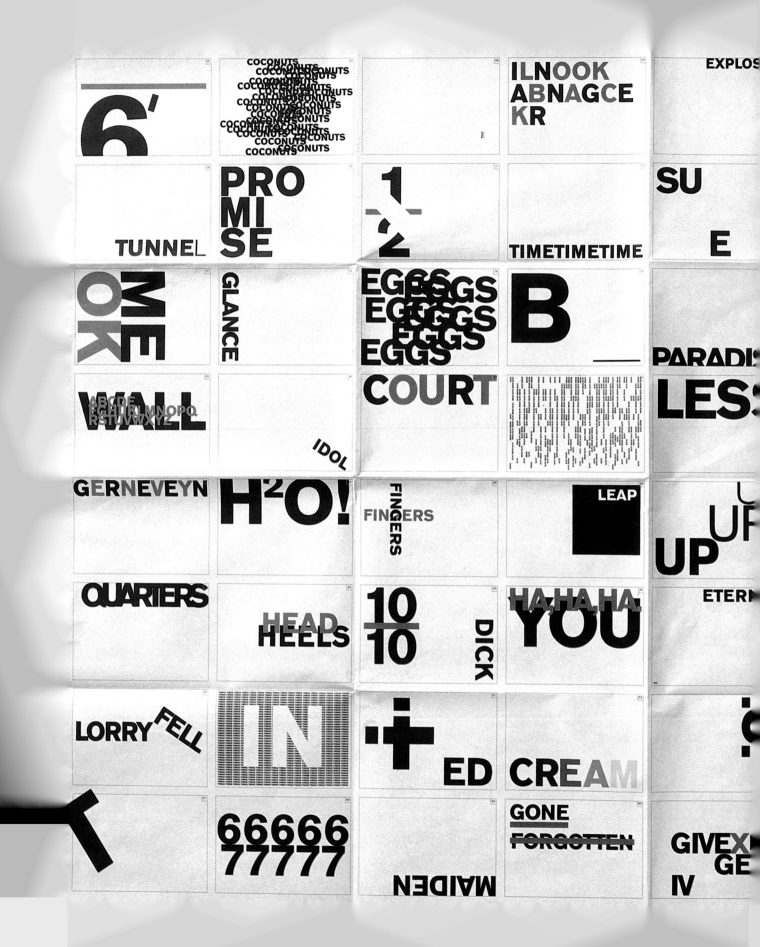

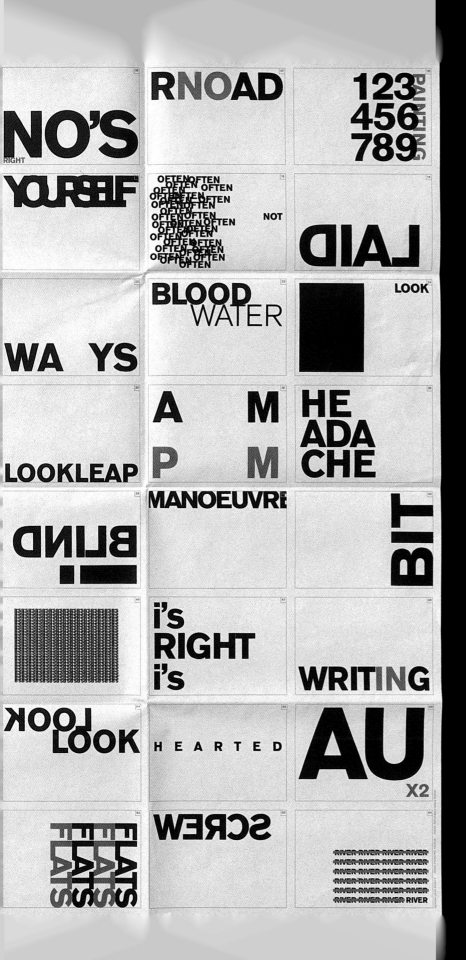

DESIGN
LIPPA PEARCE DESIGN
LOCATION
LONDON, UK
CREATIVE DIRECTORS
HARRY PEARCE, DOMENIC LIPPA

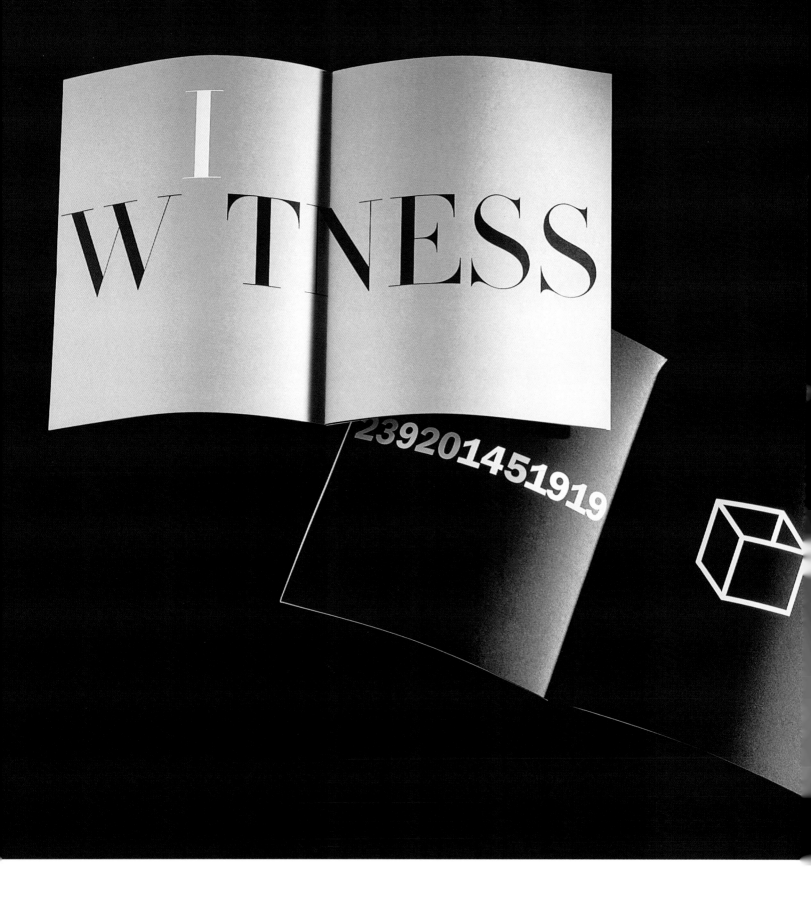

DESIGN
LIPPA PEARCE DESIGN
LOCATION
LONDON, UK
CREATIVE DIRECTORS
HARRY PEARCE, DOMENIC LIPPA

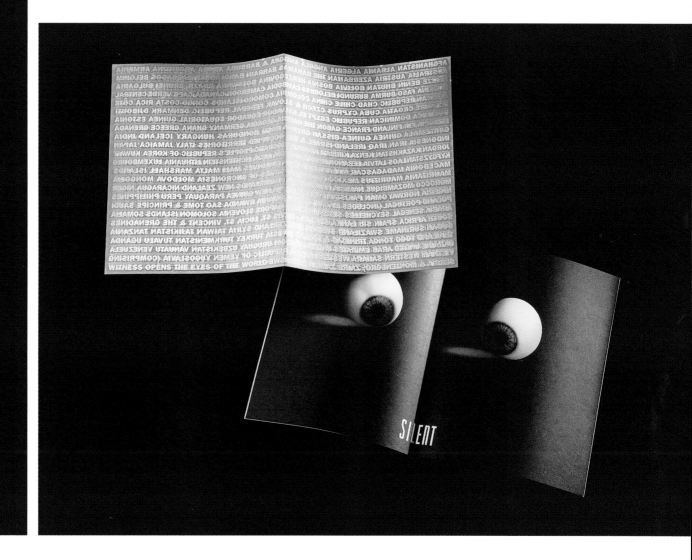

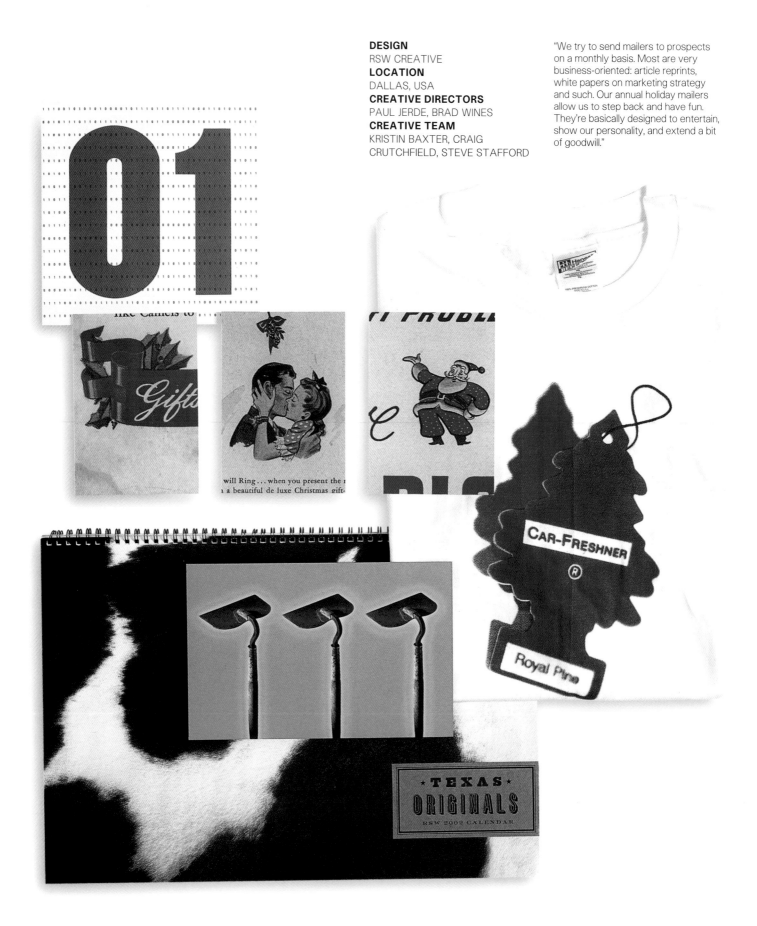

DESIGN
RSW CREATIVE
LOCATION
DALLAS, USA
CREATIVE DIRECTORS
PAUL JERDE, BRAD WINES
CREATIVE TEAM
KRISTIN BAXTER, CRAIG
CRUTCHFIELD, STEVE STAFFORD

"We try to send mailers to prospects on a monthly basis. Most are very business-oriented: article reprints, white papers on marketing strategy and such. Our annual holiday mailers allow us to step back and have fun. They're basically designed to entertain, show our personality, and extend a bit of goodwill."

01

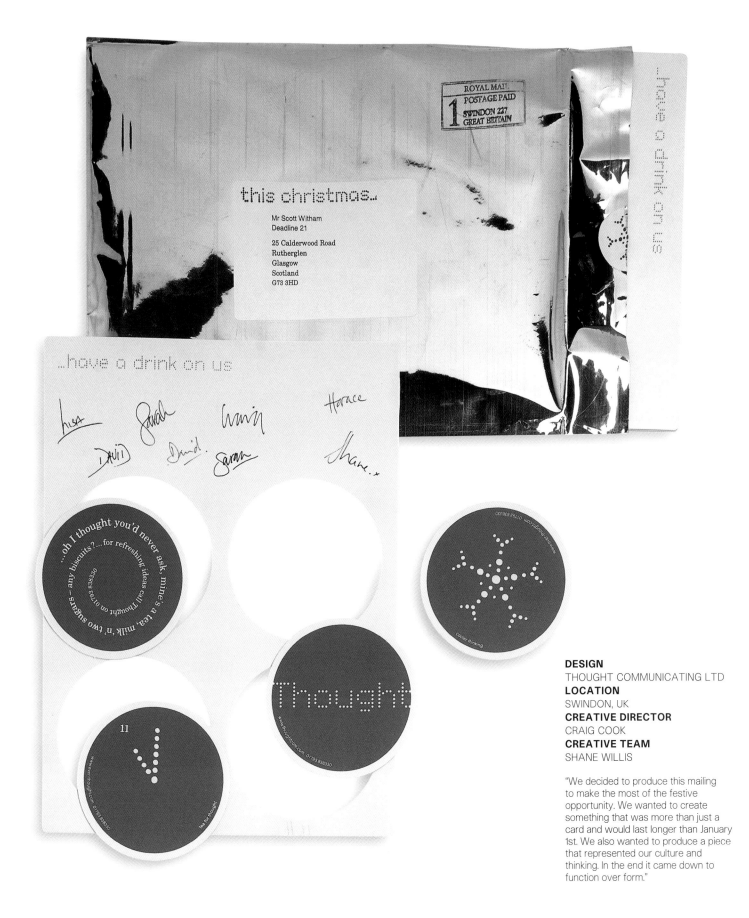

DESIGN
THOUGHT COMMUNICATING LTD
LOCATION
SWINDON, UK
CREATIVE DIRECTOR
CRAIG COOK
CREATIVE TEAM
SHANE WILLIS

"We decided to produce this mailing to make the most of the festive opportunity. We wanted to create something that was more than just a card and would last longer than January 1st. We also wanted to produce a piece that represented our culture and thinking. In the end it came down to function over form."

DESIGN
J WALTER THOMPSON
LOCATION
BUENOS AIRES, ARGENTINA

"Every year end we want to share a positive message for the future with a humorous and light-hearted approach."

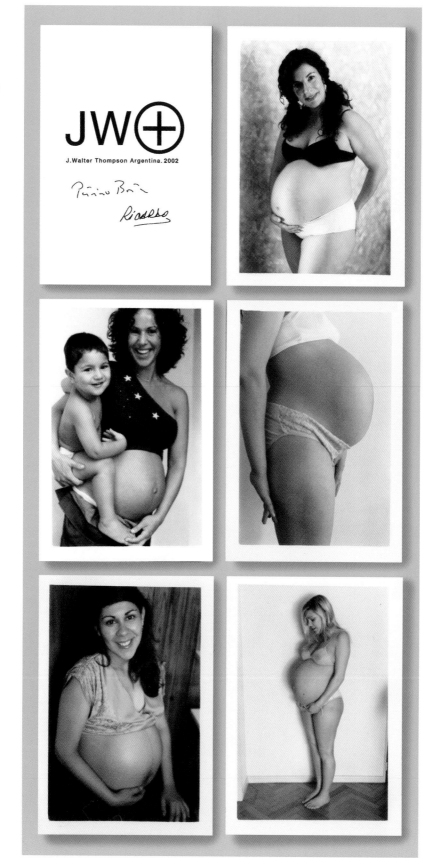

DESIGN
MINALE TATTERSFIELD
& PARTNERS LTD
LOCATION
RICHMOND, UK
CREATIVE DIRECTORS
MARCELLO MINALE,
ALEX MARANZANO
CREATIVE TEAM
MARIO POTES, LIZ JAMES,
IAN DELANY

"We always enjoy doing festive mailers, especially our own. They are one of the few occasions when you can use creative wit and humour, without being constrained by restrictive guidelines."

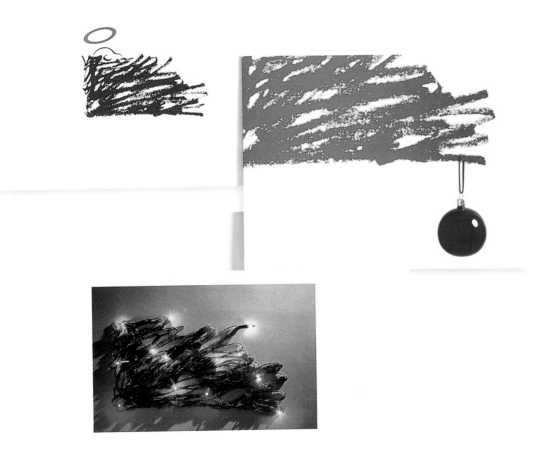

DESIGN
SIBLEY PETEET DESIGN
LOCATION
DALLAS, USA
CREATIVE DIRECTOR
DON SIBLEY
CREATIVE TEAM
BRANDON KIRK

"Dallas, Texas rarely sees snow around the holidays. We designed a holiday card with a series of die cuts that allow the recipient to build their own snowman regardless of the weather outside."

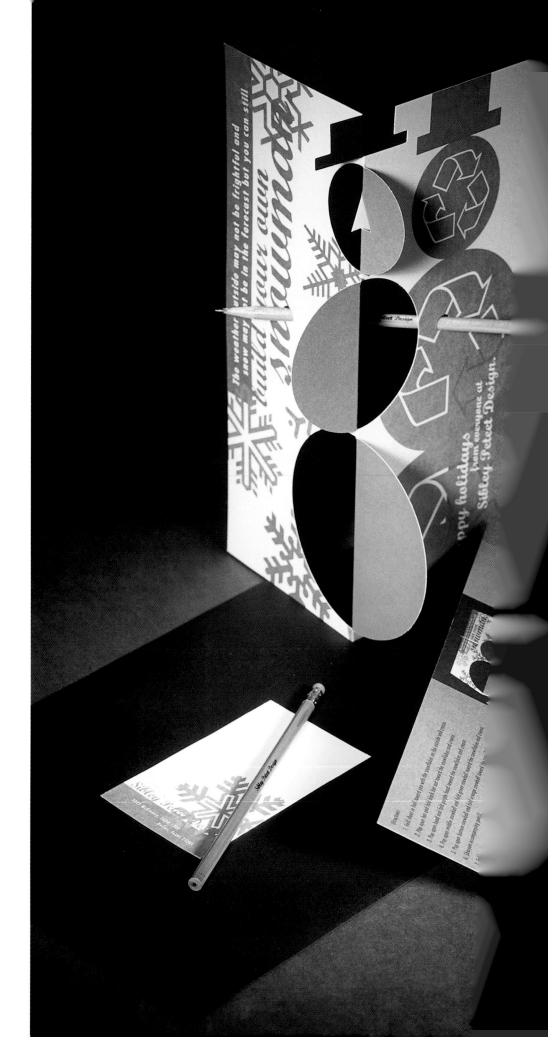

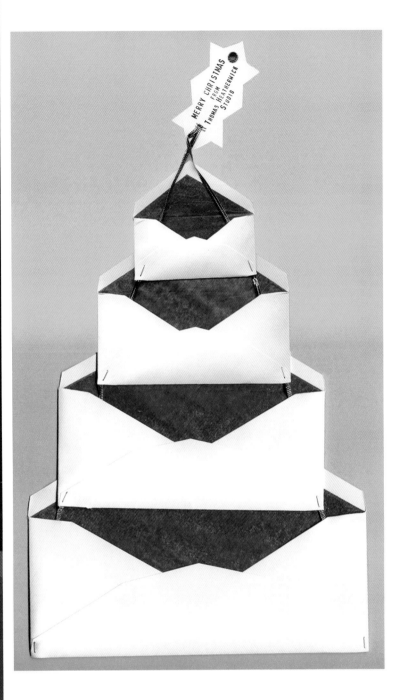

DESIGN
THOMAS HEATHERWICK STUDIO
LOCATION
LONDON, UK

"We produced several hundred cards, which we hope will have flummoxed and amused the postmen and recipients around the United Kingdom and abroad."

DESIGN
LANCER DESIGN PTE
LOCATION
SINGAPORE
CREATIVE DIRECTOR
MARK PHOOI
CREATIVE TEAM
MUHAMAD YAZID M., KAREN MAH

"The design concept for this greeting card was based on that of our latest published book *Discover Singapore* – the first publication in our exclusive series on travel in the Asia-Pacific region. The festive card, aimed at generating awareness for *Discover Singapore* and our new initiative in publishing, was sent to hotels, clients and other business associates."

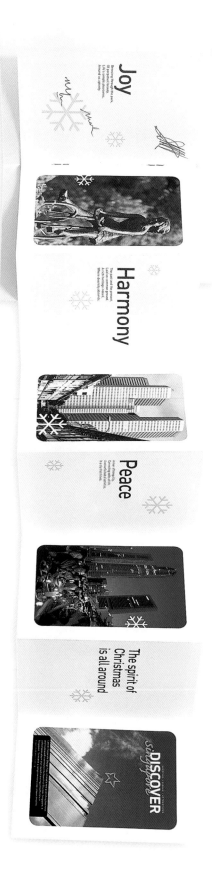

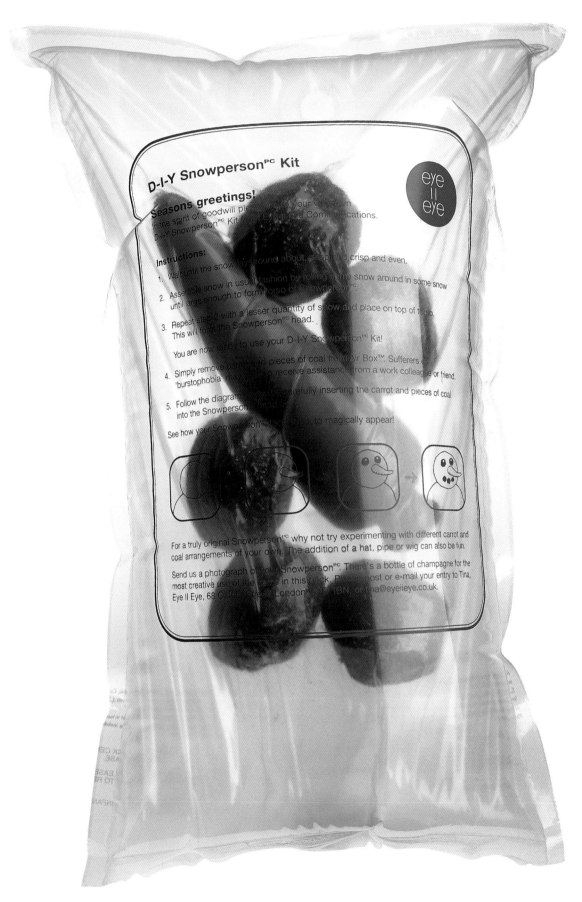

D-I-Y Snowperson^{PC} Kit

Seasons greetings! [...] your very own
In the spirit of goodwill ple[...] [...]e Communications.
D-I-Y Snowperson^{PC} Kit f[...]

Instructions:

1. Wait until the snow l[...]round about [...]ep and crisp and even.

2. Assemble snow in usual fashion by rolling [...]tle snow around in some snow
until large enough to form torso of Snowperson^{PC}.

3. Repeat step 2 with a lesser quantity of snow and place on top of torso.
This will form the Snowperson^{PC} head.

You are now ready to use your D-I-Y Snowperson^{PC} Kit!

4. Simply remove carrot and pieces of coal from Air Box™. Sufferers o[...]
'burstophobia' may [...] receive assistance from a work colleague or friend.

5. Follow the diagram [...] [...]efully inserting the carrot and pieces of coal
into the Snowperson^{PC} head.

See how your Snowperson^{PC} [...] [...] to magically appear!

For a truly original Snowperson^{PC} why not try experimenting with different carrot and
coal arrangements of your own. The addition of a hat, pipe or wig can also be fun.

Send us a photograph of your Snowperson^{PC}. There's a bottle of champagne for the
most creative use of the [...]s in this pack. Please post or e-mail your entry to Tina,
Eye II Eye, 68 C[...] Street, London [...] BN, [...]tina@eyeiieye.co.uk.

eye
II
eye

DESIGN
PERCEPTOR (FORMERLY EYE II EYE)
LOCATION
LONDON, UK
CREATIVE DIRECTOR
TONY O'BRIEN
CREATIVE TEAM
ADRIAN BRITTON

"We wanted to produce a piece
that was a bit of fun and engaged
our clients – we also prayed for
some snow!"

DESIGN
DIESEL DESIGN
LOCATION
SAN FRANCISCO, USA
CREATIVE DIRECTOR
JEFFREY HARKNESS
CREATIVE TEAM
JOSH GLENN, MARCO CONTRARAS

"At Diesel, we always strive for maximum interactivity with a nod towards traditional design principles. These pieces attempt to make a visual and tactile impact without overwhelming the recipient."

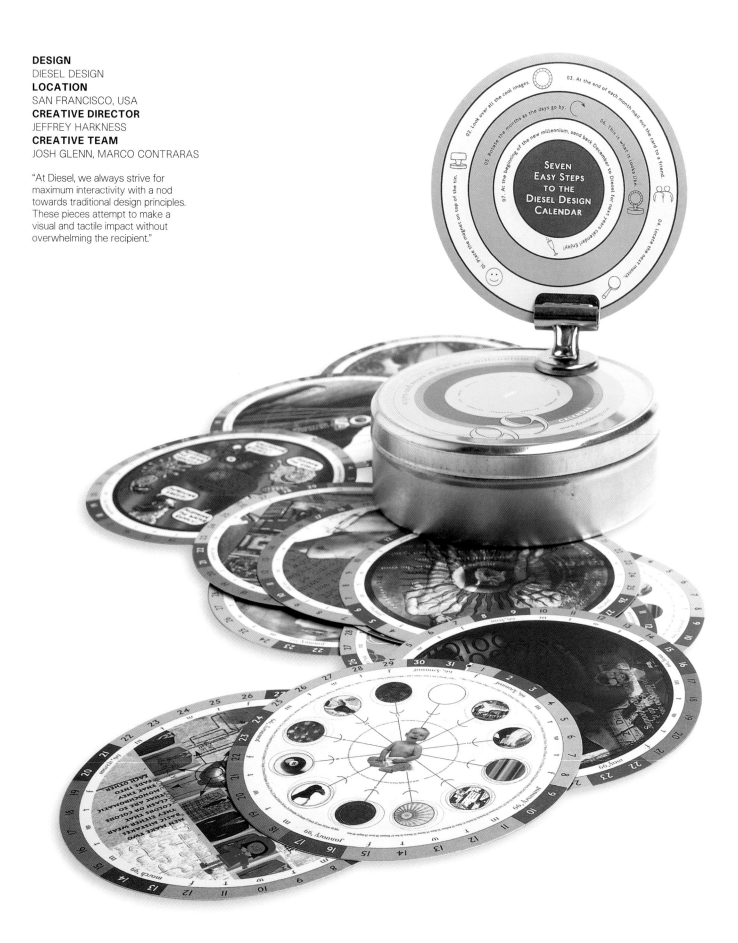

DESIGN
DIRECT DESIGN STUDIO
LOCATION
MOSCOW, RUSSIA
CREATIVE DIRECTORS
DMITRY PIORYSHKOV,
LEONID FEIGIN

"It gives us great pleasure to work
on designs for festive mailings and
agency souvenirs. It is both an original
test and a form of relaxation for us;
in each piece of work we put a part of
our soul."

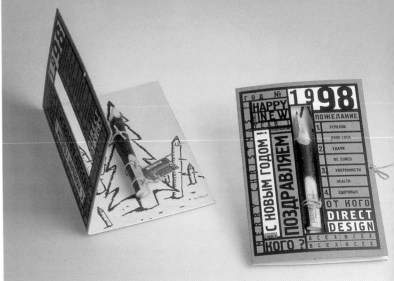

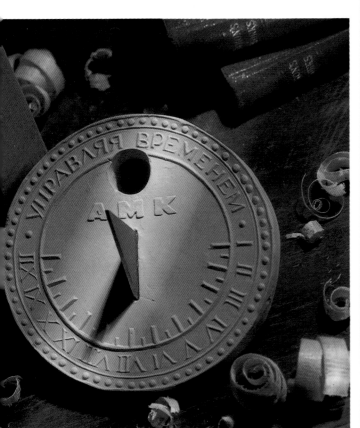

DESIGN
TOP DESIGN STUDIO
LOCATION
LOS ANGELES, USA
CREATIVE DIRECTOR
PELEG TOP
CREATIVE TEAM
MARY YANISH

"We chose the 'relax' theme for this year's annual year-end mailing as we felt we needed to remind people to slow down, take a breath and enjoy the simple things in life."

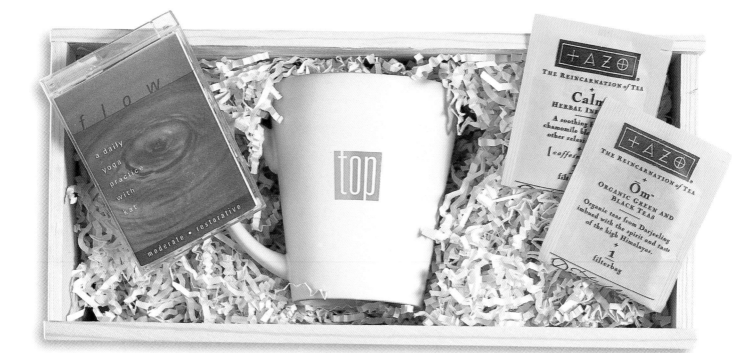

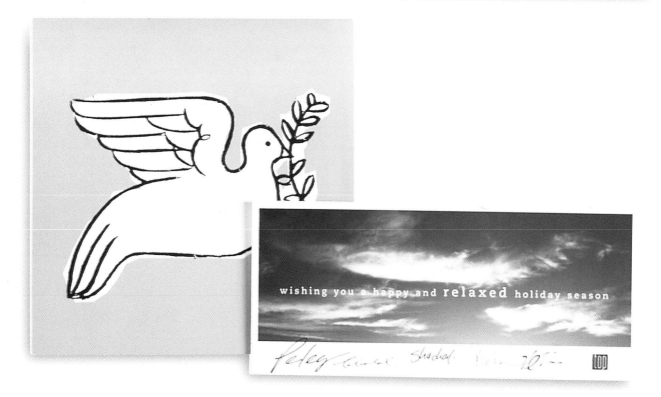

DESIGN
D7 DI CREW
LOCATION
BUENOS AIRES, ARGENTINA
CREATIVE DIRECTORS
STEVE MACLEAN,
LUCIANA FAIMAN
CREATIVE TEAM
SOL BOECHI

"Our job is to build strong personalities for the companies and products we work for. D7 di crew treat these brands as living beings, and we advise on the right behaviour that best suits each situation. Showing companies' feelings with greeting communications can be part of that personality; sharing those feelings is our objective."

... QUE NECESITAN UN ESPACIO EN EL 2000. LA GENTE DE SGP OCUPA ESTE PARA DESEARLE LO MEJOR.

MUCHAS FELICIDADES

homenaje de **puntok** a las influenci
(a casi todas)

BRERO MARZO ABRIL MAYO JUNIO JULIO AGOSTO SEPTIEMBRE OCTUBRE NOVIEMBRE DICI

mt. de alvear 416 1 y 2 piso tel: 4315-3151 tel/fax: 4311-5525 e-mail: puntok@netcli

2002

365 days of joy

DESIGN
THOMPSON DESIGN
LOCATION
LEEDS, UK
CREATIVE DIRECTOR
IAN THOMPSON
CREATIVE TEAM
DAVID SMITHSON

"'365 Days of Joy' is a response to the tough year that 2001 proved to be for almost everyone. We chose to remind people of life's simple joys and set ourselves the challenge of coming up with one for each day of the year. Design, like other creative disciplines, is about making a connection with people and finding a common language."

www.thompsondesign.co.uk
0113 232 9222

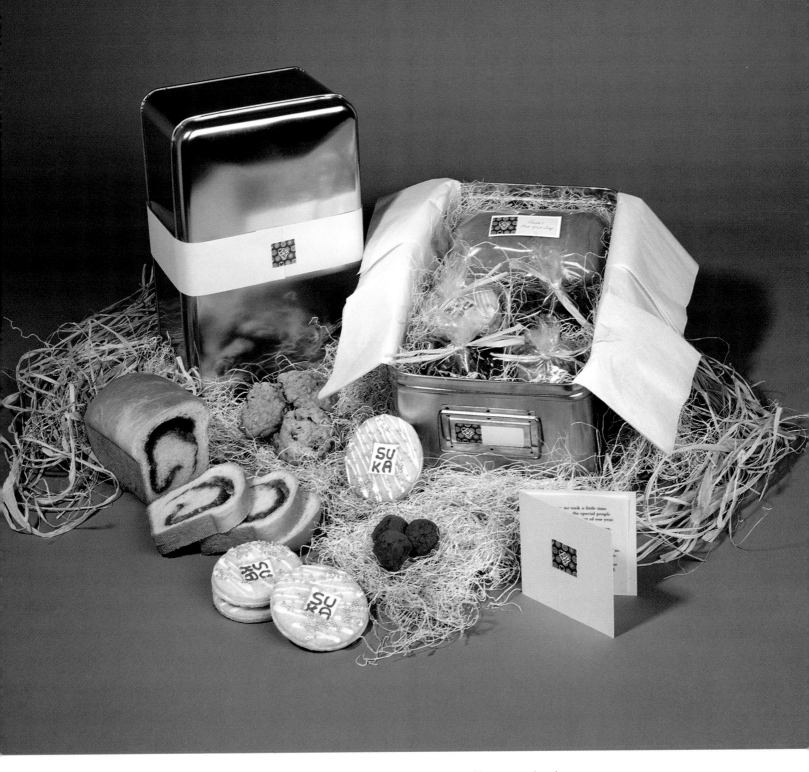

DESIGN
SUKA & FRIENDS DESIGN INC
LOCATION
NEW YORK, USA
CREATIVE DIRECTORS
BRIAN WONG, GWEN HABERMAN

"The 2001 holiday season played a
particularly meaningful role in the
post-9/11 recovery for New York. Suka
& Friends embraced the return to
home-based comforts with a box of
homemade treats prepared by Suka
staff for clients, vendors and friends."

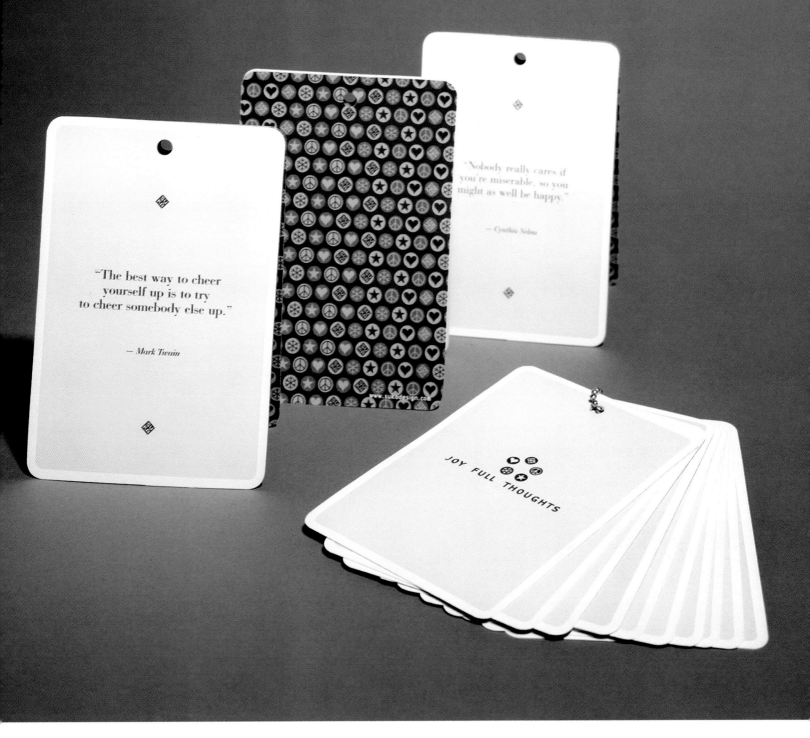

Suka & Friends Design involved
Mark Twain, Anne Frank, Benjamin
Franklin, Jacqueline Kennedy Onassis
and others for their 2001 holiday card
entitled 'Joy Full Thoughts'. The card
delivered words of wit and wisdom on
the topic of joy.

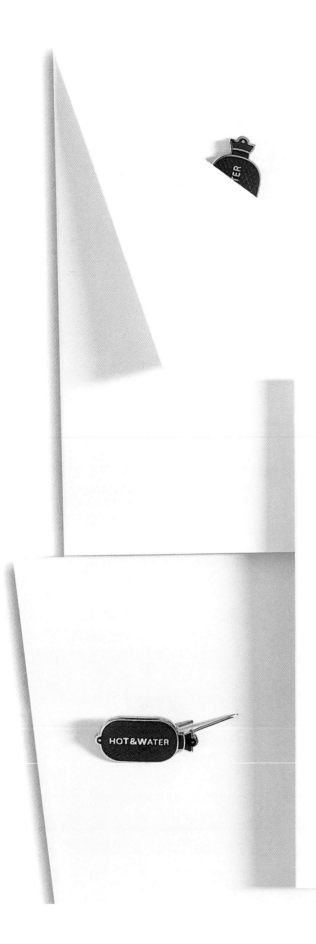

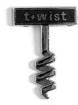

A right little corker from Trickett & Webb

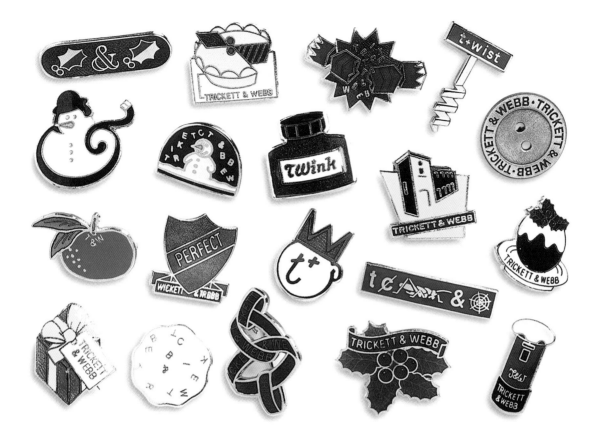

DESIGN
TRICKETT & WEBB
LOCATION
LONDON, UK
CREATIVE DIRECTORS
LYNN TRICKETT, BRIAN WEBB
CREATIVE TEAM
HEIDI LIGHTFOOT, GAVIN
ANDERSON

"Part of a series of enamel badge Christmas cards. We are badge enthusiasts and can't resist the challenge of thinking of yet another slant on Christmas!

"Our Christmas card is a reminder to ourselves as well as our clients that we should all aim to be a little more witty in the New Year. It is also an opportunity to indulge one of our 'collective' passions – enamel badges. Everyone can identify with enamel badges – from ex-Mickey Mouse club members to bowling club fanatics. Whenever a new, young designer tries his hand at our Christmas badge, there is a learning curve while we try to explain the difference between a badge and a piece of jewellery. Badge good, jewellery not. All subtle stuff – but worth it in the end!"

DESIGN
RESERVOIR + OH BOY, ARTIFACTS
LOCATION
SAN FRANCISCO, USA
CREATIVE DIRECTOR
DAVID SALANITRO
CREATIVE TEAM
TED BLUEY

"Holiday = Cheers"

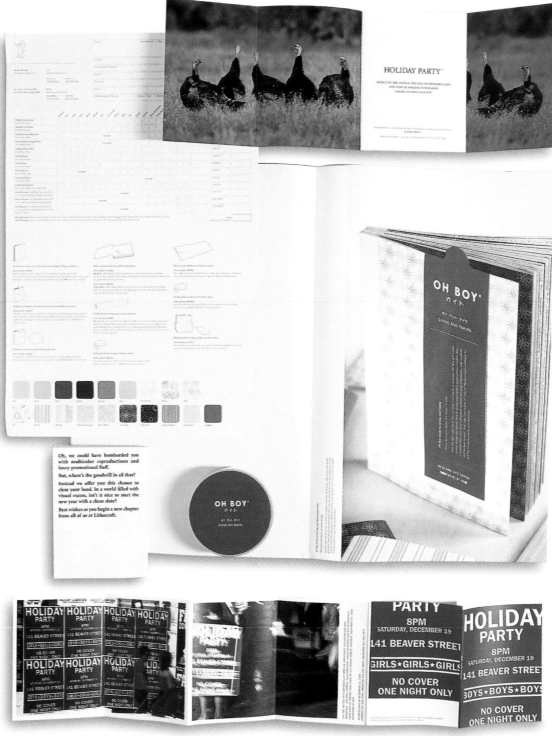

DESIGN
KRAFT & WERK
LOCATION
MARIBOR, SLOVENIA
CREATIVE DIRECTOR
DAMIJAN VESLIGAJ

"2002 kW wine is Kraft & Werk's festive mailing for our clients and friends and goes out with our best wishes."

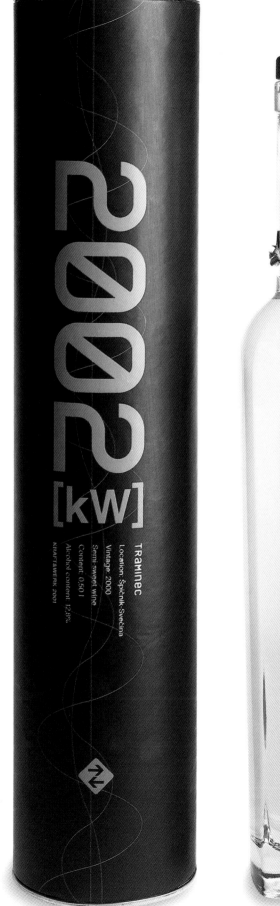

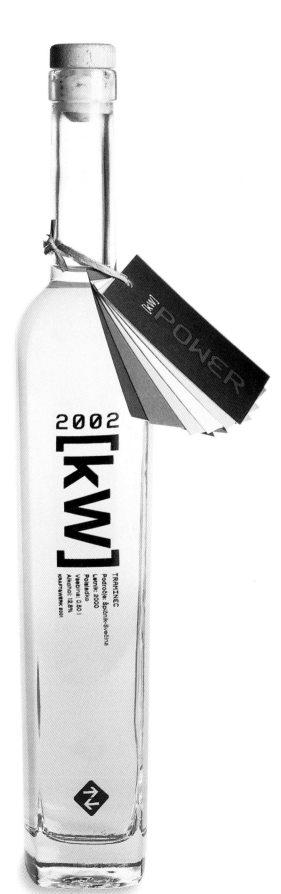

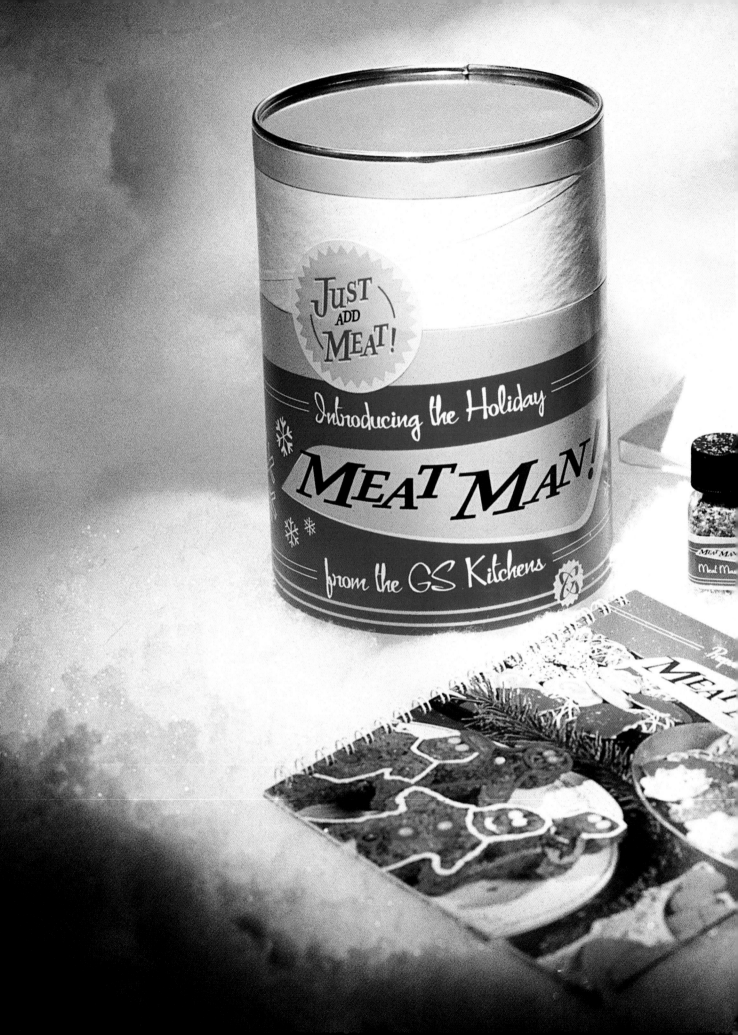

DESIGN
GS DESIGN INC
LOCATION
MILWAUKEE, USA
CREATIVE DIRECTORS
MIKE MAGESTRO, KELLY HEISMAN,
DAVE KOTLAN
CREATIVE TEAM
STEVE RADTKE

GS Design's 2001 holiday promotion
[see page 12] placed a humorous spin
on a sensitive and newsworthy topic.
The kit consisted of a magnetic DNA
Acceleration Chamber (a cocktail
shaker), a 50ml Erlenmeyer flask, a
50ml beaker and a Genetic Cloning
Guide – packaged in a white foam
containment system. Recipients were
able to replicate White Russians and
other 'clones'.

For its 2000 holiday promotion, GS
Design wanted to create a quality
giveaway package, reminiscent of
a 1950s holiday cookbook. Lucky
recipients received a specially designed
culinary kit consisting of a 'Meat
Man' cutter, cookbook and savoury
seasonings. Tasteful indeed.

DESIGN
STOCKS TAYLOR BENSON
LOCATION
LEICESTER, UK
CREATIVE DIRECTORS
JOHN BENSON, GLENN TAYLOR,
DARREN SEYMOUR
CREATIVE TEAM
JONATHAN RAGG,
VICKEY FELTHAM

"If we can't produce highly creative, imaginative Christmas cards year after year for ourselves, how can we produce innovative and successful design solutions time after time for our clients?"

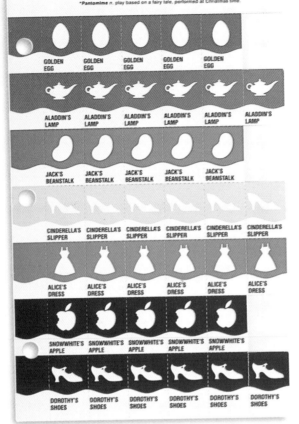

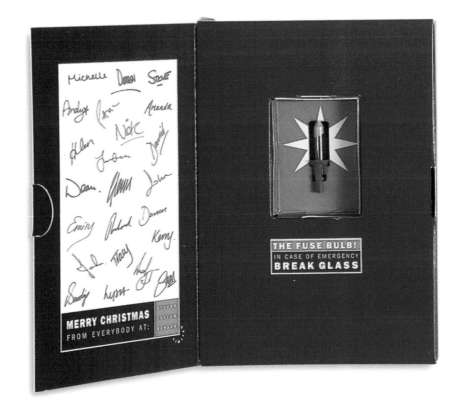

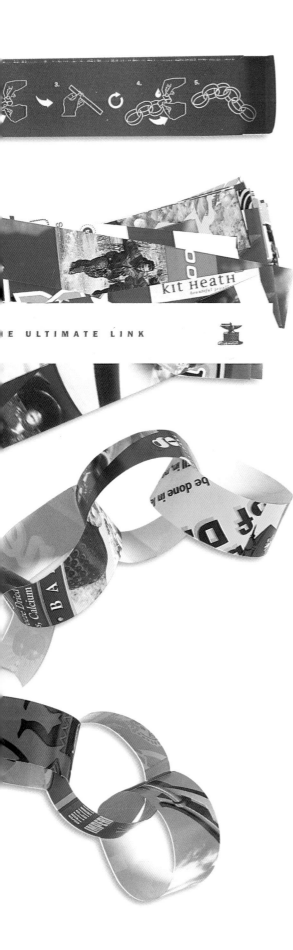

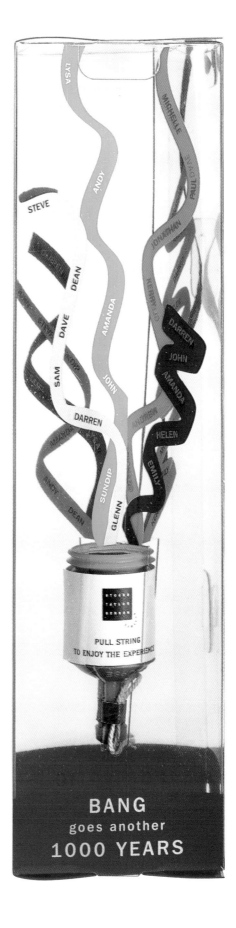

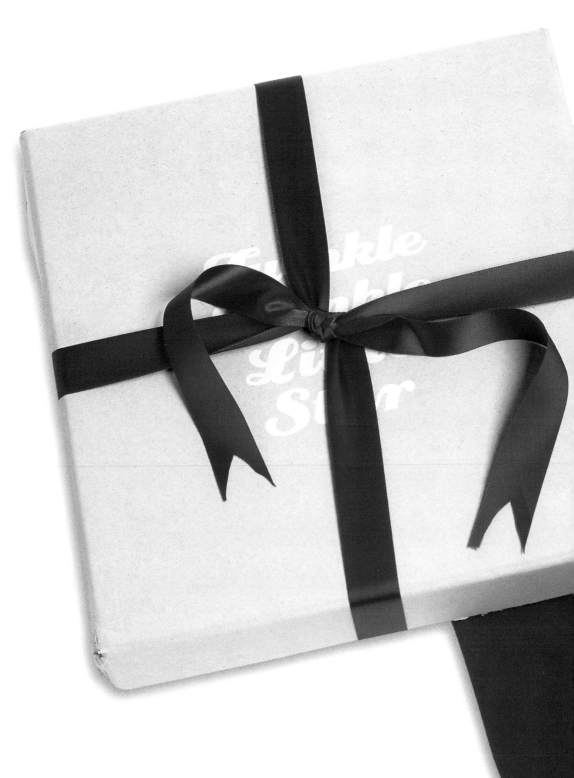

DESIGN
VIRGIN PROJECTS
LOCATION
LONDON, UK
CREATIVE DIRECTOR
TIM FRASER
CREATIVE TEAM
GEMMA THOMSON

"We wanted to thank our clients for
their interest and business for the year.
The idea was to congratulate them
for this by telling them that we thought
they were stars! Rather than blatantly
promoting ourselves, we felt we
should reward them with a fun item
that was well made in traditional
Christmas packaging."

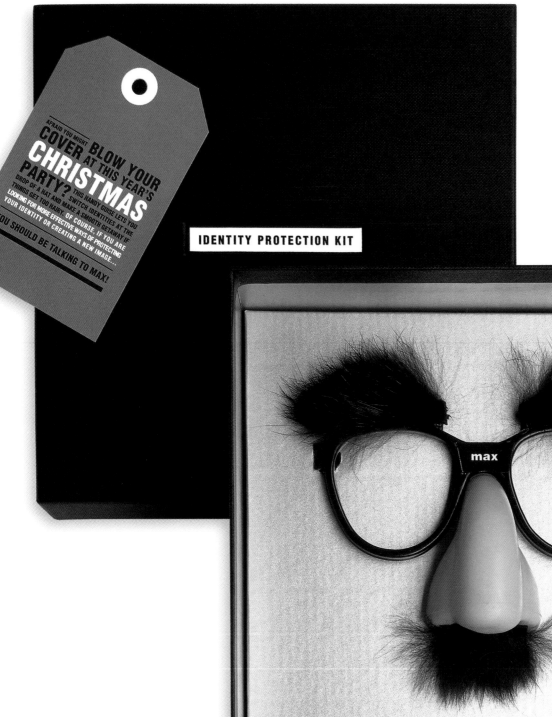

IDENTITY PROTECTION KIT

DESIGN
MAX AND CO
LOCATION
ABERDEEN, UK
CREATIVE DIRECTOR
CLAIRE CORMACK
CREATIVE TEAM
TANIA FENTON, MAIRI MACLEOD, KELLY MEARNS, DAVID ELLIOT

"The 'Identity Protection Kit' cleverly combines the concepts of corporate and personal identity comprising a set of joke-shop nose glasses mounted inside a specially commissioned box. The cheap disguise is a subtle dig at brand naïvety and the so-called identity 'solutions' that result in numerous ineffectual clones. The attached gift tag continues our tradition of reminding clients that if they want things done properly, they need to talk to 'Max'."

DESIGN
PHILIPP UND KEUNTJE GMBH
LOCATION
HAMBURG, GERMANY
CREATIVE DIRECTOR
JANA LIEBIG
CREATIVE TEAM
EVA ROHNG, MICHEL FONG,
ALEX BUSCH, YONA HECKL,
JUSTUS VON ENGELHARDT,
SVEN SCHRODER

"First of all, we wanted to create
something people would want to keep
around for a long time. Something that
survives Christmas. Something people
have fun with. What could be better
than a game including our staff, our
building and the charming beauty of
St Pauli, Hamburg?"

DESIGN
PLUS ONE DESIGN
LOCATION
BRISTOL, UK
CREATIVE DIRECTOR
DENISE HARRIS
CREATIVE TEAM
MARIE HAWKINS, PAUL HOCKING

Plus One have traditionally hand-made their Christmas cards. This textile snowball design was made to be hung on the company Christmas tree. The idea is light-hearted and simply fun.

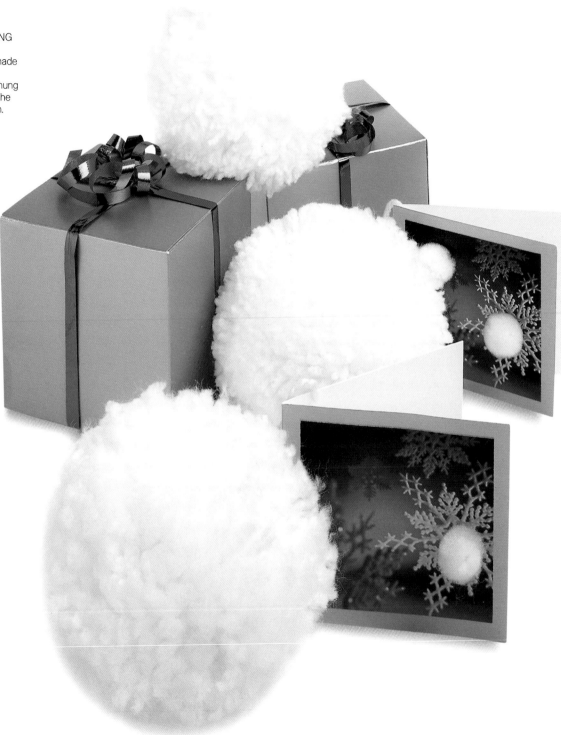

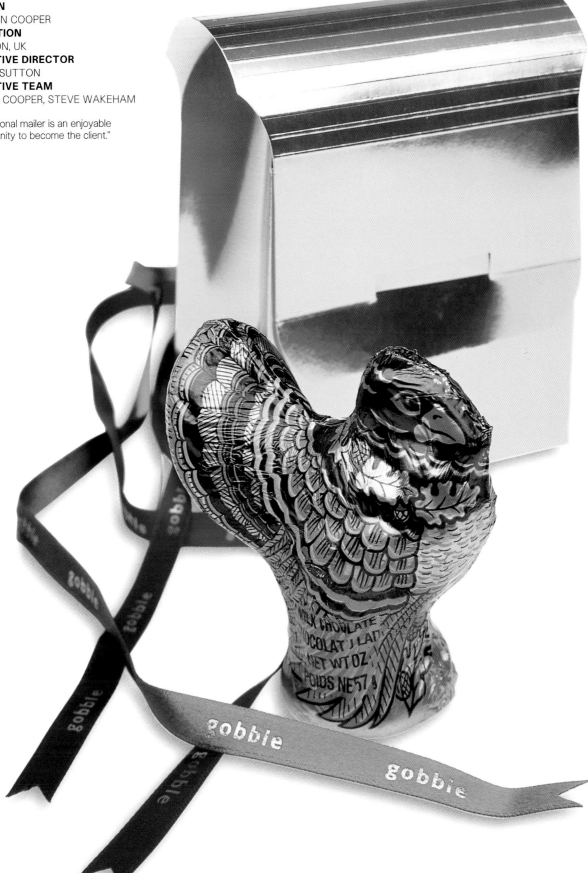

DESIGN
SUTTON COOPER
LOCATION
LONDON, UK
CREATIVE DIRECTOR
LINDA SUTTON
CREATIVE TEAM
ROGER COOPER, STEVE WAKEHAM

"A seasonal mailer is an enjoyable
opportunity to become the client."

DESIGN
SJI ASSOCIATES
LOCATION
NEW YORK, USA

"For SJI Associates, the holidays are a chance to create unique self-promotion pieces that combine a showcase for fresh design with the opportunity to send good wishes to their clients."

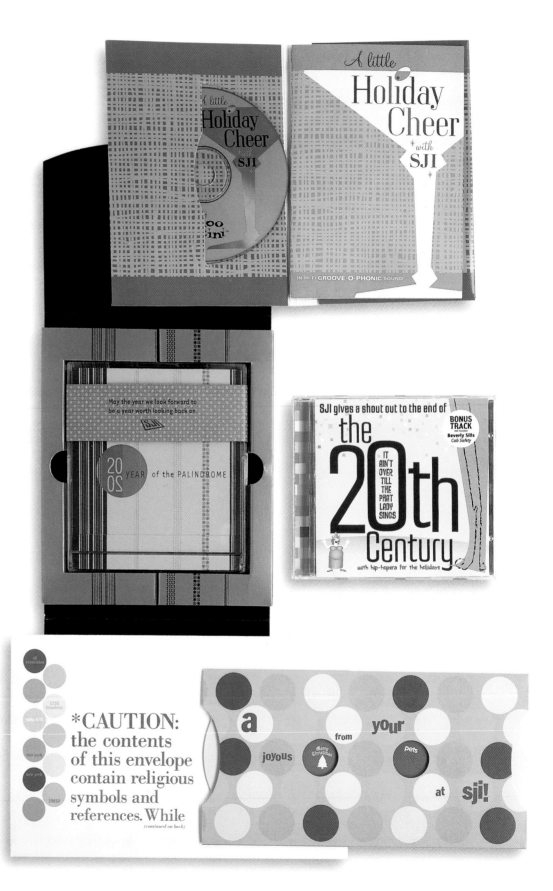

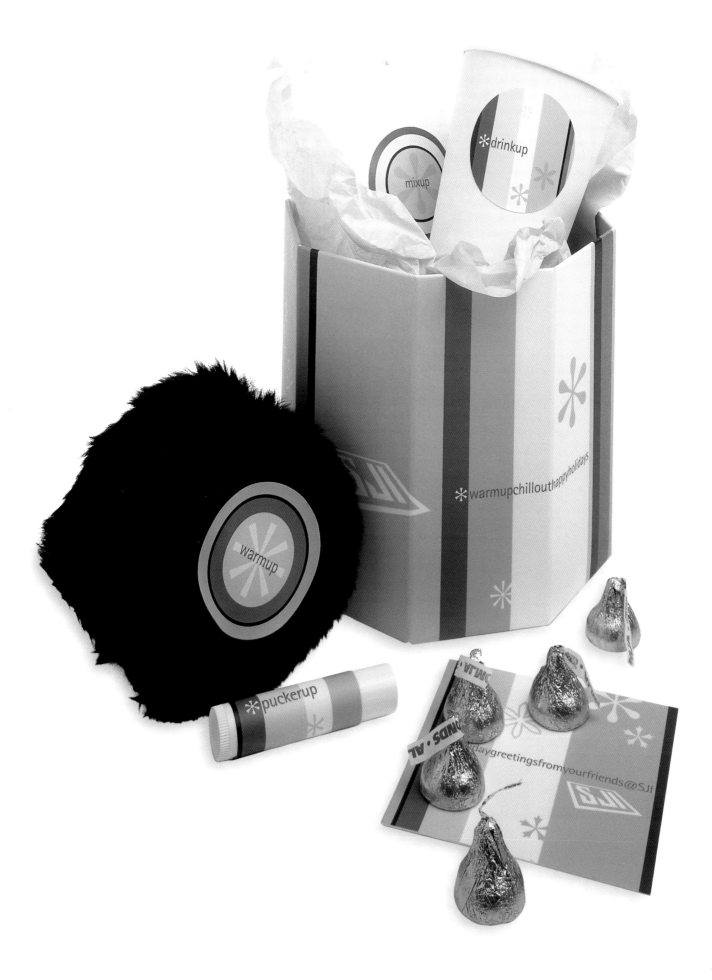

DESIGN
ID2 COMMUNICATIONS INC
(FORMERLY INKWELL DESIGN INC)
LOCATION
VICTORIA, CANADA
CREATIVE DIRECTOR
VALERIE ELLIOT
CREATIVE TEAM
STEPHAN JACOB, KERRY SWARTZ

"iD2 Communications' creative festive
gifts thank our clients for their business
over the past year in a memorable
and personal way. They also
demonstrate iD2's creative abilities.
Illustrating our love for diversity of
culture, we send our gifts out at the
calendar New Year, setting them apart
from the many received over the
Christmas season."

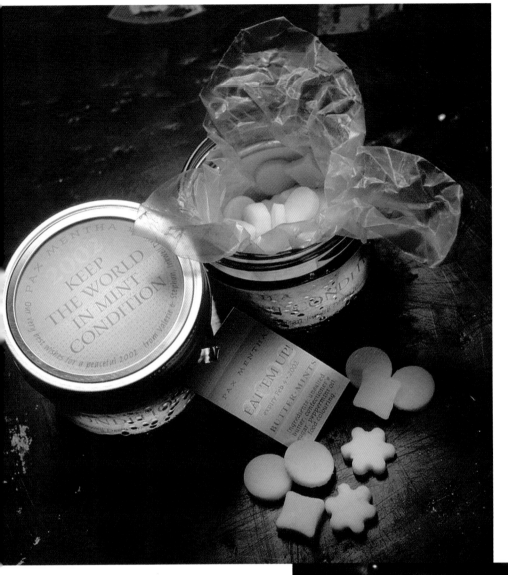

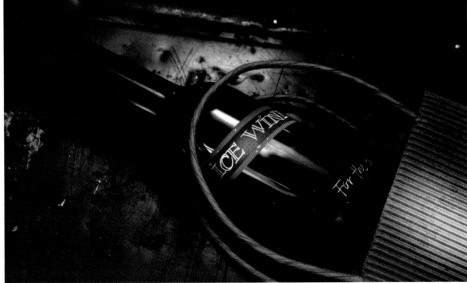

DESIGN
METHOD INTEGRATED MARKETING
LOCATION
COLUMBUS, USA
CREATIVE DIRECTOR
BEVERLY BETHGE
CREATIVE TEAM
SCOTT RAZEK, JEFF WALTER,
TODD STEVENS

"On the 'Sock Monkey and Kitty' mailer,
well, our clients have come to expect a
bit of goofiness in the holiday mailers
and, darn it, we just like sock monkeys!
And, of course we love bouncing kitty
head dolls.

"On the 'What's So Funny' card, it was
the right sentiment at the right time and
summed up our thoughts of this past
year very nicely."

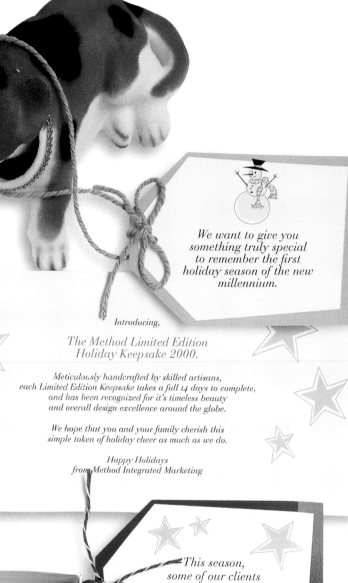

We want to give you
something truly special
to remember the first
holiday season of the new
millennium.

Introducing,

*The Method Limited Edition
Holiday Keepsake 2000.*

*Meticulously handcrafted by skilled artisans,
each Limited Edition Keepsake takes a full 14 days to complete,
and has been recognized for it's timeless beauty
and overall design excellence around the globe.*

*We hope that you and your family cherish this
simple token of holiday cheer as much as we do.*

*Happy Holidays
from Method Integrated Marketing*

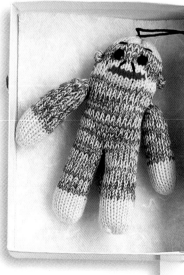

*This season,
some of our clients
are receiving really nice
holiday gifts.*

Some aren't.

*Happy Holidays
from Method.*

DESIGN
ONE O'CLOCK GUN
LOCATION
EDINBURGH, UK
CREATIVE DIRECTOR
MARK HOSKER
CREATIVE TEAM
MICHAEL DUNLOP,
VICKY BEMBRIDGE

"Producing a festive mailer is a great
opportunity to be our own client as well
as to show off our creative talents with
no restrictions. It's a fun time of year to
do a fun project."

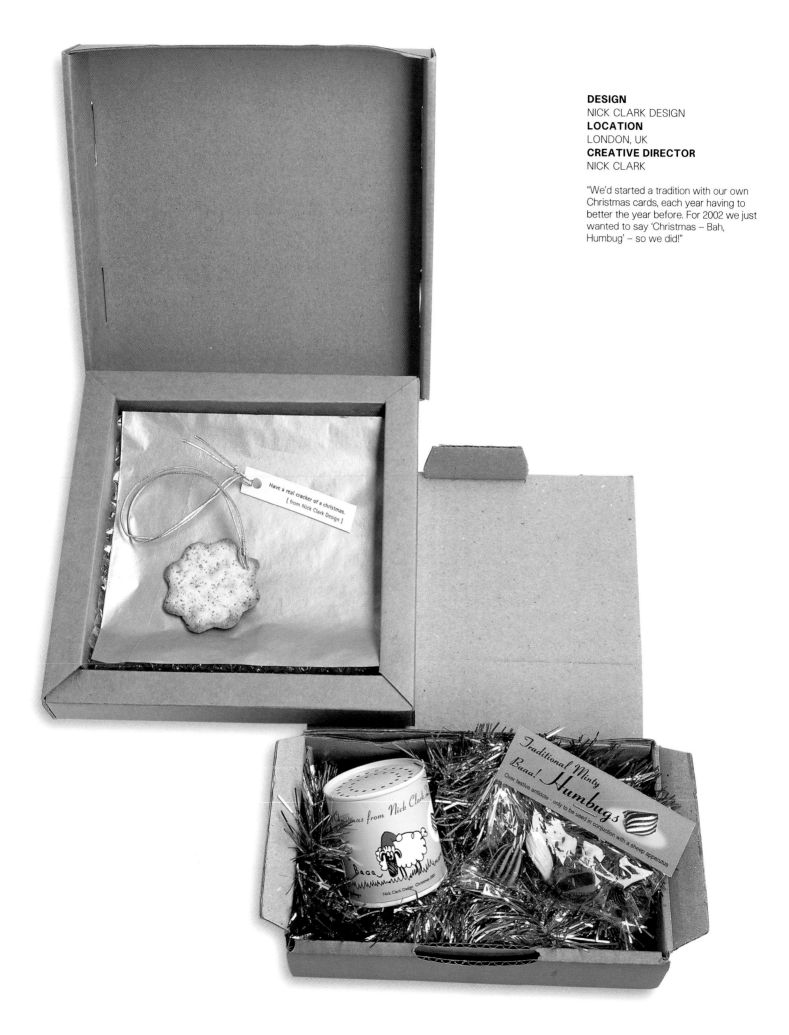

DESIGN
NICK CLARK DESIGN
LOCATION
LONDON, UK
CREATIVE DIRECTOR
NICK CLARK

"We'd started a tradition with our own Christmas cards, each year having to better the year before. For 2002 we just wanted to say 'Christmas – Bah, Humbug' – so we did!"

Have a real cracker of a christmas.
[from Nick Clark Design]

Traditional Minty
Baaa! *Humbugs*
Over festive antidote - only to be used in conjuction with a sheep apparatus

Christmas from Nick Clark D...
Baaa
Nick Clark Design, Christmas 200?

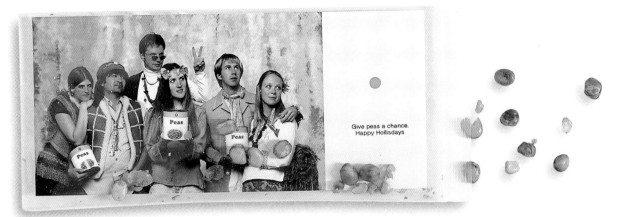

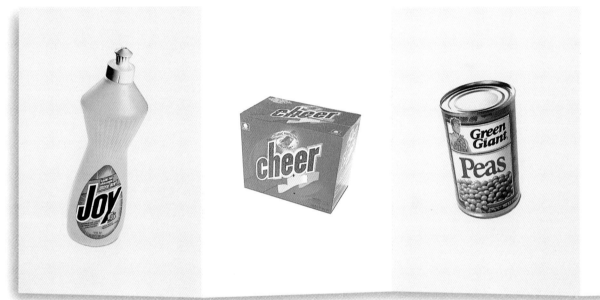

HAPPY HOLIDAYS: AISLE 6

*Wishing you the key ingredients
for a prosperous New Year.
Hollis Design*

DESIGN
HOLLIS
LOCATION
SAN DIEGO, USA
CREATIVE DIRECTOR
DON HOLLIS
CREATIVE TEAM
GUUSJE BENDELER, JOHN SHULZ,
PAM MEIERDING, GINA ROSENTHAL

Give Peas a Chance
"Post-9/11 holidays seemed a difficult subject. We wanted to share our holiday spirit while finding a simple message with value and relevance in today's world. In searching for that message, we discovered an old one that was well worth repeating. John Lennon said it best. We just said it again with a little holiday twist."

Joy, Cheer, Peas
"The purpose behind our fold-out mailer was to find a universal message to share for the holidays while still communicating something about what we do as a design firm. Product packaging photographed in a Pop Art style proved to be an appropriate recipe."

DESIGN
THINKING CAP DESIGN
LOCATION
APPLETON, USA
CREATIVE DIRECTOR
KELLY D LAWRENCE
CREATIVE TEAM
KEITH LENNOP, CHRIS LADING

"We had a small budget for the production of our holiday promotion, making it that much more creative. A few of our clients' businesses are focused on tourism during the 'snow' months and we hadn't seen any snow until December. I found these snow domes in a discount shop and inserted the Thinking Cap Design character."

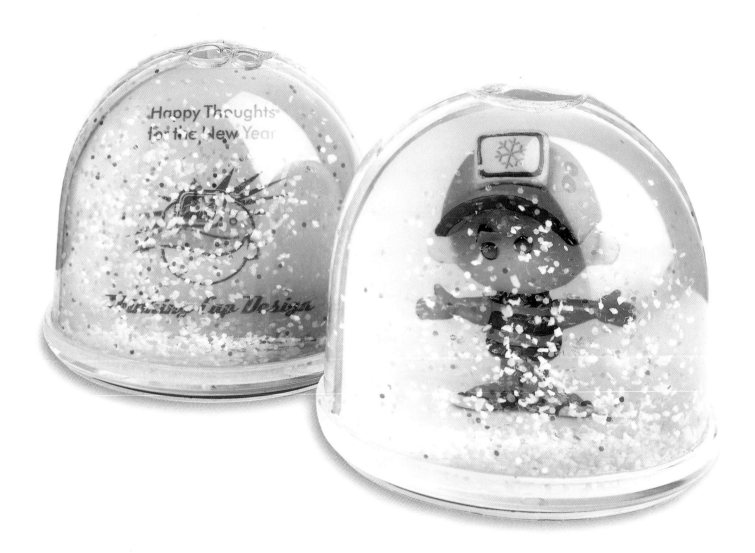

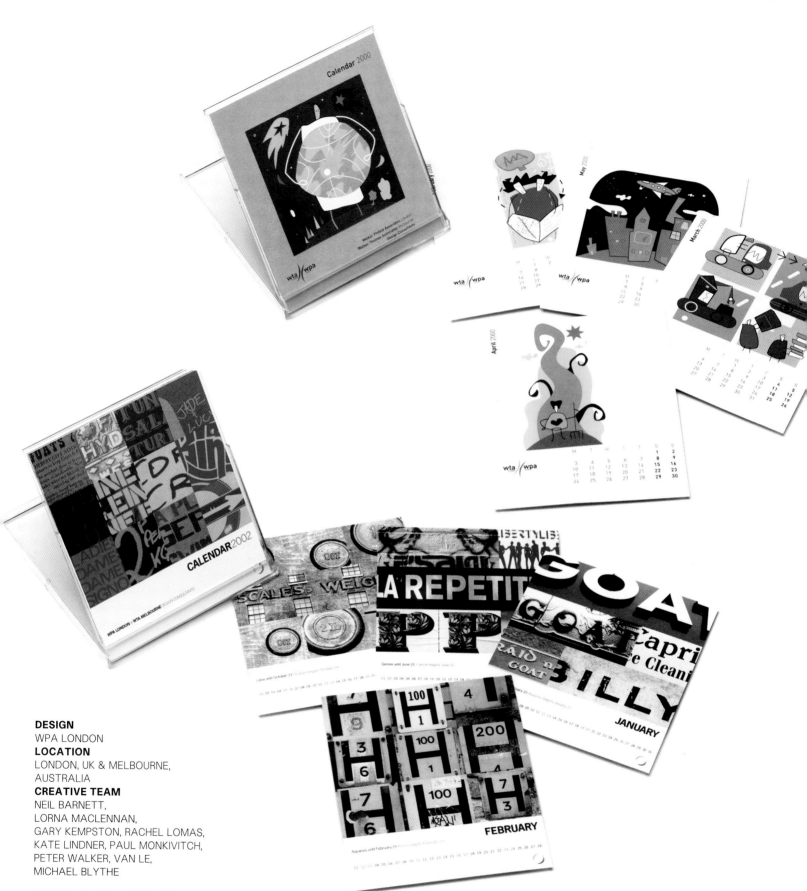

DESIGN
WPA LONDON
LOCATION
LONDON, UK & MELBOURNE,
AUSTRALIA
CREATIVE TEAM
NEIL BARNETT,
LORNA MACLENNAN,
GARY KEMPSTON, RACHEL LOMAS,
KATE LINDNER, PAUL MONKIVITCH,
PETER WALKER, VAN LE,
MICHAEL BLYTHE

A light-hearted interpretation of the
working life of designers at WPA
London and WPA Melbourne.

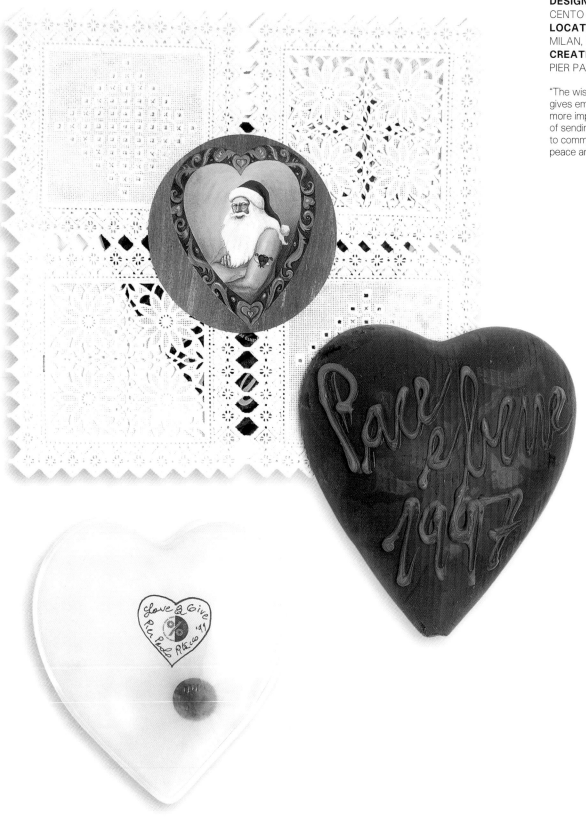

DESIGN
CENTO PER CENTO
LOCATION
MILAN, ITALY
CREATIVE DIRECTOR
PIER PAOLO PITACCO

"The wish to create something that gives emotion and memories is now more important than the simple gesture of sending a greeting card. Our intent is to communicate two feelings – those of peace and love."

DESIGN
SHERRY DESIGN LTD
LOCATION
LONDON, UK
CREATIVE DIRECTOR
KARLA THOMPSON
CREATIVE TEAM
ALAN SHERRY

"We see Christmas as a good opportunity to remind our clients that our core business is ideas. We like to create something fresh and exciting each year that both surprises them and appeals to their sense of humour."

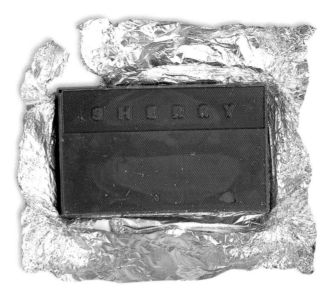

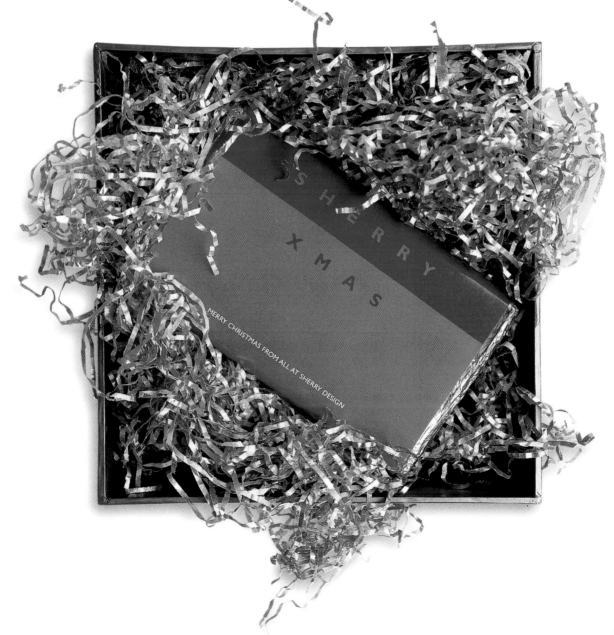

DESIGN
BD-TANK
LOCATION
GLASGOW, UK
CREATIVE DIRECTORS
GHILL DONALD, WILLIE BIGGART
PAUL GRAY, STUART GILMOUR
CREATIVE TEAM
SCOTT WITHAM, GARY DOHERTY,
JOAN GRADY, TIM WILCOX,
MAGGIE MURRAY, GARY DAWSON
AVRIL MCGRATH

This was a team effort from all at
BD-Tank, from designers working on
the typography to the account handlers
assisting in the production.

All the inflatable mailings contained
hand-finished gift boxes, each one with
a chocolate inside.

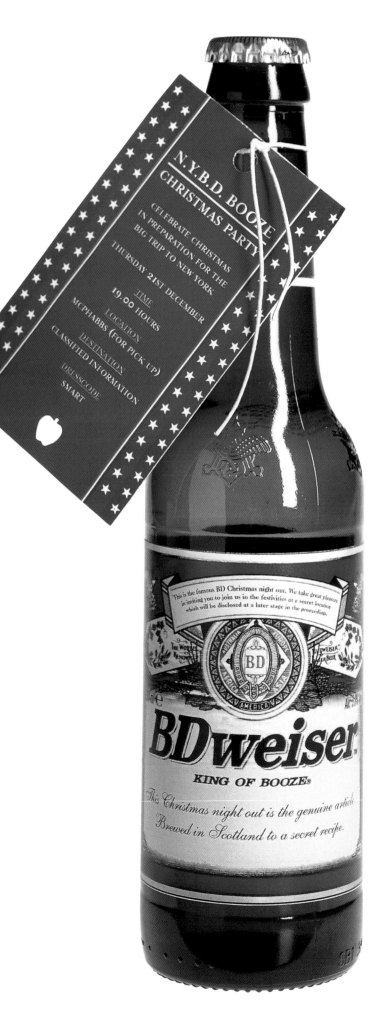

MERRY **CHRISTMAS**
XMAS 00 | HAPPY NEW NY
❄ FROM ALL AT BIGGARTD

BD

DESIGN
DEAF EYE
LOCATION
LOS ANGELES, USA
CREATIVE DIRECTOR
MARILYN JOSLYN
CREATIVE TEAM
MATTHEW COGSWELL,
SAM HUBBELL

"A festive mailing is not only good self-promotion, but it shows client appreciation. In keeping with our corporate identity, we chose to create a strong, simple yet whimsical design."

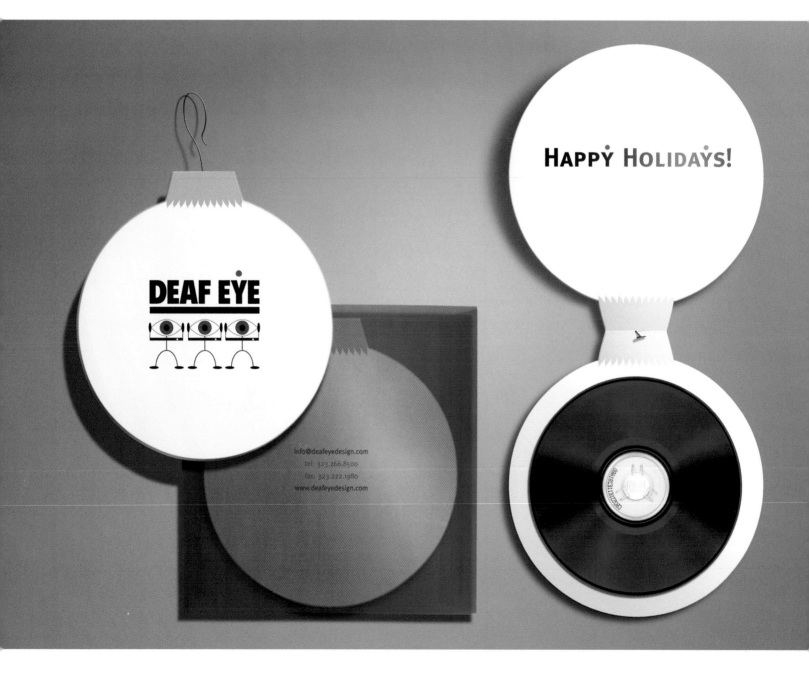

DESIGN
THE IMAGINATION GROUP LTD
LOCATION
LONDON, UK
CREATIVE DIRECTOR
GARY WITHERS

The Christmas decorations at the London headquarters of design consultancy Imagination have become a seasonal institution. The exterior of the Imagination building has been festooned as a gift-wrapped parcel, a festive table setting and a giant Christmas wreath, all made of light. The company photographs its annual 'gift' to London for the Imagination Christmas card.

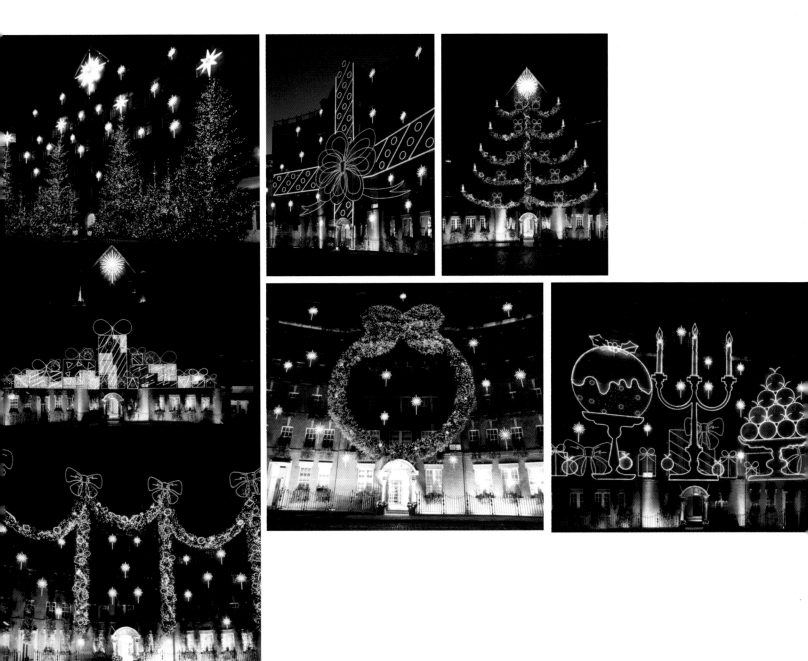

DESIGN
BLATMAN DESIGN
LOCATION
SOMERVILLE, USA
CREATIVE DIRECTOR
RESA BLATMAN

"Although I don't do much in the way of
advertising, the December holidays are
a good time to show my clients that I
appreciate their patronage. I use
attractive stock imagery that I
manipulate, and I write my own poetry
or include the poetry of others as a gift
for my family, friends and clients."

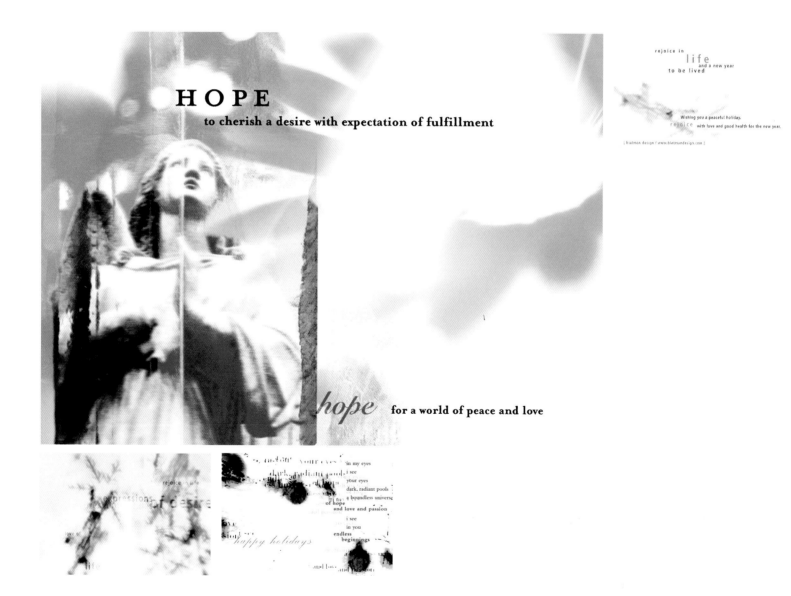

DESIGN
GRAPHIC PARTNERS
LOCATION
EDINBURGH, UK
CREATIVE DIRECTOR
GRAPHIC PARTNERS
CREATIVE TEAM
MHAIRI MCDONALD

Graphic Partners wanted to get across the message that the thought behind something is the most important thing – in a tongue -in-cheek way.

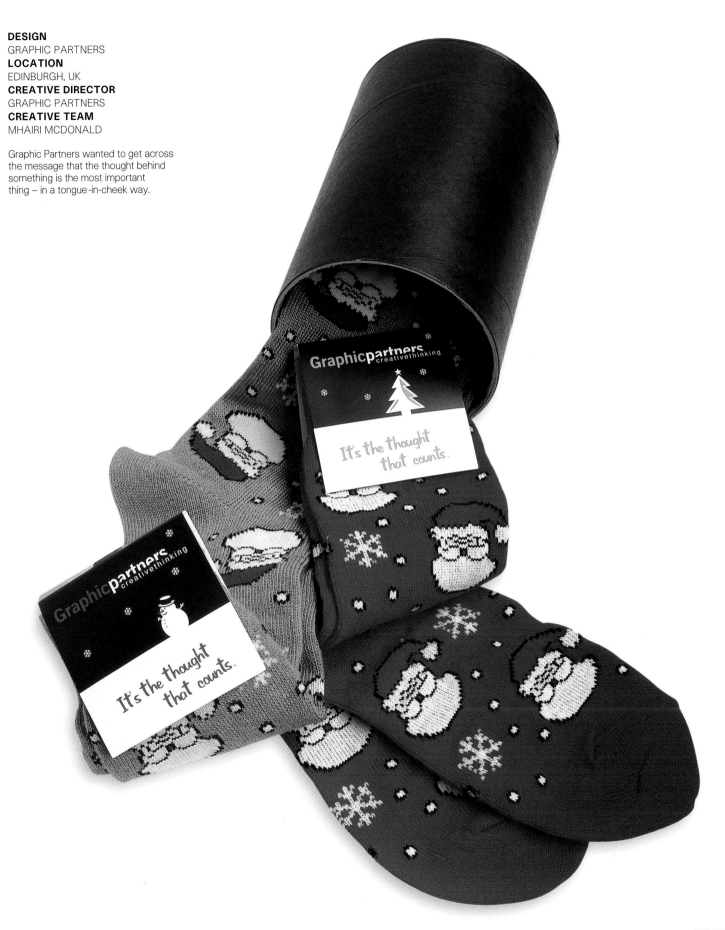

```
°C  °F
    93
    90
    86
    82
    79
    75
    73
22  72
21  70
    68
    66
    64
    63
    60
    57
```

DESIGN
WILLIAMS AND PHOA
LOCATION
LONDON, UK
CREATIVE DIRECTOR
CLIFFORD HISCOCK
CREATIVE TEAM
MATTHEW SHANNON, ROSS
SHAW, ROBB GAITT

Williams and Phoa sent out a
self-adhesive, off-the-shelf, refrigerator
thermometer 'tipped-in' to a
pre-debossed area on the front. The
message inside reads 'Warm wishes
this Christmas from Williams and Phoa'.

There were 441 screenprinted dots on
front, some of which are printed with
luminous ink. In the dark, the triangular
shape of a Christmas tree becomes
visible. The message inside reads
'Williams and Phoa wish you a brilliant
Christmas and a bright New Year'.

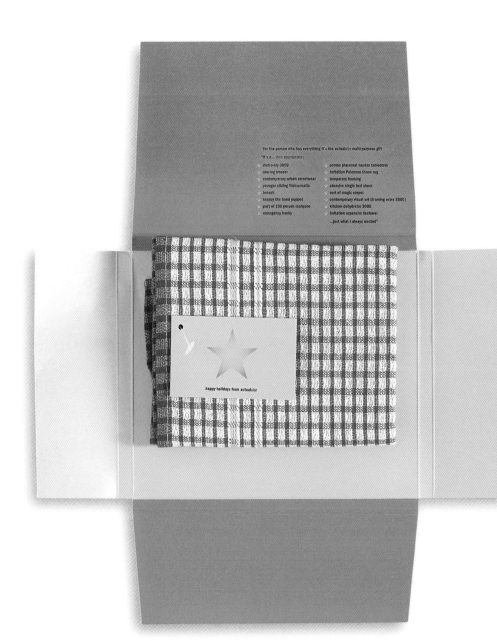

For the person who has everything it's the actualsize multi-purpose gift

"It's a... (tick appropriate)

dish-o-dry 3000
one-leg trouser
contemporary urban streetwear
younger sibling flick-o-matic
brooch
krappy the hand puppet
part of 150 person marquee
emergency hanky

combo placemat napkin tablecloth
imitation Pokemon throw rug
temporary housing
abrasive single bed sheet
sort of magic carpet
contemporary visual art (framing extra $$00)
kitchen dehydrater 3000
imitation expensive teatowel

...just what I always wanted"

happy holidays from actualsize

DESIGN
ACTUAL SIZE
LOCATION
MELBOURNE, AUSTRALIA
CREATIVE DIRECTOR
LUKE FLOOD
CREATIVE TEAM
ADELE SMITH, GARTH ORIANDER

"The ideas for our festive mailings are based on the tradition of receiving crap and diabolically inappropriate and/or ill-fitting gifts from elderly relatives. Socks, underpants, talcum powder and so on are foisted upon Australians under the age of 70, along with a simultaneous barrage of questions concerning when one was getting married and when we would draw a picture of our old Gran and we weren't ashamed of her, were we and had she ruined the day?"

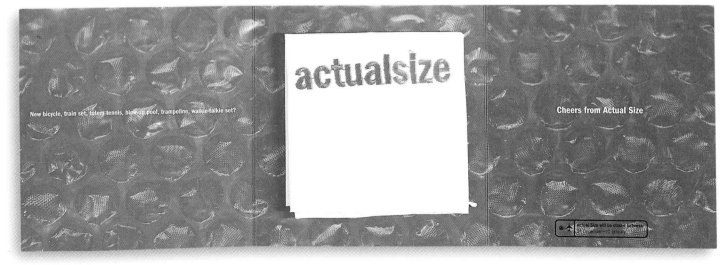

New bicycle, train set, totem tennis, blow-up pool, trampoline, walkie-talkie set?

actualsize

Cheers from Actual Size

Actual Size will be closed between 24 December–10 January

DESIGN
METHODOLOGIE
LOCATION
SEATTLE, USA
CREATIVE TEAM
GABE GOLDMAN,
SARINA MONTENEGRO

"We produce a festive mailing every year. It's a great opportunity to send something special to clients, partners and friends. This was produced in December 2001. We wanted to send out a message of hope."

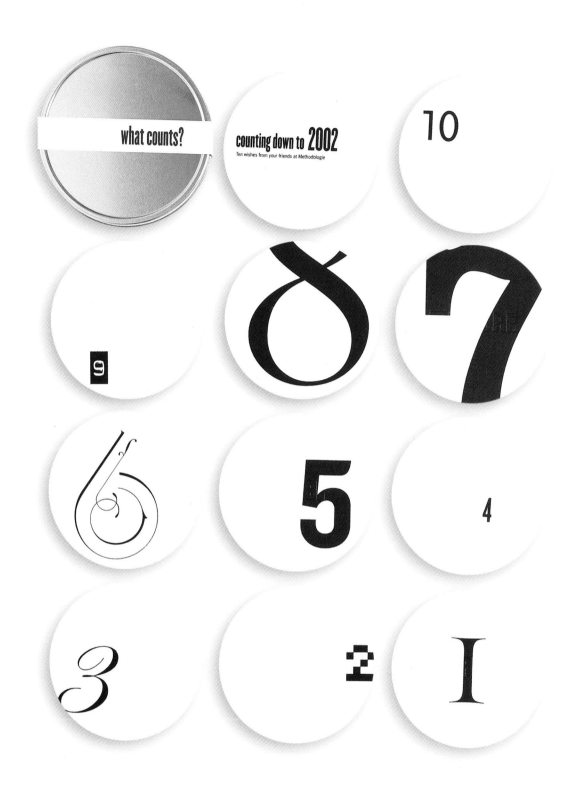

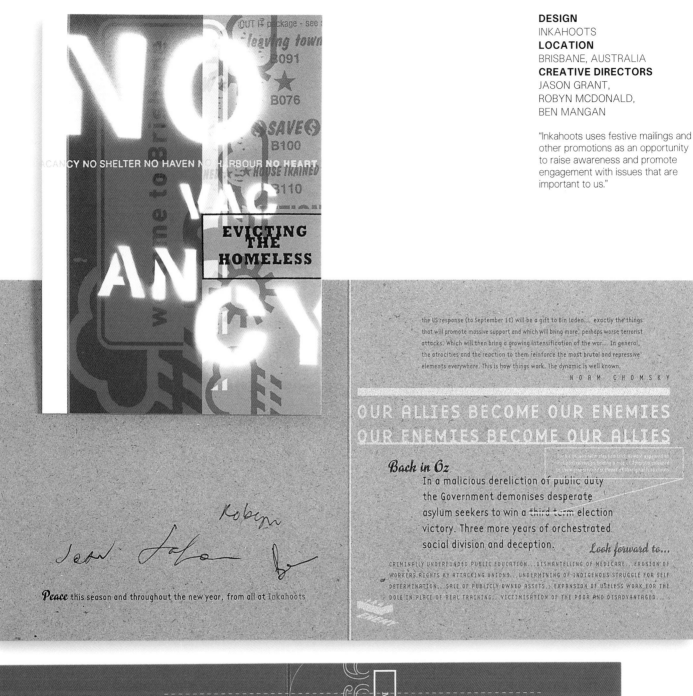

DESIGN
INKAHOOTS
LOCATION
BRISBANE, AUSTRALIA
CREATIVE DIRECTORS
JASON GRANT,
ROBYN MCDONALD,
BEN MANGAN

"Inkahoots uses festive mailings and other promotions as an opportunity to raise awareness and promote engagement with issues that are important to us."

Wij wensen u een prachtige

Kerstboom

...en een gelukkig nieuwjaar!

DESIGN
BUREAU GRAS
LOCATION
ALKMAAR, NETHERLANDS
CREATIVE DIRECTOR
RUUD WINDER
CREATIVE TEAM
ROBB GAITT, BART KEUZENKAMP,
MARJIJKE DEKKER,
ELLEN DE GRAAF

"To create a totally different Christmas
card every year gives us the
opportunity to send our best wishes in
an original way and show off our design
skills to our clients and colleagues."

PRIORITY
PRIORITAIRE

€ 0,27 FL 0.60 NEDERLAND 2001

€ 0,27 FL 0.60 NEDERLAND 2001

bureau GRAS p.o. box 3001 1801 ga alkmaar the netherlands

Deadline21
Scott Witham
25 Calderwood Rd
Rutherglen
Glasgow Scotland
G73 3HD UK

Wij wensen u een prachtige
Kerstboom

bureau GRAS fnidsen 28b, 1811 ng alkmaar
ontwerpers voor drukwerk en internet

1

9. 10. 2. 3.

8. 4.

6.

7. 5.

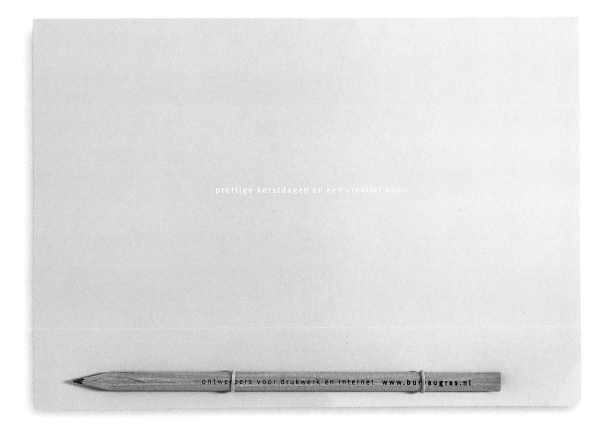

prettige kerstdagen en een creatief 2000

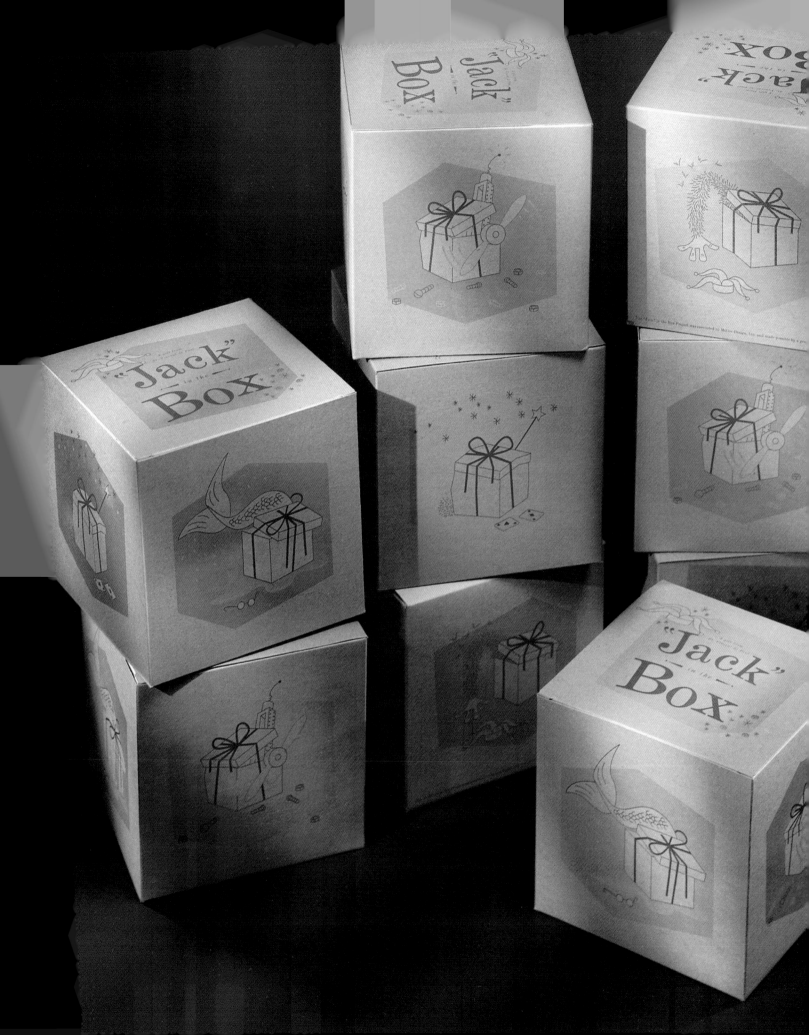

DESIGN
MOTIVE DESIGN
LOCATION
PHOENIX, USA
CREATIVE DIRECTORS
JESSE VON GLUCK,
LAURA VON GLUCK
CREATIVE TEAM
KEE RASH

"One of the goals of our design firm was to help bring Christmas to children who would normally go without. Artfully illustrated boxes titled 'Jack in the Box' are delivered to corporations around Arizona. When the potential donors receive it, a message explains that some kids won't get 'Jack' for Christmas. The empty box replicated the feeling many children experience during the holidays. The idea is that the donor fills the box and gets it distributed through St Vincent de Paul of Arizona. This project was made possible by a grant from Sappi Fine Paper."

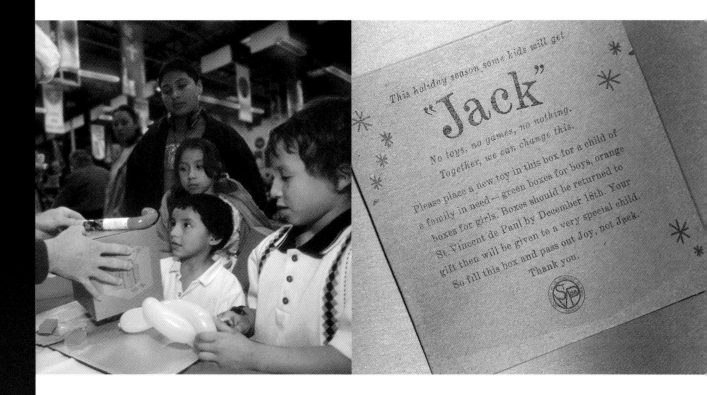

DESIGN
999
LOCATION
GLASGOW & MANCHESTER, UK
CREATIVE DIRECTORS
KEITH FORBES, AILEEN GERAGHT
CREATIVE TEAM
CHRIS HEYES, JAMES DENLEY,
SIMON HENSHAW,
LEWIS MCINTYRE

"Our Christmas cards give us the chance to showcase our creative skills, as well as demonstrating to our clients we still have a sense of humour despite another year of hard work on their behalf."

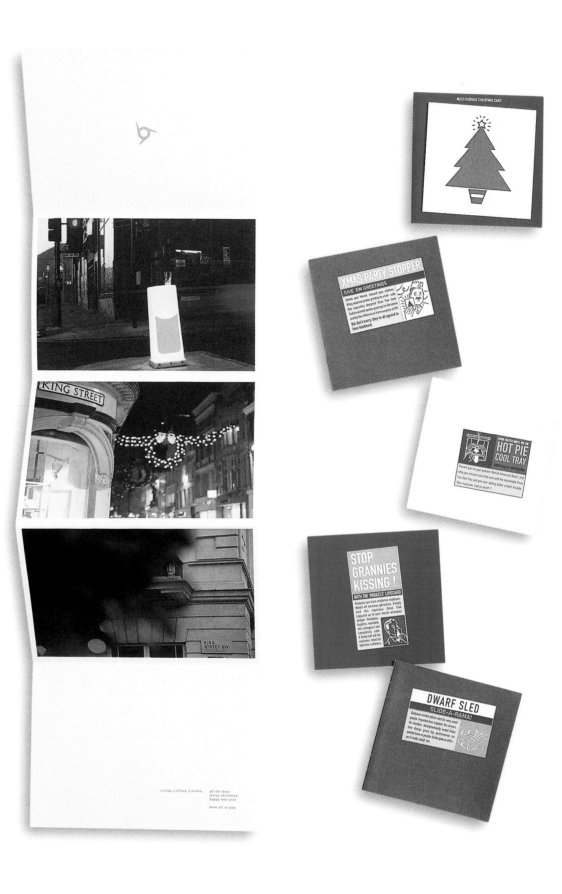

DESIGN
MORRIS CREATIVE INC
LOCATION
SAN DIEGO, USA
CREATIVE DIRECTOR
STEVEN MORRIS

"We're constantly looking to entertain
our audience and show our services
and capabilities. A fun, festive mailing
like this allows us to apply our product
and packaging creativity."

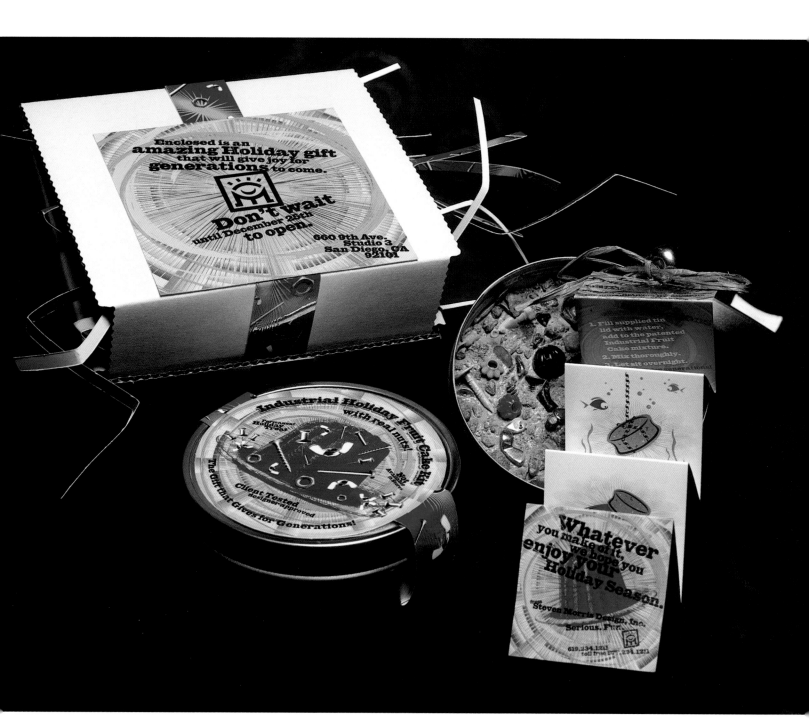

DESIGN
KBDA
LOCATION
LOS ANGELES, USA
CREATIVE DIRECTOR
KIM BAER
CREATIVE TEAM
BARBARA COOPER, LIZ BURRILL,
MAGGIE VAN OPPEN,
KATE RIVINUS, JAMIE DIERSING,
HELEN DUVALL,
JAMIE CAVANAUGH,
LISA PACKARD,
STEPHANIE ANDREWS,
MICHAEL LEJEUNE, JIM BAEHR

"We've found the best promotions are gifts and especially gifts people can really use! Our clients regularly thank us for keeping them on our mailing list."

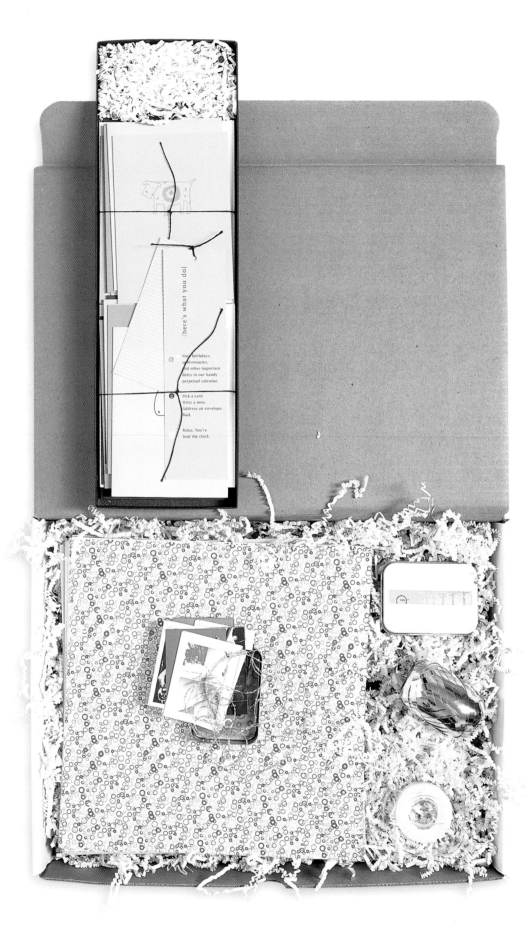

DESIGN
CREATISCOPE
LOCATION
LONDON, UK
CREATIVE TEAM
JOHN GROVER, MARK STEWART-BIRCH

"As this was one of Creatiscope's first
pieces of self-promotion, we aimed to
make a creative impact."

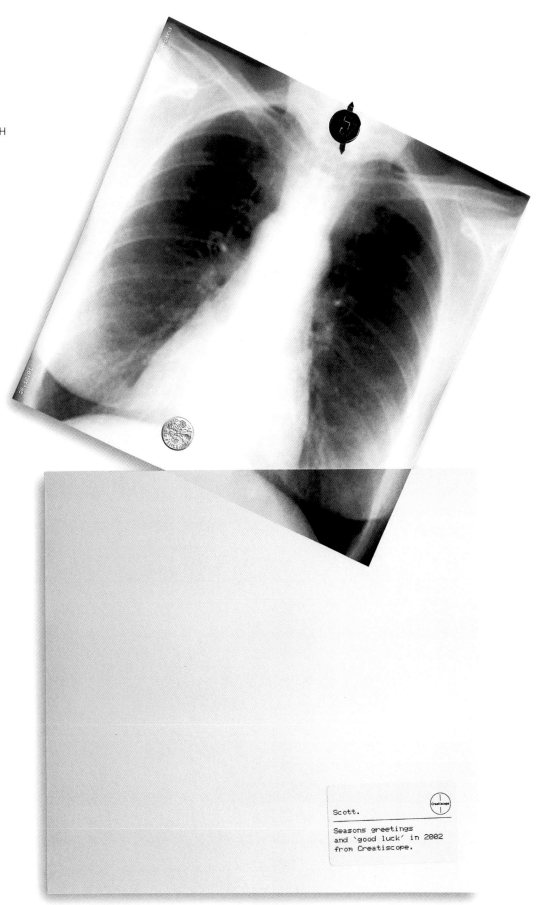

DESIGN
STILL WATERS RUN DEEP
LOCATION
LONDON, UK
CREATIVE DIRECTOR
ANITA BRIGHTLEY-HODGES
CREATIVE TEAM
ALLISON JACOBS, NATASHA
SEARS, TAMSIN ROQUES

"Still Waters Run Deep has always sent a variety of creative mailings throughout the year. They are a fun way to showcase our talents as designers as well as an opportunity to thank our clients and suppliers for their loyalty over the past year."

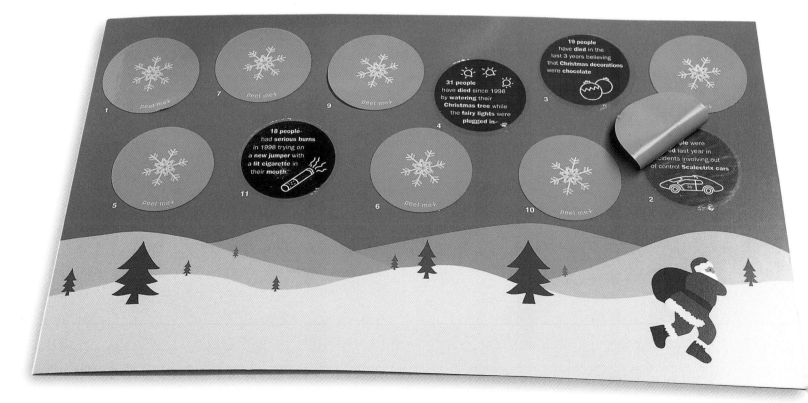

DESIGN
SAYLES GRAPHIC DESIGN
LOCATION
DES MOINES, USA
CREATIVE DIRECTOR
JOHN SAYLES

Using 'The Twelve Days of Christmas'
as a theme, this custom-designed
holiday clock was a unique and
memorable gift. The ceramic clock
measures 18" in diameter and features
original illustrations by John Sayles.

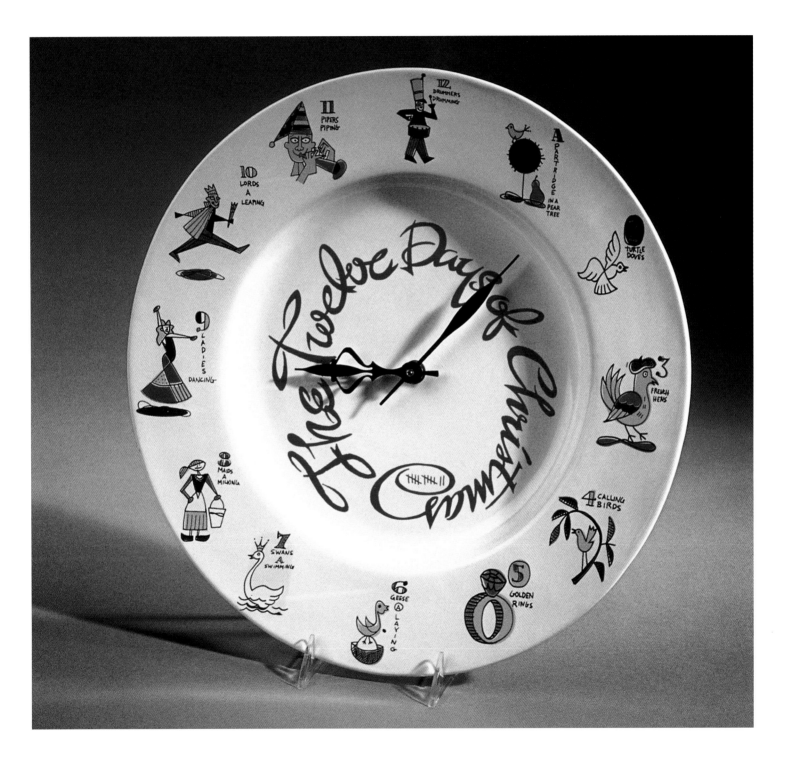

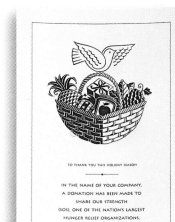

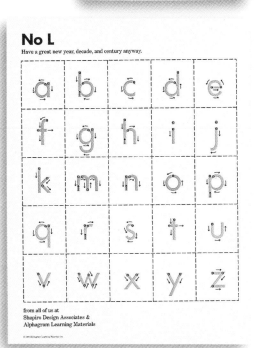

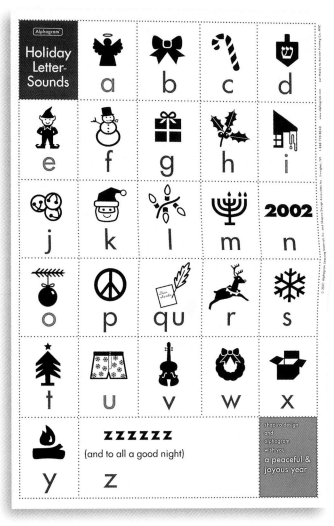

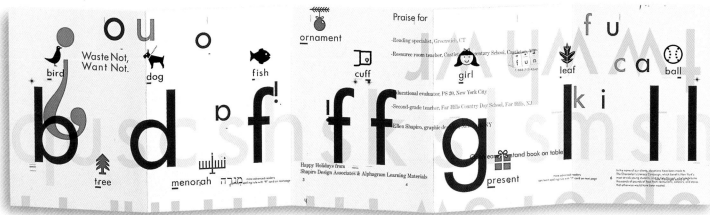

1995
A Year of Recipes

by
Ellen Shapiro

Illustrated by
Paul Hoffman

Spicy Pumpkin Soup

After enjoying a rich, curried pumpkin soup at the Vermont home of Paul Ferber, law school professor, skier, and *bon vivant*, I decided that those cute little pumpkins that grace roadside stands every October deserve to become more than decorations. This soup can be made with almost any combination of vegetables; try winter squash, leek and potato, and all kinds of mixed greens. Paul's recipe called for 2 cups of heavy cream. I hope he doesn't mind the revision.

1 each large onion, celery stalk, carrot
2 Tb. butter, 1 Tb. salad oil
1/2 tsp. each ground cumin, turmeric, ginger, coriander
1/4 tsp. each white pepper, allspice, cayenne
1 3-lb. pumpkin
1 tsp. salt; 1 bay leaf
1 can chicken broth plus 2 cups water
1/2 cup half-and-half or heavy cream

Peel the onion, celery (to remove strings), and carrot, and dice roughly. Heat the butter and oil in a large soup pot and sauté vegetables until tender. Cut the pumpkin in half crosswise, remove the seeds and fibers, and with a sharp knife, peel and cut the flesh into chunks. Add to the pot.
Blend in the spices and stir until fragrant. Add the broth and water and bring to a simmer. Add salt and bay leaf. Cover and simmer about 40 minutes or until pumpkin is very tender, almost falling apart.
Transfer the contents of the pot, minus bay leaf, to a food processor and purée. Don't overdo the processing – the soup should have some texture. Reheat slowly, season with salt and white pepper, and add the half-and-half or cream.
Serve topped with a sprinkling of ground cumin.

23

DESIGN
SHAPIRO DESIGN ASSOCIATES
LOCATION
IRVINGTON, USA
CREATIVE DIRECTOR
ELLEN SHAPIRO

"We designed fairly traditional holiday greetings often with gifts (such as donations to 'Share our Strengths' – a hunger relief organisation). In 1999 we started publishing Alphagram Learning Materials, which help children to read. Then we began a series based on alphabet letters and holiday letter-sound pictograms."

DESIGN
THE OPEN AGENCY
LOCATION
LONDON, UK
CREATIVE DIRECTOR
GARY COOKE
CREATIVE TEAM
AL FULLER, MARTYN ROUTLEDGE,
ANDY HOLTON, IAIN HUTCHINSON

"The Open Agency is not a company to
miss out on celebrating any festive
occasion! Christmas is another excuse
to have a bit of fun and remind our
clients that we are an ideas agency."

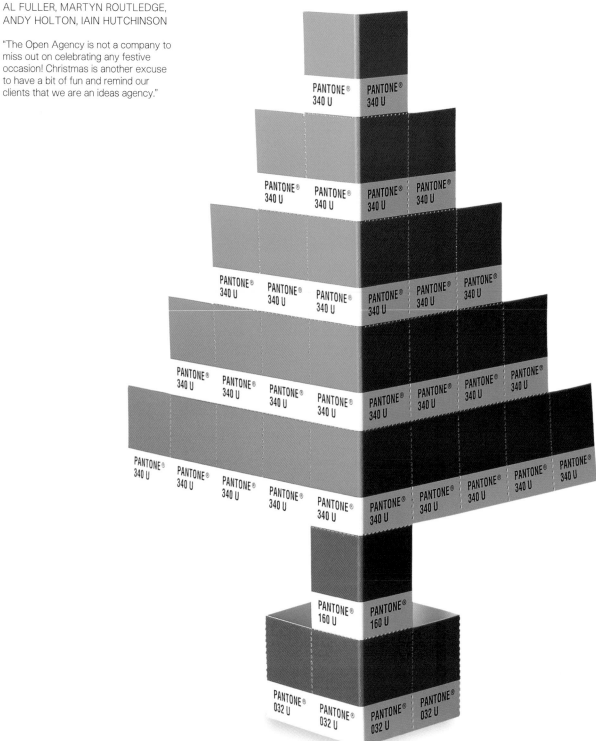

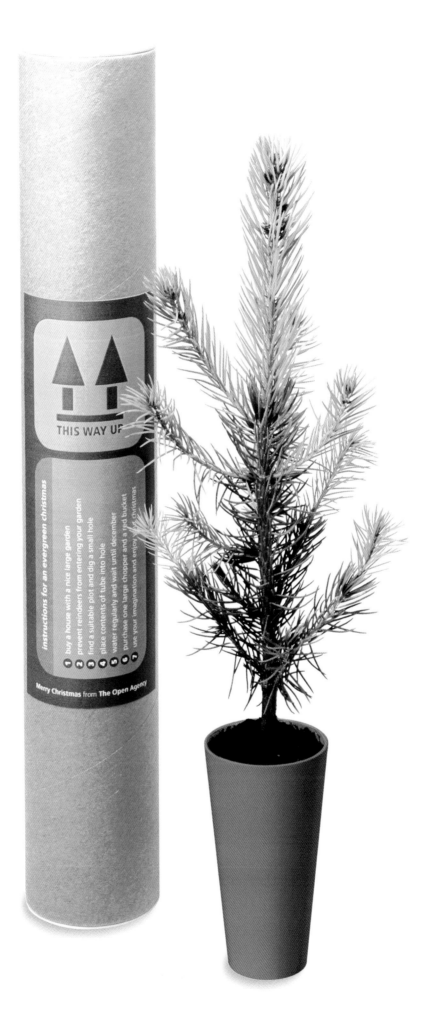

DESIGN
THE OPEN AGENCY
LOCATION
LONDON, UK
CREATIVE DIRECTOR
GARY COOKE
CREATIVE TEAM
AL FULLER, MARTYN ROUTLEDGE,
ANDY HOLTON, IAIN HUTCHINSON

The Judges D&AD Awards 2002
Floor U2
9 Graphite Square
Vauxhall Walk
London SE11 5EE

Dear Judges

We hope you'll sing a happy tune whilst
wearing these five gold Tiffany rings.
Merry Christmas and a Happy New Year
from everyone here at the Open Agency.

Humbug!

DESIGN
RIORDON DESIGN GROUP INC
LOCATION
OAKVILLE, CANADA
CREATIVE DIRECTOR
RIC RIORDON
CREATIVE TEAM
AMY MONTGOMERY,
SHARON PECE

"Each year we design and produce a festive mailing, partly as a promotional venture, but also as a gesture of appreciation to our clients and suppliers. This year we wanted to design a more reflective, spiritual and philosophical piece. The calendar featured interesting quotes from the Bible and more editorial images, in an effort to be sensitive to the growing trouble in the world."

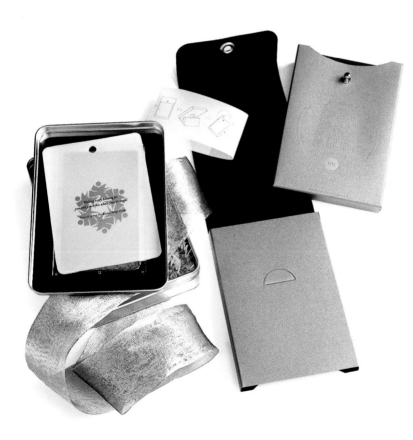

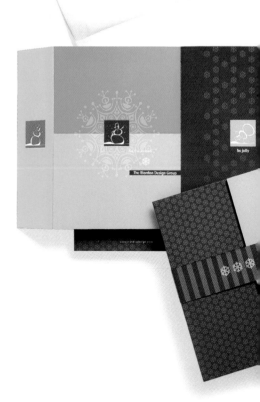

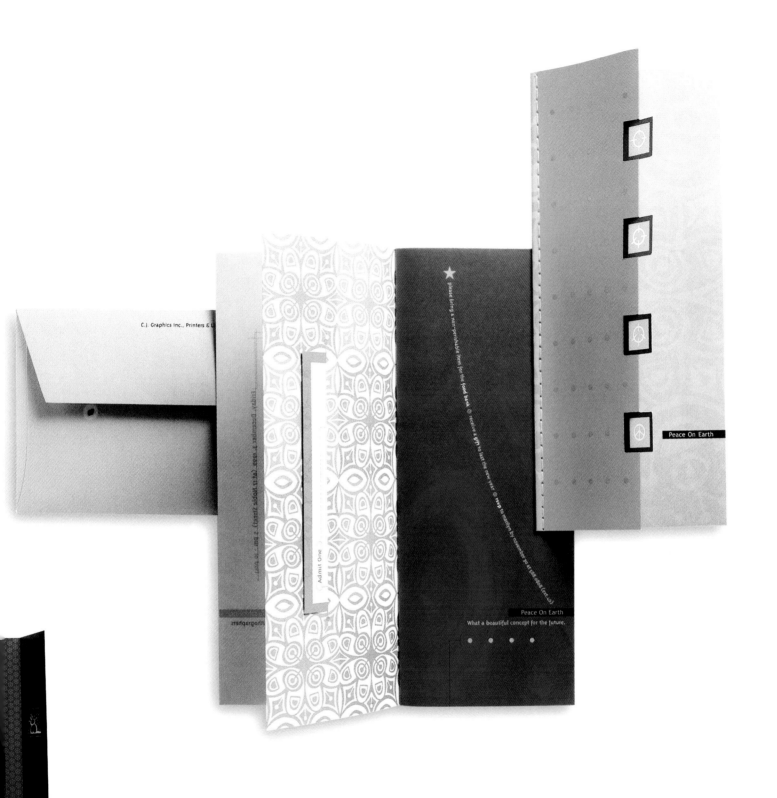

C.J. Graphics Inc., Printers & L...

Admit One

★ please bring a non-perishable item for the food bank ❋ receive a gift to last the new year ❋ rsvp to notify by november 24 at 555-5555 (ext. 13)

Peace On Earth
What a beautiful concept for the future.

Peace On Earth

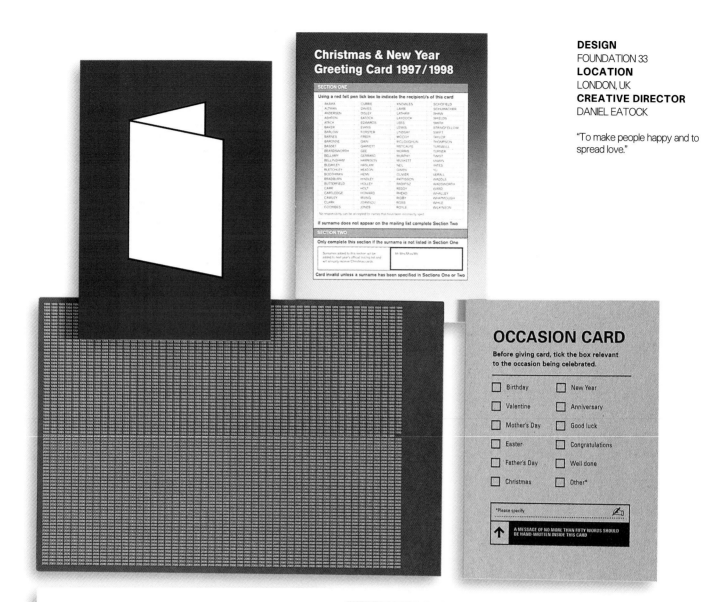

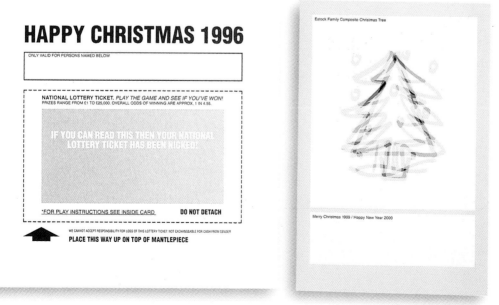

DESIGN
FOUNDATION 33
LOCATION
LONDON, UK
CREATIVE DIRECTOR
DANIEL EATOCK

"To make people happy and to spread love."

DESIGN
SINCLAIR/LEE
LOCATION
BRISBANE, AUSTRALIA
CREATIVE TEAM
NATALIE TAYLOR,
CATHERINE KERR

"This self-promotional piece is a three-dimensional card that the recipient assembles. It is an interactive solution to the age-old problem of producing a Christmas card that stands out among the masses and has an extended life.

"Our firm's idea of a fabulous Christmas holiday was the emotion behind the creation of this piece."

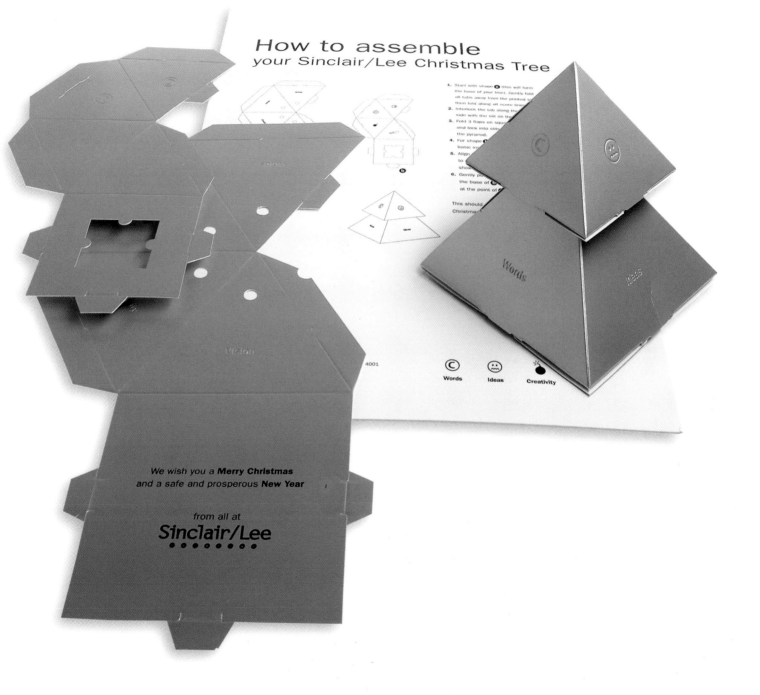

DESIGN
WYSIWYG COMMUNICATIONS
LOCATION
CALCUTTA, INDIA
CREATIVE DIRECTOR
NIDHI HARLALKA
CREATIVE TEAM
MOUSIM MITRA, MIHIR CHANCHANI

"A holiday mailer represents a unique opportunity. It allows us to greet our clients and gives us a chance to showcase our design talent without any restrictions of colour and shape. Free to operate as we like, we give our imaginations full rein."

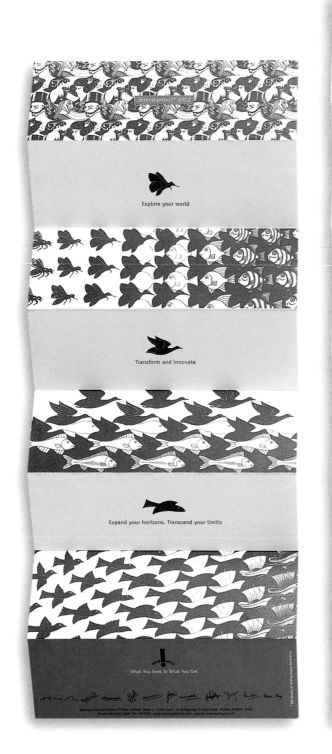

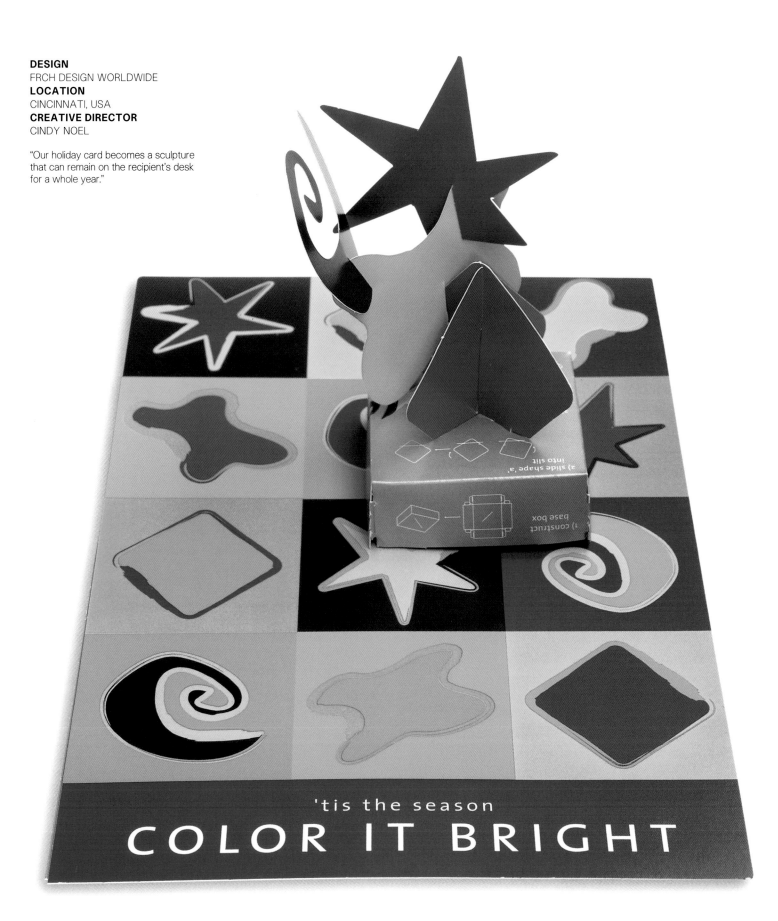

DESIGN
FRCH DESIGN WORLDWIDE
LOCATION
CINCINNATI, USA
CREATIVE DIRECTOR
CINDY NOEL

"Our holiday card becomes a sculpture that can remain on the recipient's desk for a whole year."

'tis the season
COLOR IT BRIGHT

Merry Christmas /HNY2002

DESIGN
PAUL GRAY
LOCATION
GLASGOW, UK
CREATIVE DIRECTOR
PAUL GRAY

"A personal Christmas mailing from myself and my partner to add the personal touch."

LOGO	ADDRESS	TELEPHONE	E MAIL	WITH OUR LOVE		
	Apartment 7	0141 887 7202	GrayAprtmntsvn@aol.com	Paul		x
	Orr Square Church					
	Orr Square			Lisa		x
	Oakshaw					
	Paisley					
	PA1 2DL					

DESIGN
ABM
LOCATION
BARCELONA, SPAIN
CREATIVE DIRECTOR
JAUME ANGLADA
CREATIVE TEAM
NACHO TABARES, JAUME DIANA,
ISABEL BENAVIDES, IVAN BAQUÉRO

"During the week before Christmas the image of pine cones started to appear – on the notice boards, between the sheets of a document, in the rest rooms etc. Closer to Christmas Day, the number of pine cones increased. The last day before the holidays, at the end of the Christmas dinner, cards were given to everybody with 'we are a pine cone' written on them. (In Spanish this expression means 'we are the whole thing', 'we are together'.)"

Checkpoint
METO

SOMOS UNA PIÑA
Navidad 2001

DESIGN
ZEN DESIGN GROUP
LOCATION
BERKLEY, USA
CREATIVE DIRECTOR
SUN YU
CREATIVE TEAM
KOK HWA CHUNG, MARIE GEBBIA

The Zen Design Group decided to usher in 2002 by using the horse in their holiday clamshell, representing their area of expertise, packaging design. The recipient can enjoy the origami ornament or become proactive with the instructions and additional paper supplied within the package.

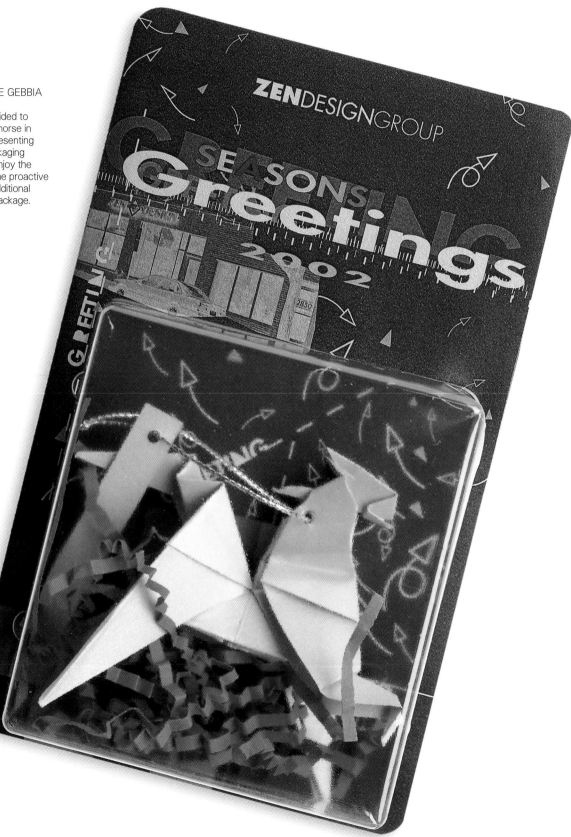

DESIGN
CUTTS CREATIVE
LOCATION
BRISBANE, AUSTRALIA
CREATIVE DIRECTOR
HANNAH CUTTS
CREATIVE TEAM
JESSIE CUTTS, LETICIA MORAN,
RACHEL ARTHUR

"Each year we create a January to
January calendar as a present for
clients. They are simple and meant to
be scribbled upon. Photos in them are
from holidays to reinforce that they
have a good Christmas vacation."

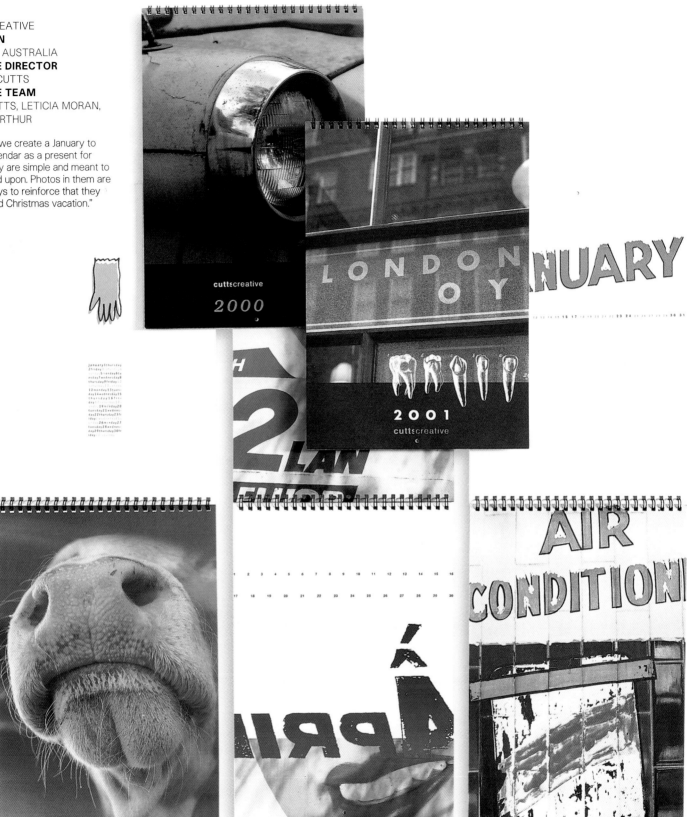

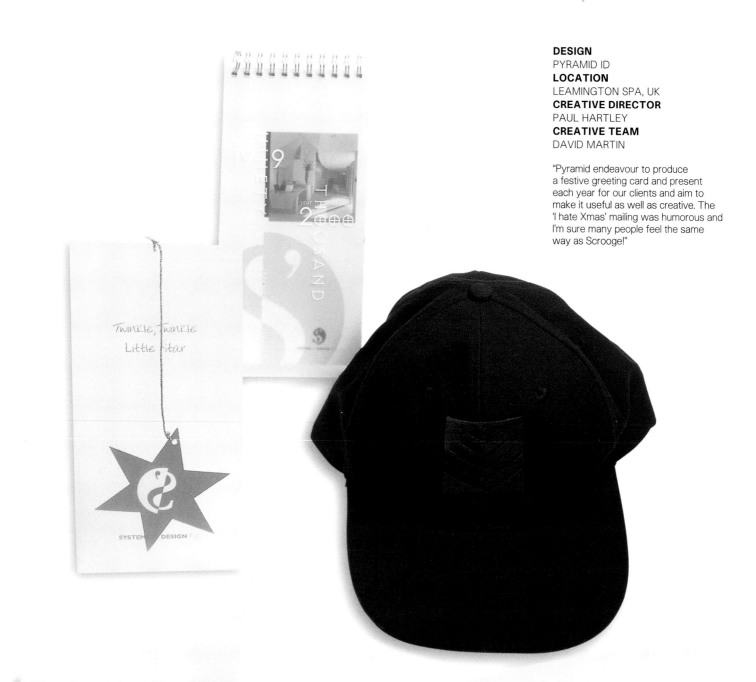

DESIGN
PYRAMID ID
LOCATION
LEAMINGTON SPA, UK
CREATIVE DIRECTOR
PAUL HARTLEY
CREATIVE TEAM
DAVID MARTIN

"Pyramid endeavour to produce a festive greeting card and present each year for our clients and aim to make it useful as well as creative. The 'I hate Xmas' mailing was humorous and I'm sure many people feel the same way as Scrooge!"

Twinkle, Twinkle
Little Star

SYSTEM DESIGN P.C.

I HATE CHRISTMAS

Ebenezer Scrooge 1843

KISS

MY

ASS

DESIGN
HEAD TO HEAD
LOCATION
LONDON, UK
CREATIVE DIRECTOR
WALTER DENNY
CREATIVE TEAM
TOBY ORTON

"As an agency our business is all about grabbing attention, so a Christmas card is a good opportunity to show what we can do. Our festive mailing has to cut through the layers of clutter that engulf most clients' desks at Christmas. It also had to be relevant and capture the personality of the agency."

merry christmas
from head to head

DESIGN
NOFRONTIERE
LOCATION
VIENNA, AUSTRIA
CREATIVE DIRECTOR
MAURITIO POLETTO
CREATIVE TEAM
ENRICO BRAVI

"Our goal was to produce 'different' Christmas cards – not the tree, not Santa Claus, no clichés so we decided to produce a collection of our logos and wish everybody in all languages a Merry Christmas. 300 cards were produced; all of these are numbered and unique."

"DEAR NOFRONTIERE I LIKE YOUR LOGO"
A CALCULATED RANDOMNESS FROM A SEA OF PROBABILITY.

"DEAR NOFRONTIERE I LIKE YOUR LOGO"
A CALCULATED RANDOMNESS FROM A SEA OF PROBABILITY.

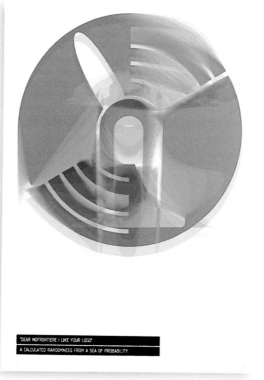

"DEAR NOFRONTIERE I LIKE YOUR LOGO"
A CALCULATED RANDOMNESS FROM A SEA OF PROBABILITY.

Frohe Weihnachten und ein gutes neues Jahr!
Merry Christmas and a Happy New Year!
Buon natale e felice anno nuovo!
Joyeux Noel et une bonne année novelle!
Veselé vánoce a šťastný nový rok!
God jul og godt nytt år!
God jul och gott nytt år !
God jul og godt nytår!
Boze Narodzenie i szczesliwy nowy rok!
Sretan bozic i novu godinu!
Frohi Wienacht, u n'äs guets Nöis!
Kellemes Karácsonyi Unnepeket és Boldog Uj Évet!

NOFRONTIERE TONGUES IN DECEMBER 2001

N COPIES 14T /331

YEAR 2001

SIGNATURE

LIMITED EDITION PRINT / AUTHENTICATED BY THE ARTIST
CREATE YOUR OWN ARTWORK AT WWW.NOFRONTIERE.COM/PS

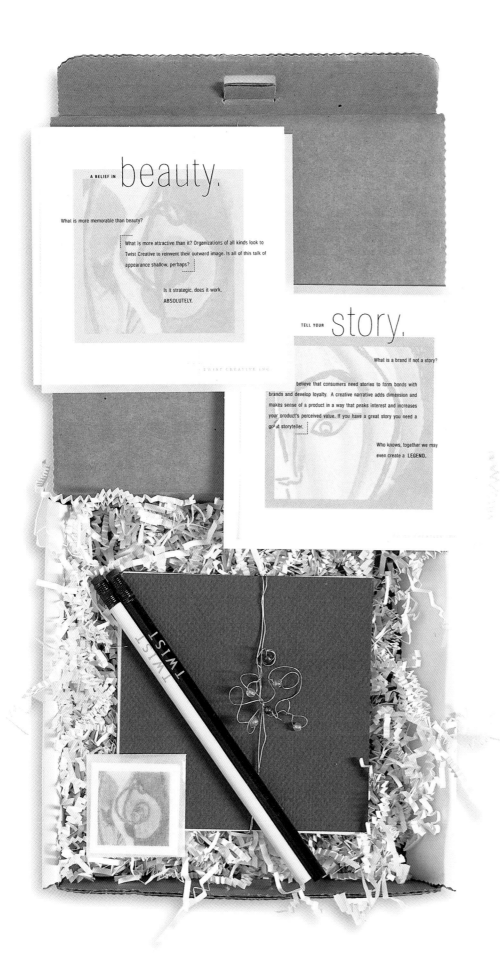

DESIGN
TWIST CREATIVE INC
LOCATION
CLEVELAND, USA
CREATIVE DIRECTOR
CONNIE OZAN
CREATIVE TEAM
NICHOLL JENSEN, MICHAEL OZAN

"The Twist self-promotion is a celebration of the launch of our new name. We chose to send our clients, friends, family and prospects a holiday gift that celebrates giving. Each piece of original art is in a postcard form. We have included pencils and stickers for a complete stationery set. It is an art you share."

DESIGN
BOB'S YOUR UNCLE
LOCATION
BOSTON, USA
CREATIVE DIRECTOR
MARTIN YEELES
CREATIVE TEAM
MARK FISHER

The calendars were produced as a useful gift and desktop reminders to current and prospective clients.

A CALENDAR OF BRITISH EXCLAMATIONS

tin design

Codswallop!

JANUARY

mon	tue	wed	thu	fri		sat	sun
1	2	3	4	5		6	7
8	9	10	11	12		13	14
15	16	17	18	19		20	21
22	23	24	25	26		27	28
29	30	31					

TIN

A Calendar of British Expressions

Designed by Martin Yeeles at Tin Design | 617.923.8976

1 9 9 8

illustrations by Mark Fisher | 978.392.0303

February

| 2 | 3 | 4 | 5 | 6 | 7 | 8 | 9 | 10 | 11 | 12 | 13 | 14 | 15 |
| 16 | 17 | 18 | 19 | 20 | 21 | 22 | 23 | 24 | 25 | 26 | 27 | 28 |

Thick as two short planks Really stupid

CAPRICORN
AQUARIUS
PISCES
ARIES
TAURUS
GEMINI
CANCER
LEO
VIRGO
LIBRA
SCORPIO
SAGITTARIUS

2002

CAPRICORN
PATIENT
WRY
DISCIPLINED
PESSIMIST

DECEMBER JANUARY

22 23 | 24 25 26 27 28 **29 30** | 31 1 2 3 4 5 **6** 7 8 9 10 11 **12 13** | 14 15 16 17 18 **19 20**

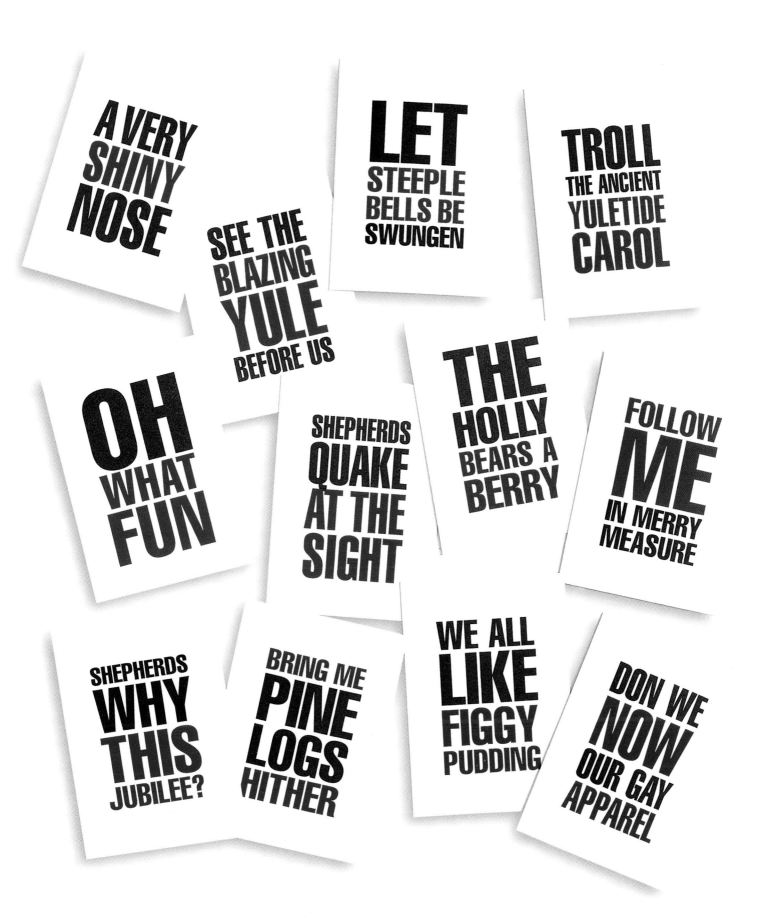

DESIGN
FIELD DESIGN CONSULTANTS LTD
LOCATION
LONDON, UK
CREATIVE DIRECTOR
NIGEL ROBERTS

"Rather than sending a company brochure to prospective clients, we decided to direct them towards our website by means of an unusual seasonal mailer. We like the idea that the mittens would be cool but also practical, and that people would really enjoy wearing them."

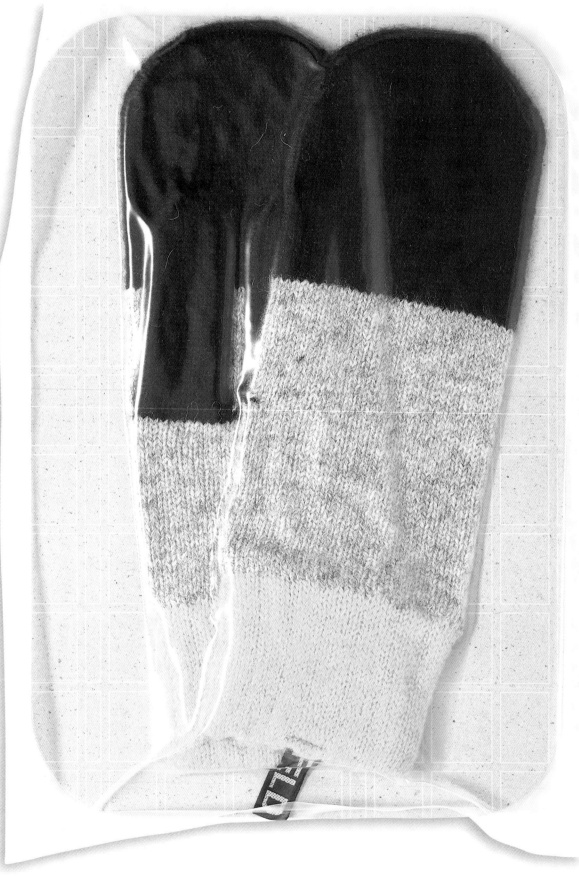

DESIGN
BLUE STUDIOS
LOCATION
BALTIMORE, USA
CREATIVE DIRECTOR
KEN FEURER
CREATIVE TEAM
LEO BATTERSBY,
DAVE WHEELOCK

"We view the holiday mailer as a nice way to thank clients and friends for their support through the year and as a fun way to showcase our creativity."

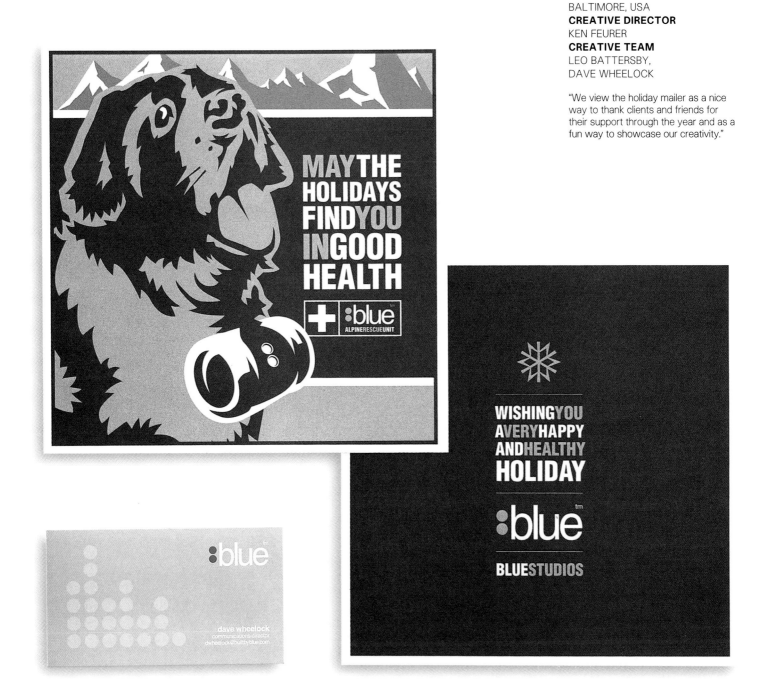

DESIGN
KYSEN COMMUNICATIONS GROUP
LOCATION
LONDON, UK
CREATIVE DIRECTOR
NICK O'TOOLE

"Sometimes our solutions are unusual; on other occasions they are refreshingly simple and different.

"Kysen has spent the past ten years following this design philosophy and, judging by the smiles, we managed to achieve just that with the Christmas and Millennium cards that we sent out to our clients."

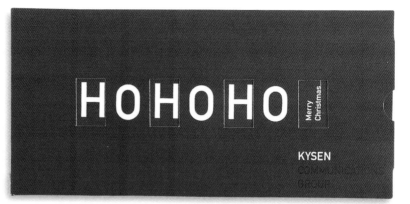

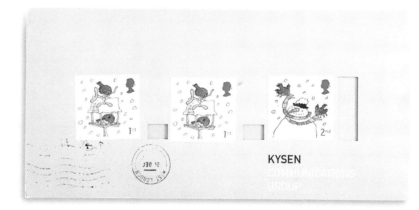

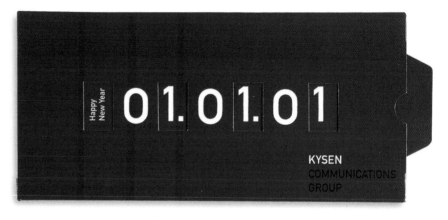

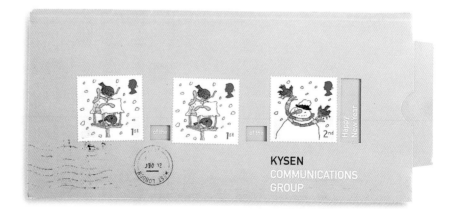

DESIGN
PCI : LIVE
LOCATION
LONDON, UK
CREATIVE DIRECTORS
FELICITY KELLY, DAVID MORGAN
CREATIVE TEAM
NADINE AKHRAS, TIKI GRAVES,
FRIXOS AFXENTIOU

"There was no immediate criteria for last year's Christmas card other than it had to be fun and endure the festive season. We wanted to create a piece of direct mail/marketing that people would react to with a smile. The animation on the CD gave us an opportunity to explore different media and have some festive fun and cheer!

"A great way to combine some corporate values and an interactive piece of direct mail, our Christmas tree brought to life what we as an events company stood for: excitement, creativity, face-to-face business, interactivity, light-heartedness and wit! A combination of a Christmas greeting and company cheer."

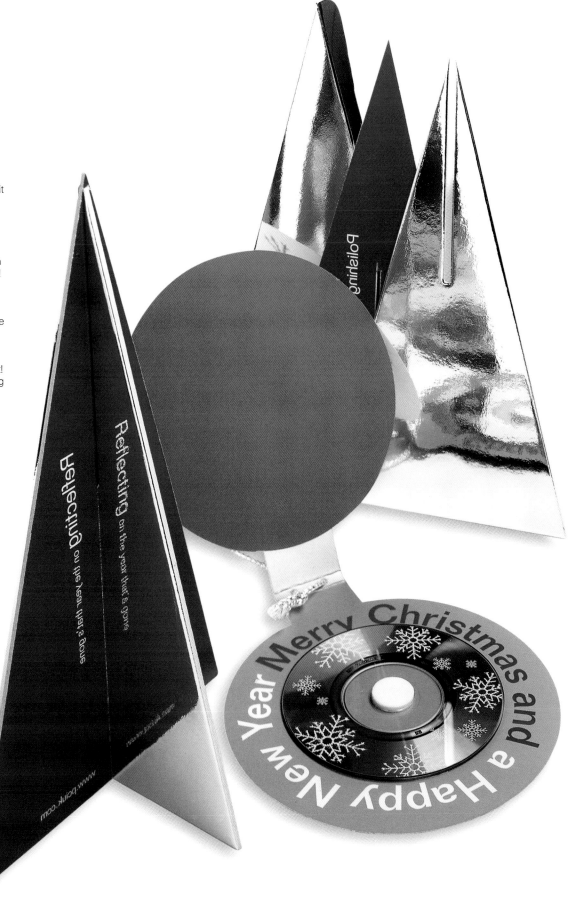

Why do you say that?

DESIGN
PENTAGRAM DESIGN LTD
LOCATION
LONDON, UK
CREATIVE DIRECTORS
JOHN MCCONNELL,
DAVID HILLMAN
CREATIVE TEAM
LAURA COLEY, PENTAGRAM
DESIGN LTD

Each year for Christmas, Pentagram designs and publishes a small booklet and sends it to friends, colleagues and clients. These annual greetings booklets are intended to provide diversions in the less busy moments of the Christmas and New Year season. The booklets traditionally avoid any reference to the festive season, adopting a strong graphic vocabulary in order to set them apart from the myriad of cards received during the period.

All the King's Horses
This idea employs a distinctly graphic take on the traditional jigsaw puzzle. Nine graphic icons (including 'Ladies' and 'Gentlemen' toilet signs, a train and a telephone) were chopped up and rearranged to create a series of abstract images. The challenge was to guess the final icon. Answers are provided inside the back cover of the booklet.

Why Do You Say That?
We say them all the time – phrases so familiar we rarely think what they mean or where they come from. Here are just a few, with a visual clue to each so that you can figure out why they mean what they do. If you still can't work out how these things became such popular and commonly used expressions in the English language, the answers are on the back.

'Bloody computer crashed, and I'm at the end of my <u>tether</u>'

'So it's back to <u>square one</u> for the design team'

All the King's horses

DESIGN
DEVER DESIGNS
LOCATION
LAUREL, USA
CREATIVE DIRECTOR
JEFFREY L DEVER

"We always try to create something unusual that will be recognised as spiritual, but not overtly religious, for the holiday season and particularly the New Year season. For this card, we used the metaphor of time as a gift, which was further enhanced by the use of a ribbon."

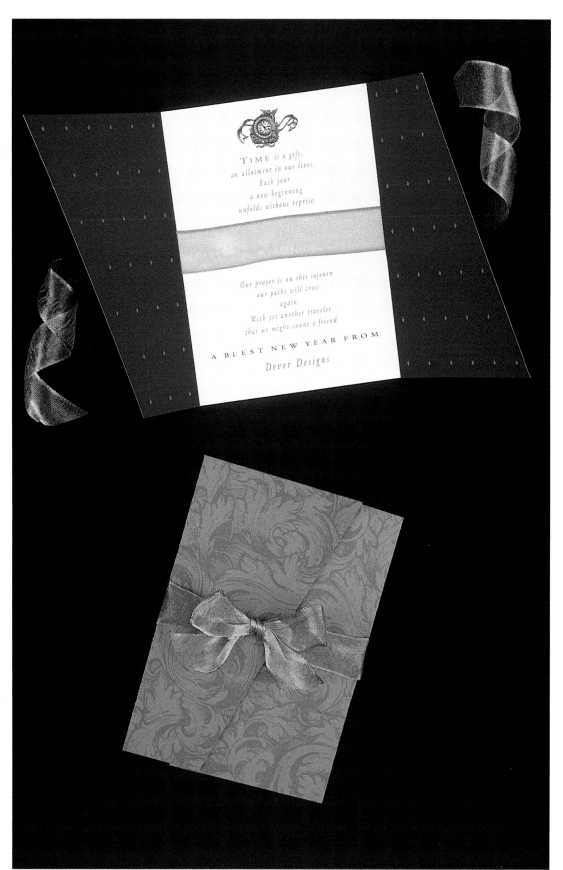

DESIGN
CATO PURNELL & PARTNERS
LOCATION
MELBOURNE, AUSTRALIA

"The festive mailing was created as
part of our 'broader visual language'."

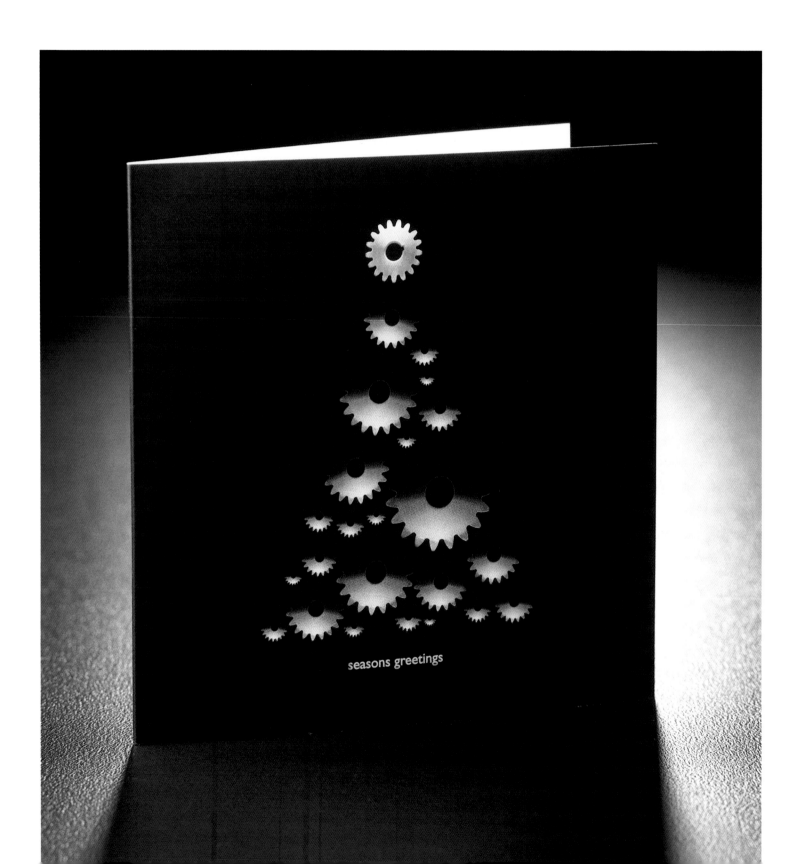

DESIGN
GBH
LOCATION
LONDON, UK
CREATIVE DIRECTORS
JASON GREGORY, PETER HALE,
MARK BONNER

GBH made the observation that December 25th isn't just Christmas but a very special birthday too. "One thing led to another and soon we had a full-blown birthday card, complete with a real 'I am 2001' badge. In order not to offend, the legend inside read 'For God's sake it's just a joke'."

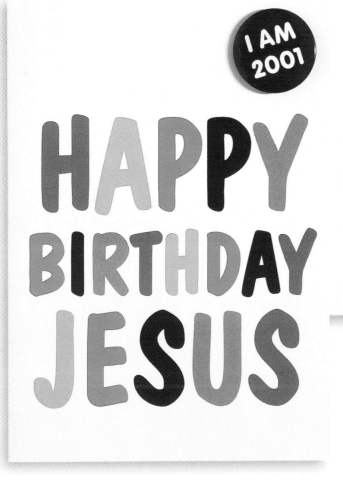

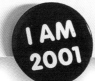

For God's sake it's just a joke!

DESIGN
ONIO DESIGN PVT LTD
LOCATION
PUNE, INDIA
CREATIVE DIRECTOR
MANOJ KOTHARI
CREATIVE TEAM
PRAKASH KHANZODE

"We wanted to mail something that people could use and not throw in the dustbin after a day. 'Diwali' is a festival of light, so something 'creative and usable' was the target behind this."

On this festival of light a
small endeavor from ONIO
to brighten your home
- a handmade paper lamp enclosed.

Unfold Open & Mount

SHOOt

1. 2. 3. 4 5.

* To avoid
overheating
of the lamp
please use 25W bulb

May this Diwali bring to you and your
family joy, peace and health for the year ahead.

Prakash Khanzode and Manoj Kothari
ONIO DESIGN
Email- onio2@giaspn01.vsnl.net.in

Office-
E-14, Srichetan Hsg. Society
47/1 Aundh Road, Pune -411 003
Ph- 0212-316262

DIWALI 98' WISHES

Onio

DESIGN
WHY NOT ASSOCIATES
LOCATION
LONDON, UK
CREATIVE TEAM
WHY NOT ASSOCIATES
EXTRA MATERIAL BY
ROCCO REDONDO, PHOTODISC

DESIGN
344 DESIGN LLC
LOCATION
LOS ANGELES, USA
CREATIVE DIRECTOR
STEFAN G BUCHER

"The whole point of 344 is to create objects you can fall in love with.

"I keep the company branding to a minimum because these are gifts and I want people to be able to hang them without feeling that I am out to hawk my wares. There is no phone number, address, website or even the word 'design', just 344, that's it. A secret handshake for friends and family. (And yes, there are hidden messages for the very, very attentive. Never underestimate the power of 4 point type and varnish.)"

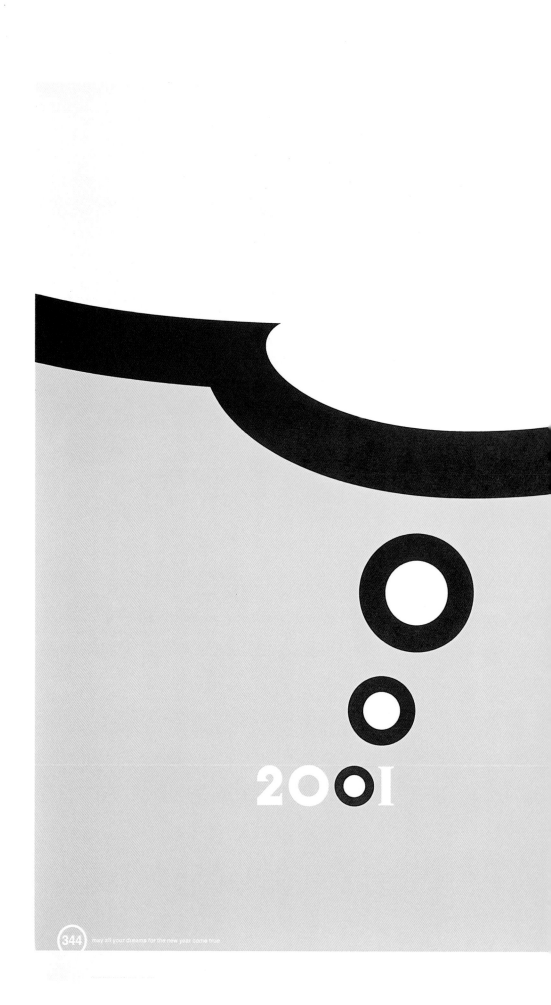

DESIGN
LABEL COMMUNICATIONS
LOCATION
GENEVA, SWITZERLAND
CREATIVE DIRECTOR
PATRIC BUETIKOFER
CREATIVE TEAM
ELLA OED MANN, VINCENT
THEVENON, VLADIMIR MARTI

"Our Christmas cards are produced to
thank the clients and to push the
agency's creative limits."

Toute l'équipe de Label Communication vous
remercie de votre confiance. Surtout, nous
vous souhaitons d'excellentes fêtes et vous
donnons rendez-vous l'année prochaine pour
construire ensemble de nouveaux concepts.

DESIGN
CDT DESIGN LTD
LOCATION
LONDON, UK
CREATIVE DIRECTORS
NEIL WALKER, MIKE DEMPSEY
CREATIVE TEAM
ANDY SEYMOUR, PAUL ZAC

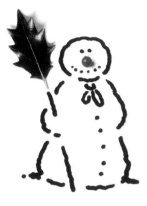

DESIGN
SPRINGETTS
LOCATION
LONDON, UK

"Direct mail is our main method of promotion, and festive mailings are a great way to keep in touch with our database."

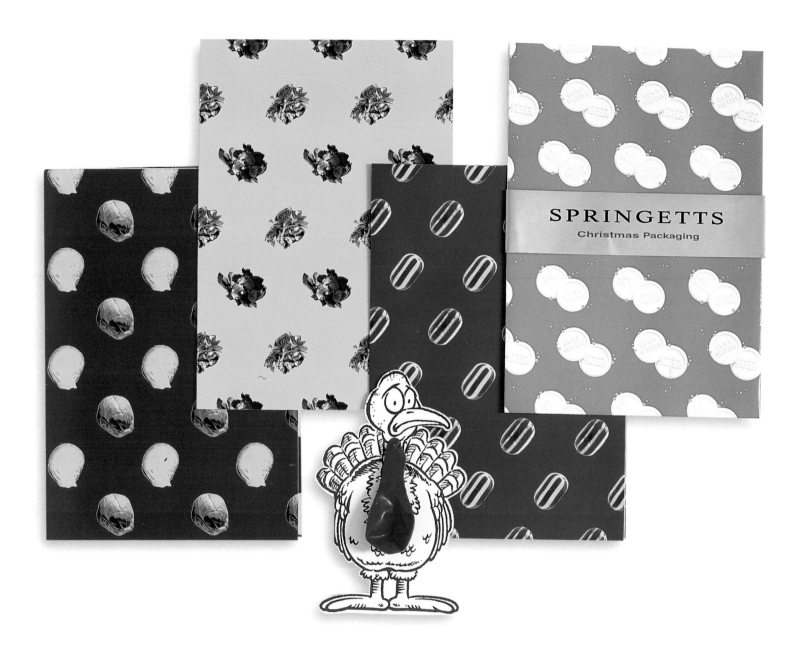

DESIGN
TAXI ADVERTISING & DESIGN
LOCATION
TORONTO & MONTREAL, CANADA
CREATIVE DIRECTOR
PAUL LAVOIE

"This card cut though the holiday clutter by including a practical way for clients and friends to celebrate safely and remember our brand name: a taxi chit."

DESIGN
GLAZER
LOCATION
LONDON, UK
CREATIVE DIRECTOR
DAVID JONES
CREATIVE TEAM
CLARE BRITTLE, SOPHIE HAYES,
GEOFF APPLETON,
RICHARD HOLLIM

Pantomime
"Following in the tradition of the
Christmas pantomime, we thought we
would design our own spoof panto
poster for our 2001 mailing."

Nativity
"The 2001 card took the form of an
off-the-shelf nativity scene. Glazer
employees were combined with
illustrations of the nativity cast and
die-cut so they could be arranged
against a backdrop of the stable."

'Rapping' Paper
"We wanted to produce a mailing that
would be useful and raise a smile. So
for 1999, we designed an A1 sheet of
wrapping paper with a 'rapping'
message on it."

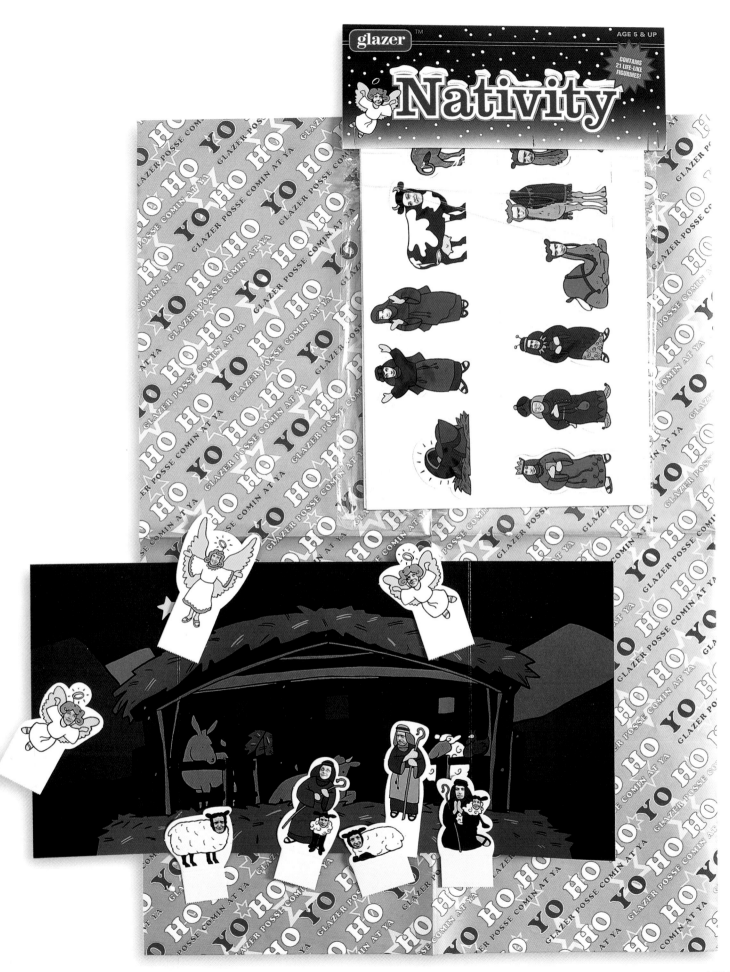

DESIGN
CORE 77
LOCATION
NEW YORK, USA
CREATIVE DIRECTOR
ALLAN CHOCHINOV

"We send a mailing every year, and we always try to do a memorable object rather than a card. In this time of economic uncertainty, an object with 2002 uses is always welcome."

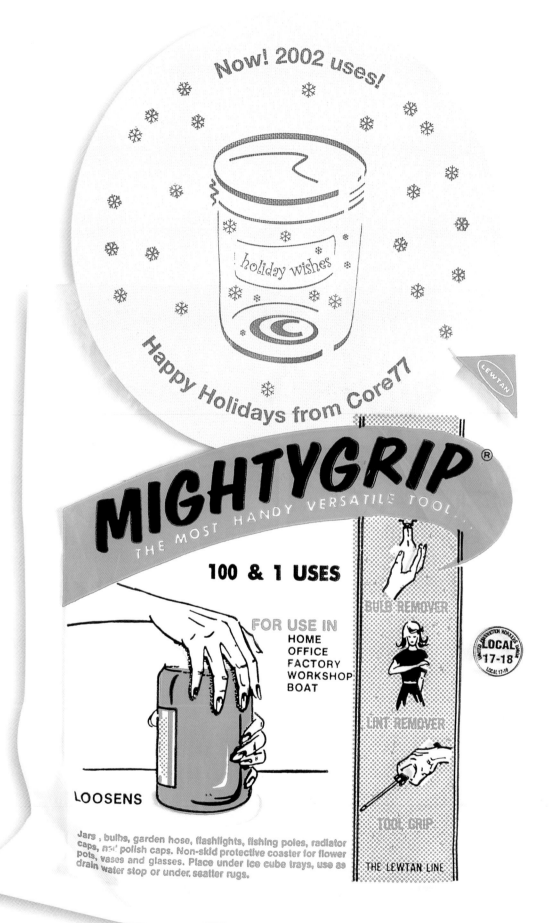

DESIGN
CRESCENT LODGE DESIGN
LOCATION
LONDON, UK
CREATIVE DIRECTOR
LYNDA BROCKBANK
CREATIVE TEAM
JANE TOBITT, MELISSA MAYES,
DUNCAN PARE

"These are warm, end-of-the-year greetings – objects rather than cards, gifts intended to celebrate the relationships we have with all the people we work with. They aren't traditional Christmas greetings because not everyone celebrates Christmas. To an extent they are self promotional and when you are the client, it's tempting to show off a bit."

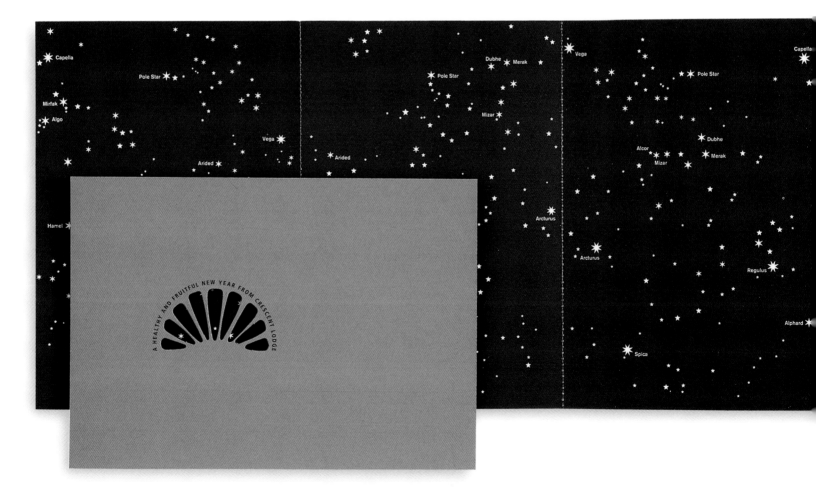

DESIGN
RALPH SELBY ASSOCIATES
LOCATION
WIRKSWORTH, UK
CREATIVE DIRECTOR
RALPH SELBY

"Each year at Christmas we give our friends and clients a new toy – always a tree and always a different material or process."

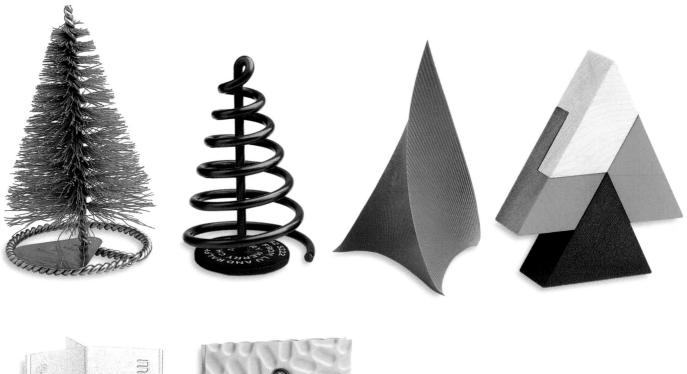

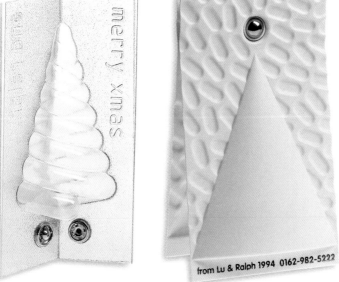

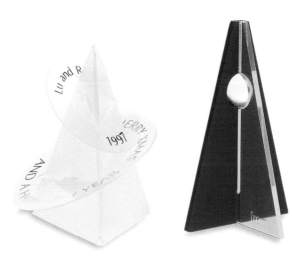

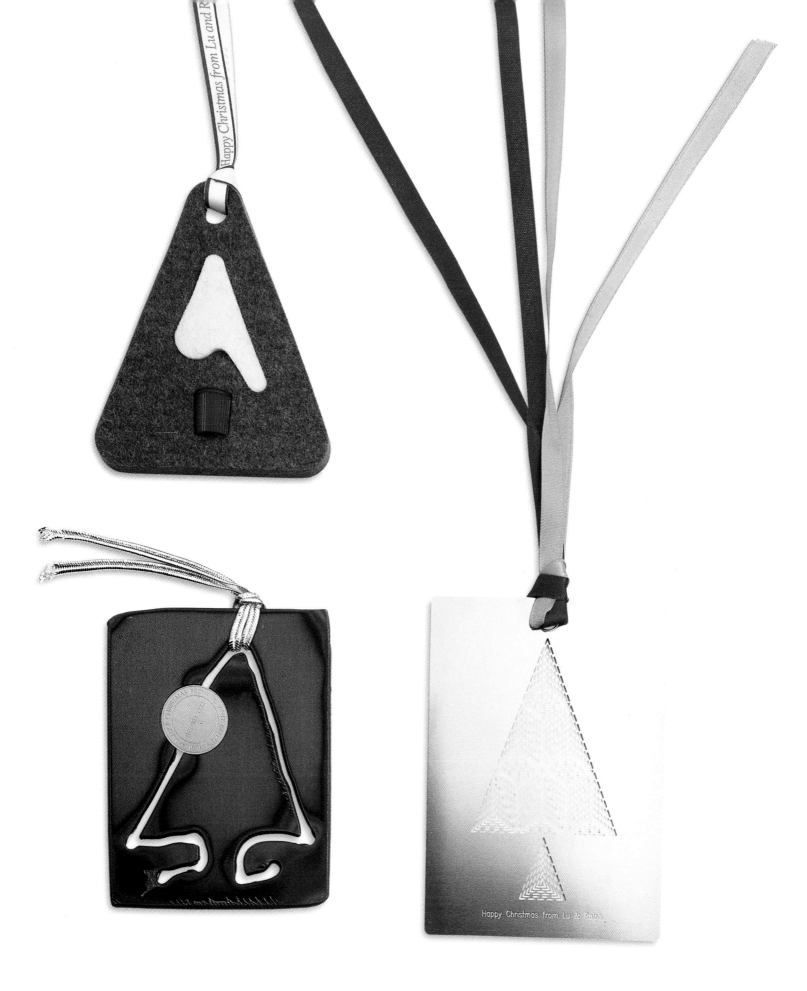

Happy Christmas from Lu and R...

Happy Christmas from Lu & Ralph.

DESIGN
BLEED
LOCATION
OSLO, NORWAY

"This was a web-based game for Bleed clients and friends. For the highest scores we sent out T-shirts as prizes."

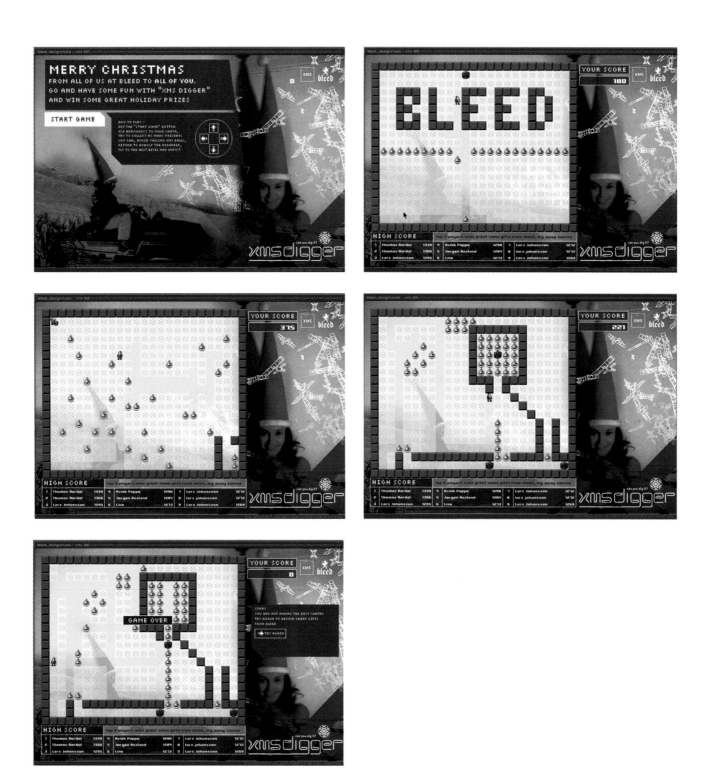

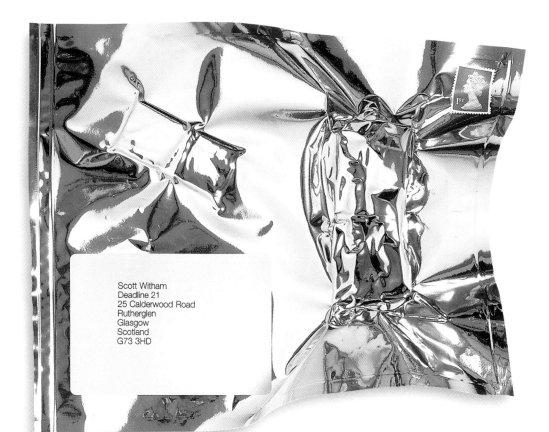

DESIGN
NAME
LOCATION
LEEDS, UK
CREATIVE DIRECTOR
MICHAEL HARRIS
CREATIVE TEAM
STUART MOREY

Created as a series of 12, each mailout contained a Christmas cracker novelty, motto and hat. Each set was vacuum packed and mailed with an address label and stamp on the reverse. This was a lightweight, cost-effective and, above all, fun solution that generated a 'swapsies' situation in marketing departments across the country.

Scott Witham
Deadline 21
25 Calderwood Road
Rutherglen
Glasgow
Scotland
G73 3HD

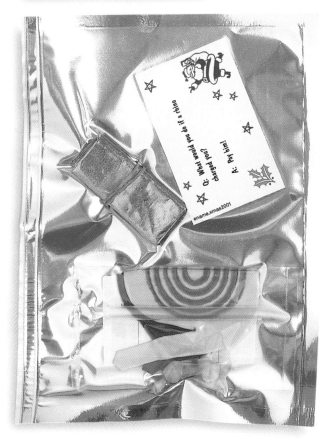

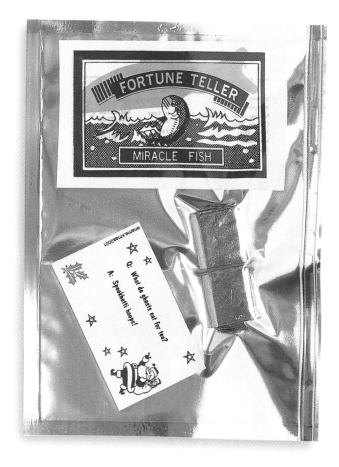

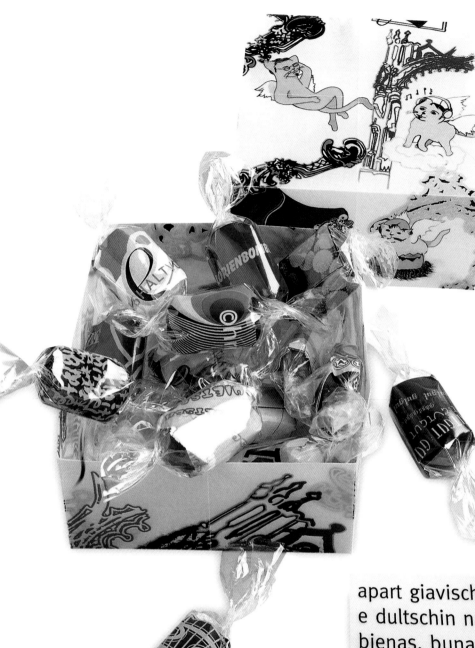

DESIGN
APART
LOCATION
ZURICH, SWITZERLAND
CREATIVE DIRECTOR
FRY GIONI
CREATIVE TEAM
CONNY JAGER, JULIA STAAT,
SILKE SCHMEING,
TANYA SCHATEMANN

"At Christmas time we wanted to surprise our clients with a gift that would contain both the aim of our agency Apart and the personality of our employees. The logo of Apart is a cat, therefore we illustrated ourselves as cats. Each of the six cats came with the typical character of the single person. In addition, every employee designed ten of the different wrappings."

apart giavischa in sonor
e dultschin nadal plein
bienas, bunas ed autras
carinadads per tgierp
ed olma. cordial engrazia-
ment per la fritgeivla
collaboraziun.

DESIGN
NB:STUDIO
LOCATION
LONDON, UK

"For Fun!!!"

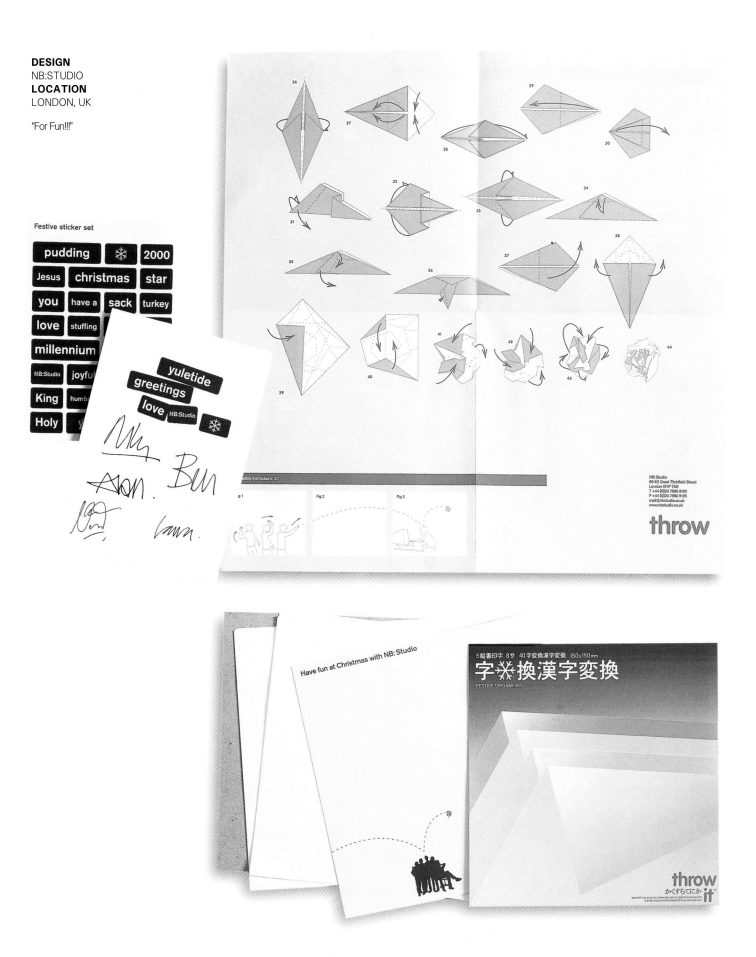

Festive sticker set

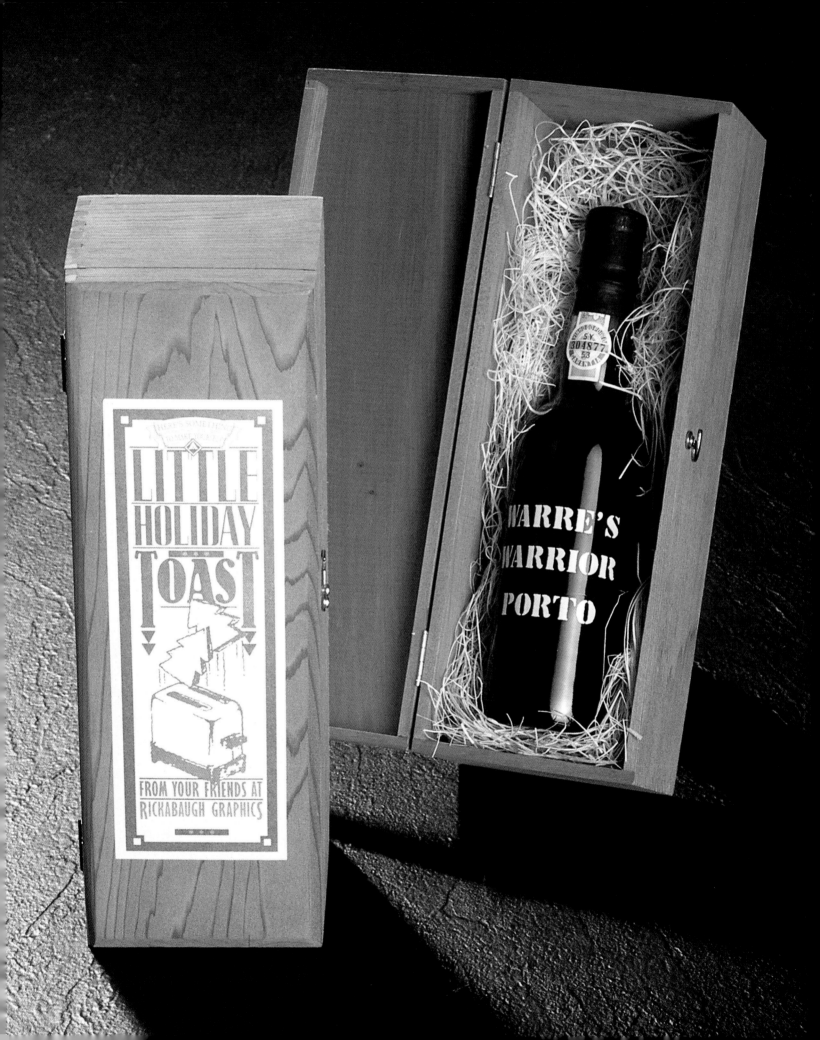

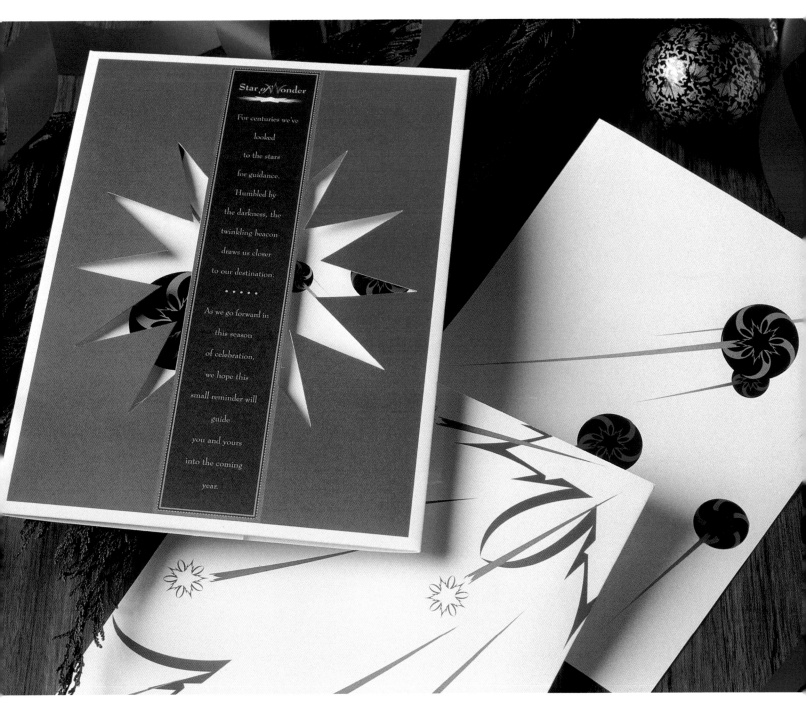

Star of Wonder

For centuries we've
looked
to the stars
for guidance.
Humbled by
the darkness, the
twinkling beacon
draws us closer
to our destination.

• • • • •

As we go forward in
this season
of celebration,
we hope this
small reminder will
guide
you and yours
into the coming
year.

DESIGN
RICKABAUGH GRAPHICS
LOCATION
COLUMBUS, USA
CREATIVE DIRECTOR
ERIC RICKABAUGH
CREATIVE TEAM
MARK KRUMEL AND
RICKABAUGH GRAPHICS

Holiday Toast
"When we created this holiday
promotion we were still giving clients
gifts at the holidays. What better than
a nice wooden box filled with some
holiday spirit? The label was a play
on the words 'Holiday Toast'. Though
we now take all this money and
donate it to charities, this was a most
memorable gift."

Star of Wonder
This holiday promotion, all built
around the theme of stars, featured
two custom-designed sheets of
wrapping paper.

DESIGN
LEWIS MOBERLY
LOCATION
LONDON, UK
CREATIVE DIRECTOR
MARY LEWIS
CREATIVE TEAM
MARGARET NOLAN,
PAUL CILIA LA CORTE

"The wording on each of the windows relates to something associated with Christmas. Inside, each window reveals a relevant piece of Lewis Moberly work. This card tells us a story of the seasons of change from spring, summer, autumn and winter through an ingenious series of laser-cut shapes, and also is a pun on the word 'seasons'."

DESIGN
CRENEAU INTERNATIONAL
LOCATION
LONDON, UK
CREATIVE DIRECTOR
WILL ERENS

"My table at home is too small to sit all my friends at – this allows them to eat Christmas dinner with me!"

CRÉNEAU INTERNATIONAL DESIGN

Wild Turkey in Curried Rice

Ingredients: rice, wild turkey, powdered butter fat, powdered cream, starch, seasoning, freeze-dried fruits (banana, pineapple), almonds, curry, iodised sea salt, sugar, guarken flour thickener, citric acid, silicic acid.
Dried meat content: 8g (equals approx. 40 g fresh meat)

net weight 125 g
added water 300 ml
ready quantity 425 g
package provides:
1 portion à 425 g

average nutritional
values per portion:
protein 17,4 g
fat 11,5 g
carbohydrates 74,0 g
kcal/kJ 469/1959
best before:
03.2003

To prepare: Stir contents into boiling water and simmer for approx. 8 minutes.

D–HE
EUZ:215
EWG

Packaged in a
protective atmosphere
L008

4 015753 050017

CRÉNEAU INTERNATIONAL DESIGN IZ DE ROODE BERG HELLEBEEMDEN 13 B-3500 HASSELT BELGIUM
T +32 11 28 47 00 F +32 11 28 47 01 E info@creneau.com W www.creneau.com

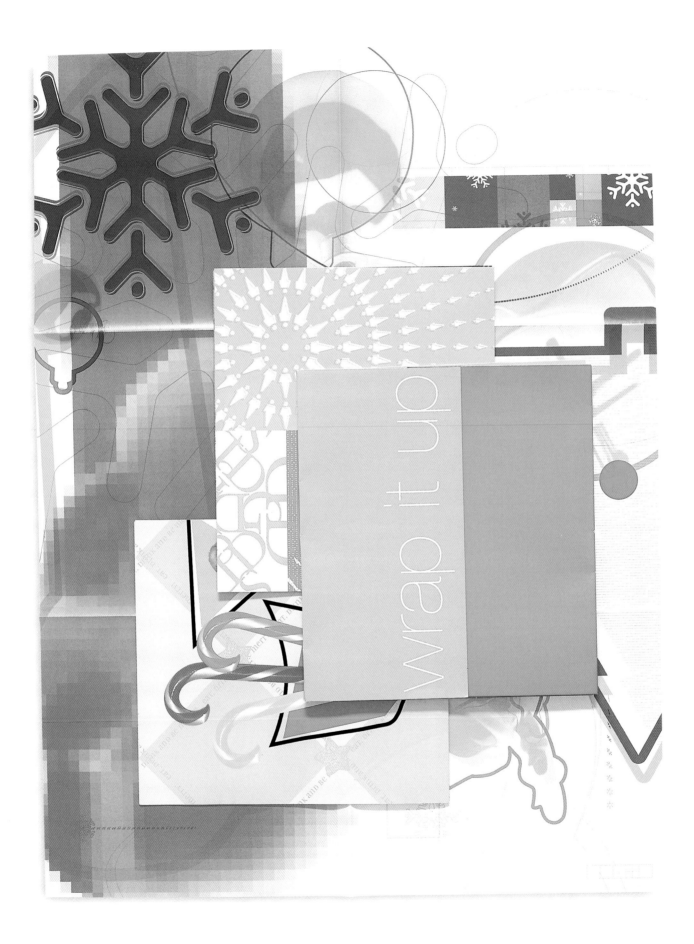

Wrap it up

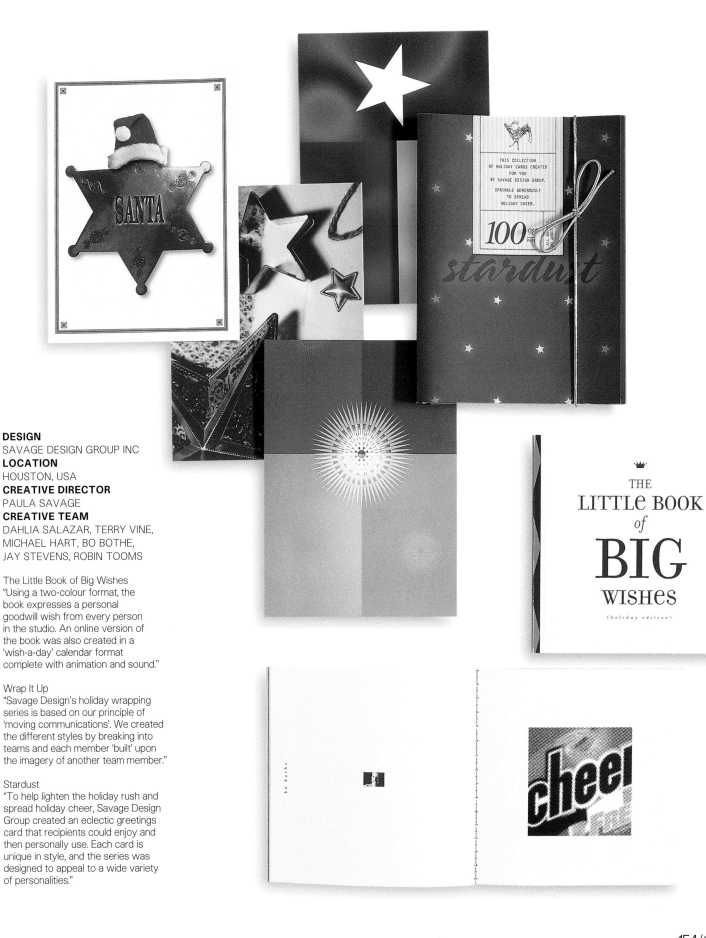

DESIGN
SAVAGE DESIGN GROUP INC
LOCATION
HOUSTON, USA
CREATIVE DIRECTOR
PAULA SAVAGE
CREATIVE TEAM
DAHLIA SALAZAR, TERRY VINE,
MICHAEL HART, BO BOTHE,
JAY STEVENS, ROBIN TOOMS

The Little Book of Big Wishes
"Using a two-colour format, the
book expresses a personal
goodwill wish from every person
in the studio. An online version of
the book was also created in a
'wish-a-day' calendar format
complete with animation and sound."

Wrap It Up
"Savage Design's holiday wrapping
series is based on our principle of
'moving communications'. We created
the different styles by breaking into
teams and each member 'built' upon
the imagery of another team member."

Stardust
"To help lighten the holiday rush and
spread holiday cheer, Savage Design
Group created an eclectic greetings
card that recipients could enjoy and
then personally use. Each card is
unique in style, and the series was
designed to appeal to a wide variety
of personalities."

THE
LITTLE BOOK
of
BIG
WISHES
[holiday edition]

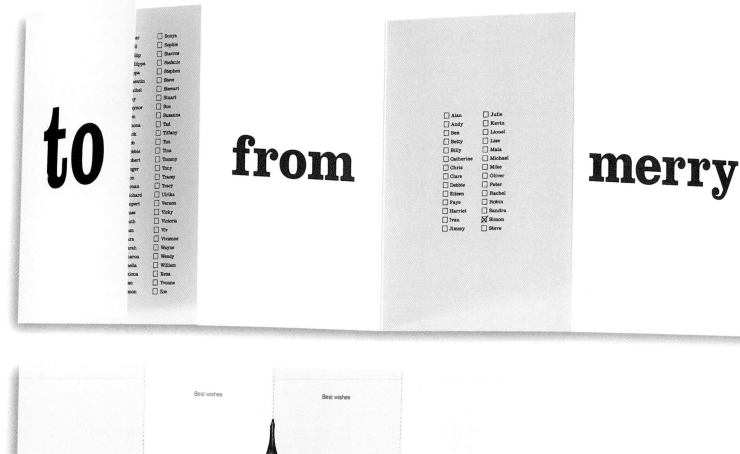

to

	☐ Sonya
	☐ Sophie
	☐ Stavros
	☐ Stefanie
	☐ Stephen
	☐ Steve
	☐ Stewart
	☐ Stuart
	☐ Sue
	☐ Susanna
	☐ Tad
	☐ Tiffany
	☐ Tim
	☐ Tina
	☐ Tommy
	☐ Tony
	☐ Tracey
	☐ Tracy
	☐ Ulrika
	☐ Verson
	☐ Vicky
	☐ Victoria
	☐ Viv
	☐ Vivienne
	☐ Wayne
	☐ Wendy
	☐ William
	☐ Xena
	☐ Yvonne
	☐ Zoe

from

☐ Alan	☐ Julie
☐ Andy	☐ Kevin
☐ Ben	☐ Lionel
☐ Betty	☐ Lise
☐ Billy	☐ Mala
☐ Catherine	☐ Michael
☐ Chris	☐ Mike
☐ Clare	☐ Oliver
☐ Debbie	☐ Peter
☐ Eileen	☐ Rachel
☐ Faye	☐ Robin
☐ Harriet	☐ Sandra
☐ Ivan	☒ Simon
☐ Jimmy	☐ Steve

merry

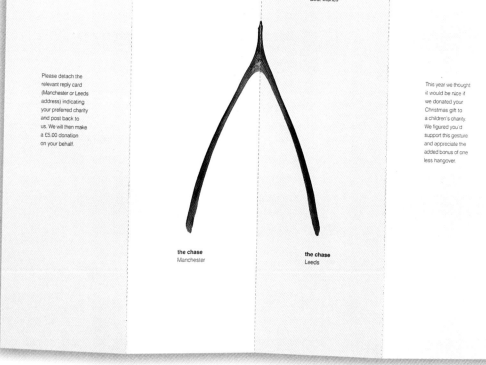

Best wishes

Best wishes

Please detach the relevant reply card (Manchester or Leeds address) indicating your preferred charity and post back to us. We will then make a £5.00 donation on your behalf.

This year we thought it would be nice if we donated your Christmas gift to a children's charity. We figured you'd support this gesture and appreciate the added bonus of one less hangover.

the chase
Manchester

the chase
Leeds

DESIGN
THE CHASE
LOCATION
MANCHESTER, UK
CREATIVE DIRECTOR
BEN CASEY
CREATIVE TEAM
HARRIET DEVOY, STEVE ROYLE

"Every year we try to produce a Christmas card that has a bit more thought to raise an eyebrow or a smile from our client/suppliers/friends. The 'Wishbone' idea related to the fact that we would make a donation to a charity of the recipients' choice instead of giving presents, whilst the 'X marks the Spot' was a clever observation, stylishly executed."

DESIGN
BLØK DESIGN
LOCATION
TORONTO, CANADA

"This project was a wonderful excuse
to experiment with patterns, colours
and forms and share with both our
clients and friends the passion we have
for the essential aspects of design."

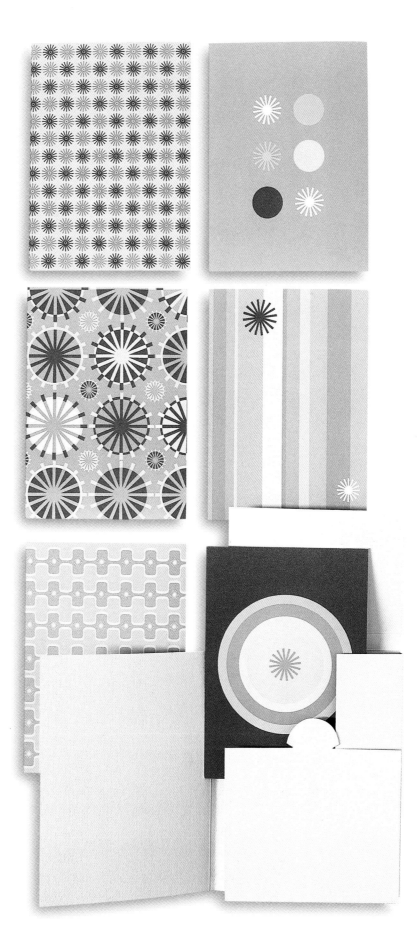

DESIGN
HOOP ASSOCIATES
LOCATION
LONDON, UK
CREATIVE DIRECTOR
PAUL NUNNELEY
CREATIVE TEAM
RUSSELL WEIGHTON

"As we all know, Christmas is an extremely dangerous time of year. With poisonous liquids, noxious vapours, harmful foodstuffs, as well as hazardous jumpers and anxiety-inducing TV to contend with, we felt it was necessary to issue festive safety instructions."

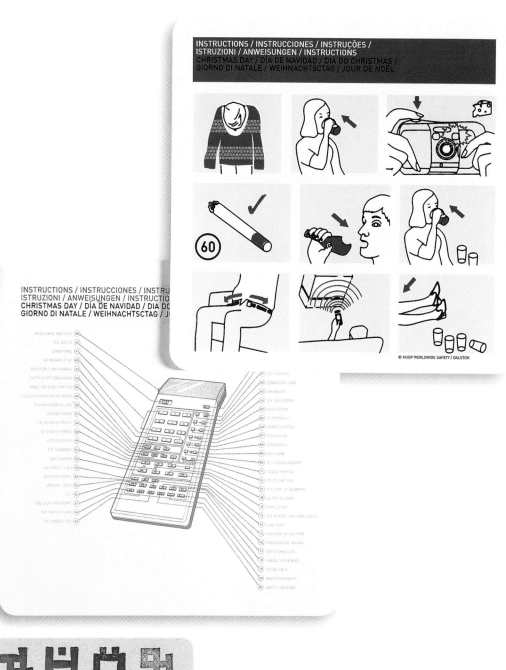

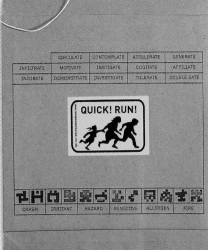

DESIGN
BELYEA
LOCATION
SEATTLE, USA
CREATIVE DIRECTOR
PATRICIA BELYEA
CREATIVE TEAM
NAOMI MURPHY, ROSANNE OLSON,
NANCY STENZ, RON LARS HANSEN,
JOCELYN CURRY, ANNE BUCKLEY

4 + 20 Blackbirds
"It was impossible to refuse when a
premium printer, 2,000 miles away from
Seattle, asked us to design a desktop
calendar featuring Rosanne Olson's
work. Her new body of fine art
photography was a delicious fantasy of
figures and feathered friends. The stark
black and white images (produced as
tritones) were paired with the edgy
calligraphy of Nancy Stentz to
produce a memorable calendar."

Pinhole Travels Calendar
"After shooting with her pinhole camera
for two years, Rosanne Olson had a
collection of incredible and moody
images. These were the inspiration for
Belyea's 1999 gift calendar."

Flora Calendar
"Belyea had a tradition of creating arty
calendars as collaborations between
our design firm, photographer Rosanne
Olson and The Allied Printers. The
printer asked us to develop a more
conventional concept, such as flowers.
We readily agreed, knowing that our
flower calendar would be like no other."

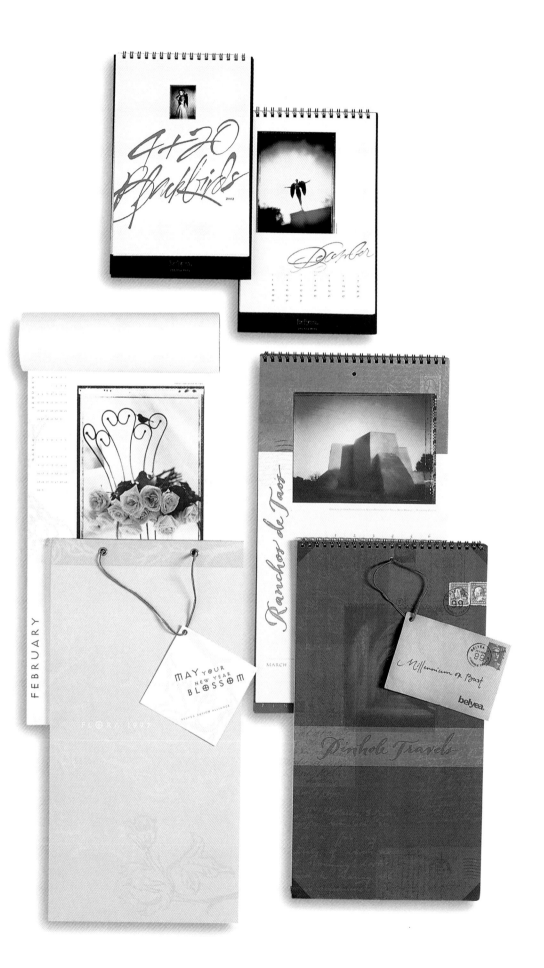

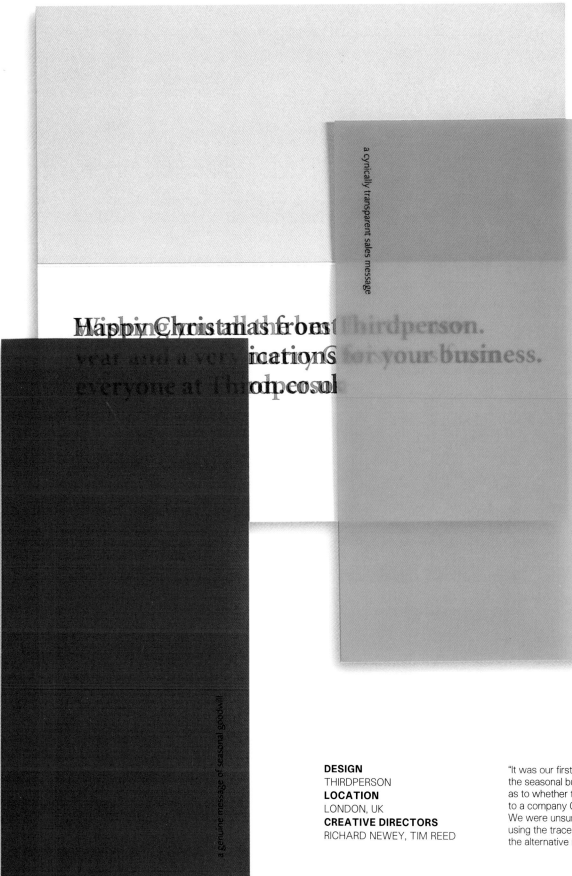

a cynically transparent sales message

Happy Christmas from thirdperson.

...ications for your business.

a genuine message of seasonal goodwill

DESIGN
THIRDPERSON
LOCATION
LONDON, UK
CREATIVE DIRECTORS
RICHARD NEWEY, TIM REED

"It was our first year and we faced the seasonal business dilemma as to whether to add a sales message to a company Christmas card. We were unsure, so we did both, using the trace paper to obscure the alternative message."

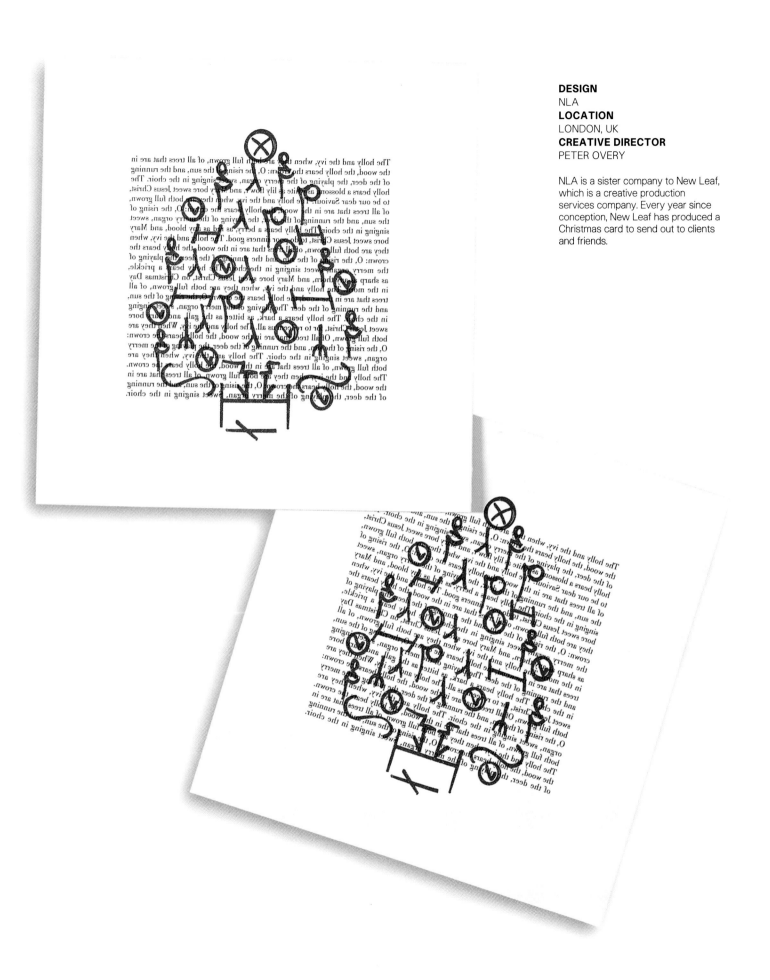

DESIGN
NLA
LOCATION
LONDON, UK
CREATIVE DIRECTOR
PETER OVERY

NLA is a sister company to New Leaf, which is a creative production services company. Every year since conception, New Leaf has produced a Christmas card to send out to clients and friends.

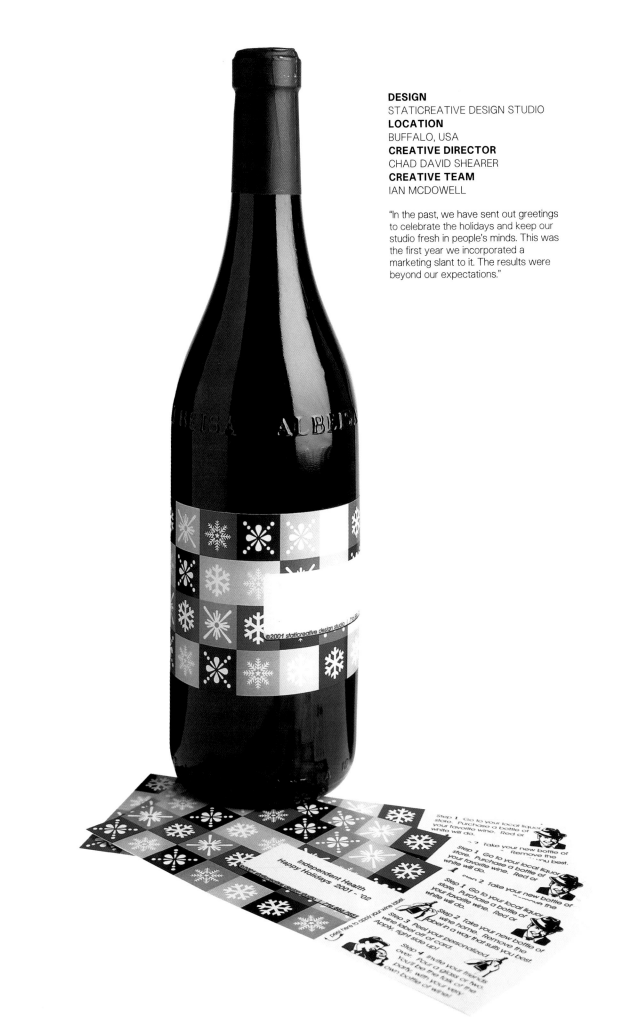

DESIGN
STATICREATIVE DESIGN STUDIO
LOCATION
BUFFALO, USA
CREATIVE DIRECTOR
CHAD DAVID SHEARER
CREATIVE TEAM
IAN MCDOWELL

"In the past, we have sent out greetings
to celebrate the holidays and keep our
studio fresh in people's minds. This was
the first year we incorporated a
marketing slant to it. The results were
beyond our expectations."

DESIGN
VANILLA DESIGN
LOCATION
GLASGOW, UK
CREATIVE DIRECTOR
ELIZABETH CARTER

"Instant snowman kit. Just add snow."

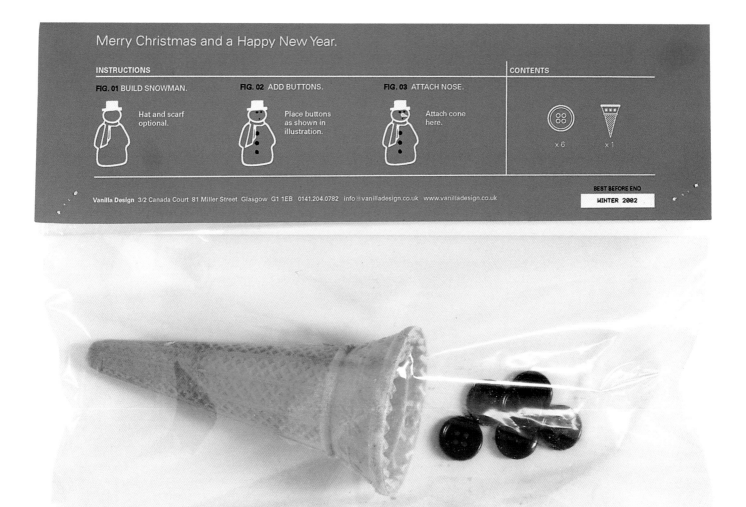

DESIGN
CONRAN DESIGN GROUP
LOCATION
LONDON, UK
CREATIVE DIRECTOR
SASHA VIDAKOVIC
CREATIVE TEAM
CAROLINE MEE, DOMENIC MINIERI
& ALL AT CONRAN DESIGN GROUP

Trees From Everyone
"Often Christmas cards from a company can seem very corporate and impersonal. We wanted to show that our card was from everyone at Conran Design Group, as it's the co-operation of our whole team, from the receptionist to the designers, directors and financial administrators, that make us who we are. Getting everyone to design a tree showed the variety of ways in which we approach projects and gave a real feeling of inclusion between all our staff."

Hugging
"The action of hugging is so simple and rewarding, yet, as a society, it is something we seem to have forgotten how to do. The card was a reminder of this."

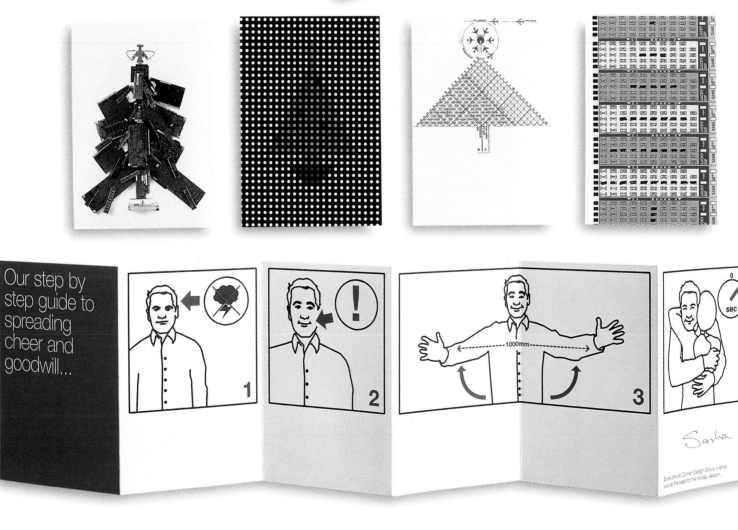

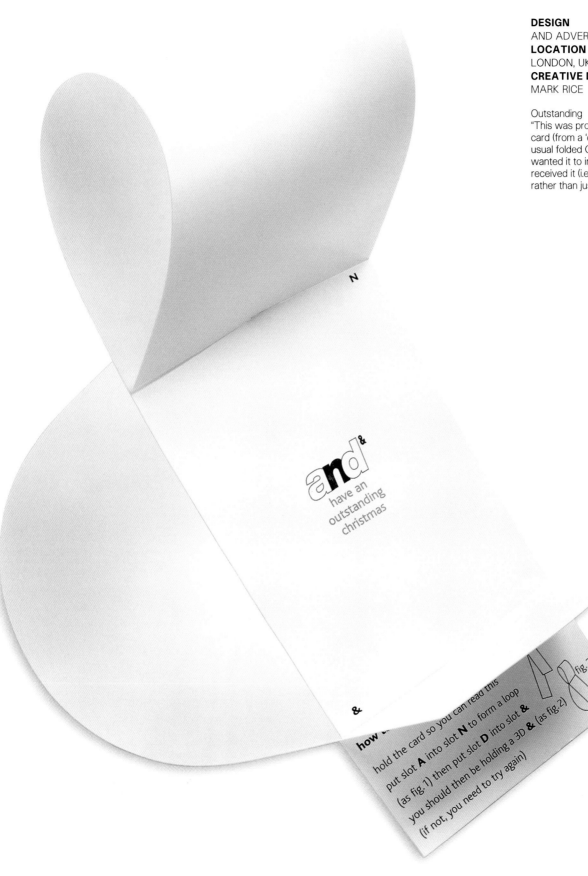

DESIGN
AND ADVERTISING
LOCATION
LONDON, UK
CREATIVE DIRECTOR
MARK RICE

Outstanding
"This was produced to de a 'different' card (from a 'different' agency) to the usual folded Christmas cards. We wanted it to involve the people who received it (i.e. they had to make it) rather than just put it on display."

and &
have an
outstanding
christmas

how
hold the card so you can read this
put slot **A** into slot **N** to form a loop
(as fig. 1) then put slot **D** into slot **&**
you should then be holding a 3D **&** (as fig 2)
(if not, you need to try again)

fig. 2

DESIGN
ARTHAUS VISUAL COMMS LTD
LOCATION
MARLOW, UK
CREATIVE DIRECTOR
ADRIAN METCALFE
CREATIVE TEAM
RICHARD JONES

Love it or hate it, alleged festive fun is hard to avoid. The combination of modern-day over-exposure, commercialism and the 'Groundhog Day' analogy make quite a Christmas cocktail. Arthaus used these factors to produce a number of amusing cut-out-and-keep survival items contained in a card. Items included the Mr Brahms and Lizst put-me-in-a-taxi card, the emergency bad fairy, a sullen Santa and the pulling power of some emergency mistletoe. It was all branded under the title 'Christmas TM' as a tribute to its own evolution. The only thing they couldn't cater for were those Brussels sprouts.

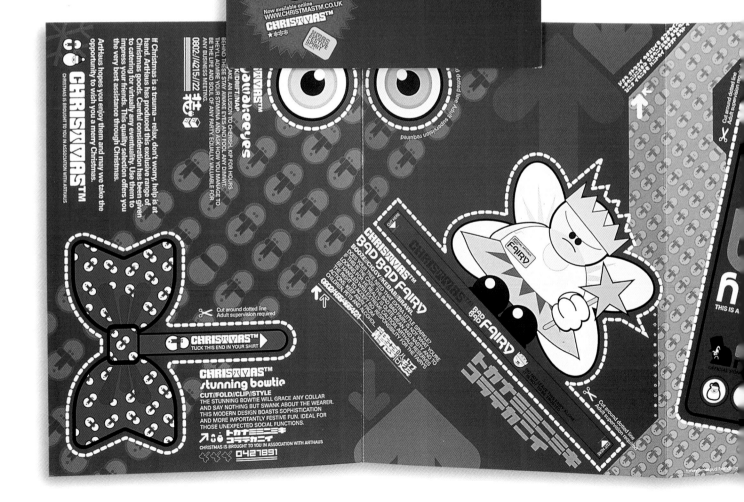

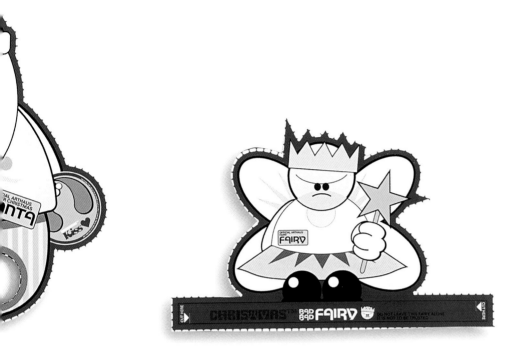

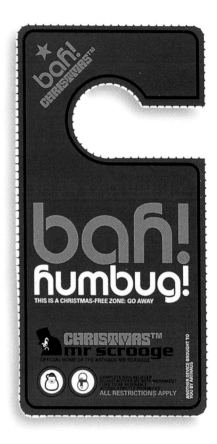

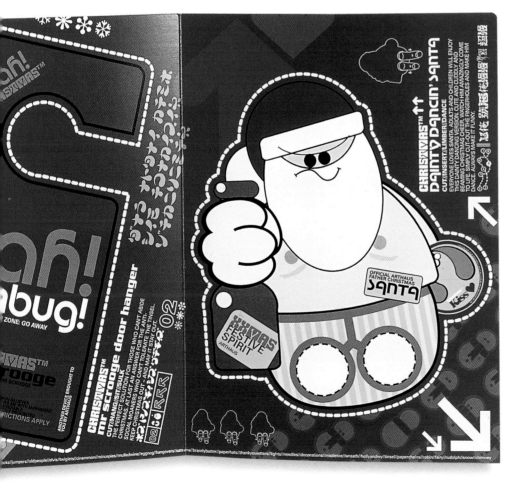

DESIGN
PREJEAN LOBUE /
DAVID CARTER DESIGN
ASSOCIATES
LOCATION
LAFAYETTE, LOUISIANA USA /
DALLAS, TEXAS USA
CREATIVE DIRECTOR
GARY LOBUE JR, KEVIN PREJEAN,
LORI B. WILSON
CREATIVE TEAM
SCOTT SIMMONS, LISA PREJEAN,
MAX WRIGHT, LINDA HELTON,
BARBARA LAMBASE,
ROBERT PRINCE,
KEITH GRAVES, KLEIN & WILSON

"To reflect upon and/or celebrate the
past year's events while promoting
our company's capabilities, talents
and personality."

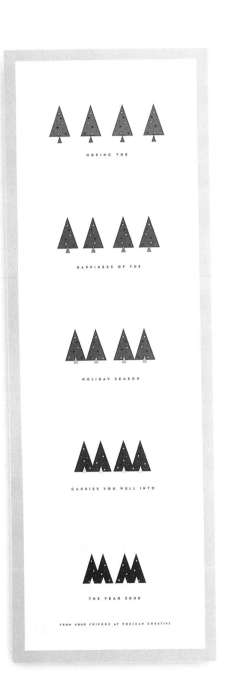

HOPING THE

HAPPINESS OF THE

HOLIDAY SEASON

CARRIES YOU WELL INTO

THE YEAR 2000

FROM YOUR FRIENDS AT PREJEAN CREATIVE

DESIGN
SAATCHI & SAATCHI DESIGN
LOCATION
LONDON, UK
CREATIVE DIRECTORS
IAIN ROSS, IAN LANKSBURY
CREATIVE TEAM
PRAD NAIR, RYDAL BOWTELL

In order to design a Christmas card for Saatchi & Saatchi Design conveying seasonal greetings and company values, the designer needs to express and reinforce innovative, imaginative and lateral thought. Here, the printed card element needed to work in construction with an online interactive version. The combined solution provided fun and an imaginative twist on a corporate theme.

MERRY
CHRISTMAS
AND A HAPPY NEW YEAR

www.saatchi-design.com/brightchristmas
TEL: 020 7307 5327 FAX: 020 7307 5328
89 WHITFIELD STREET, LONDON W1T 4HG
SAATCHI & SAATCHI
DESIGN

MERRY
CHRISTMAS
AND A HAPPY NEW YEAR

www.saatchi-design.com/brightchristmas
TEL: 020 7307 5327 FAX: 020 7307 5328
89 WHITFIELD STREET, LONDON W1T 4HG
SAATCHI & SAATCHI
DESIGN

Wishing you a www.saatchi-design.com/brightchristmas

DESIGN
JONES DESIGN GROUP
LOCATION
ATLANTA, USA
CREATIVE DIRECTOR
VICKY JONES
CREATIVE TEAM
BRODY BOYER,
KATHERINE STAGGS,
CAROLINE MCALPINE,
CHRIS MILLER

"Our annual festive mailings serve as an
opportunity to passionately collaborate
as a team."

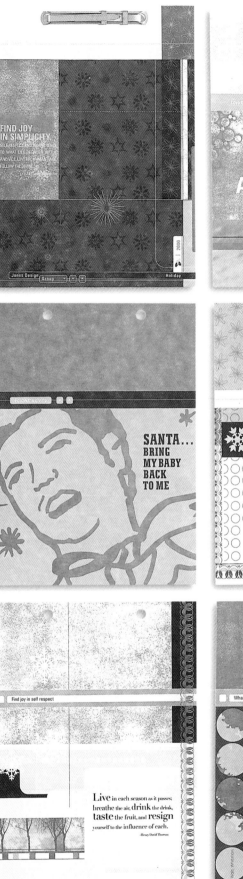
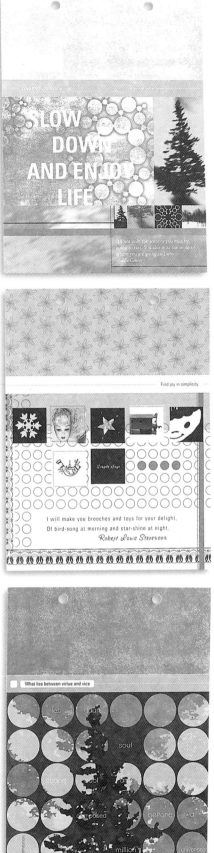

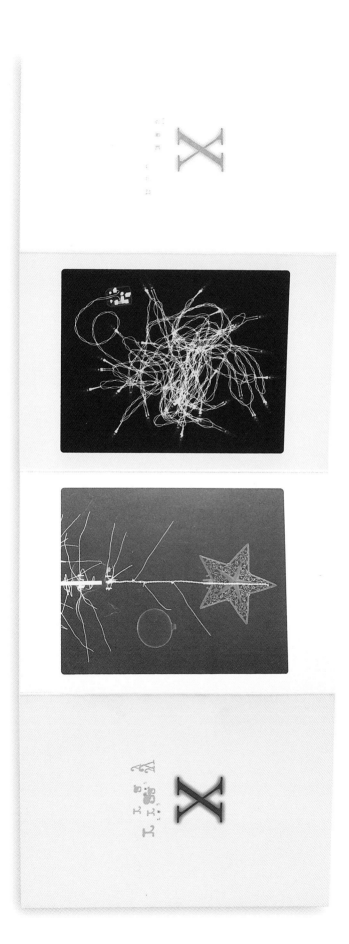

DESIGN
BIG GROUP
LOCATION
LONDON, UK
CREATIVE DIRECTOR
ERIC WITHAM
CREATIVE TEAM
COLIN GREY

"X-ray – a simple pun on the theme of Xmas that involved x-ray photography of a Christmas tree and fairy lights."

DESIGN
CARTER WONG TOMLIN
LOCATION
LONDON, UK
CREATIVE DIRECTOR
PHIL CARTER
CREATIVE TEAM
NEIL HEDGER, NICKY SKINNER,
PHIL WONG, CLARE WIGG,
ALI TOMLIN, JOHN MILLAR,
PETER DUNKLEY, PAUL DUNN

"The idea came from passing travel agents' windows. Various destinations fitting to the festive period were topped off with 'happy holidays' inside.

"We used these Christmas guidelines as a way of showing all the different methods of using type and imagery for Christmas cards."

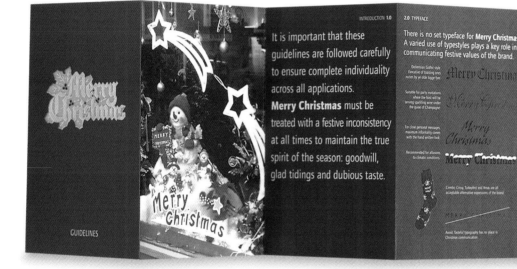

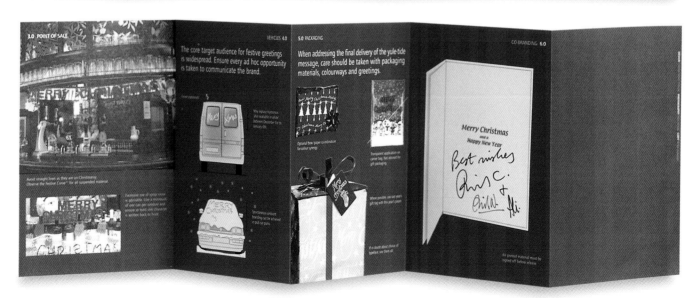

DESIGN
WASSCO
LOCATION
NEW YORK, USA
CREATIVE DIRECTOR
CHIP WASS

"Everybody loves cheese."

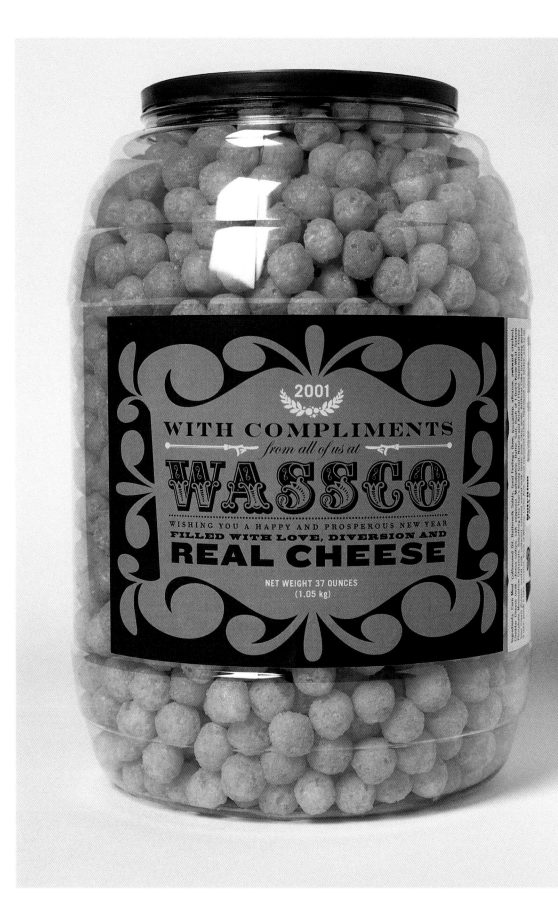

DESIGN
DUFFY LONDON
LOCATION
LONDON, UK
CREATIVE DIRECTOR
ADAM WHITAKER
CREATIVE TEAM
JAMES TOWNSEND, LOGAN FISHER

Socks
"A traditional Christmas gift with a Duffy twist – sent to a selection of clients."

Stockings
"We sent out a Christmas stocking filled with traditional items such as nuts and chocolates."

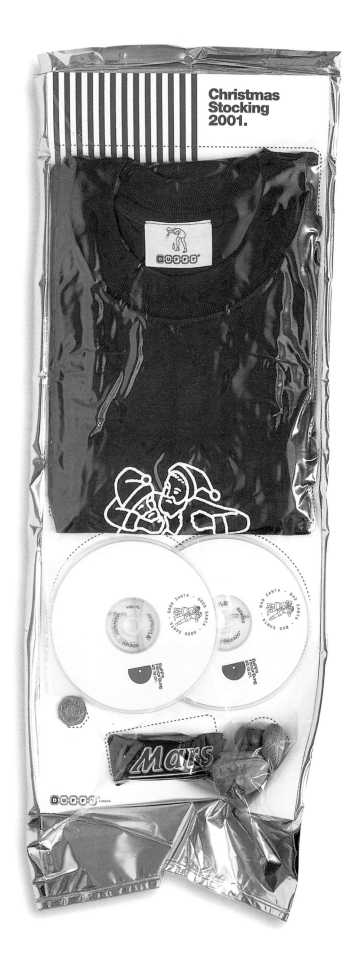

DESIGN
I.D. DESIGNERS
LOCATION
LONDON, UK
CREATIVE DIRECTOR
IVAN DODD

"The two cards selected for this book were chosen from a collection of personal Christmas/New Year cards designed, produced and sent to clients and friends over the last 40+ years."

Do It Yourself
"This is one of the oldest greetings and was produced at the time DIY started to become a UK hobby."

Cigar/Union Jack Fan
"This fan was a 'ready-made' I discovered amongst old stock at a long-gone novelty shop in Islington, London. This find coincided nicely with the 'Establishment Satire' movement of the time (early sixties), which also spawned the Soho satire club, The Establishment, founded by Peter Cook, Dudley Moore and pals."

ABCDEFGH
JKLMNOP
STUVWXYZ
1234567 8
abcdefghijk
nopqrstuvwx

from Jennifer and Ivan Dodd

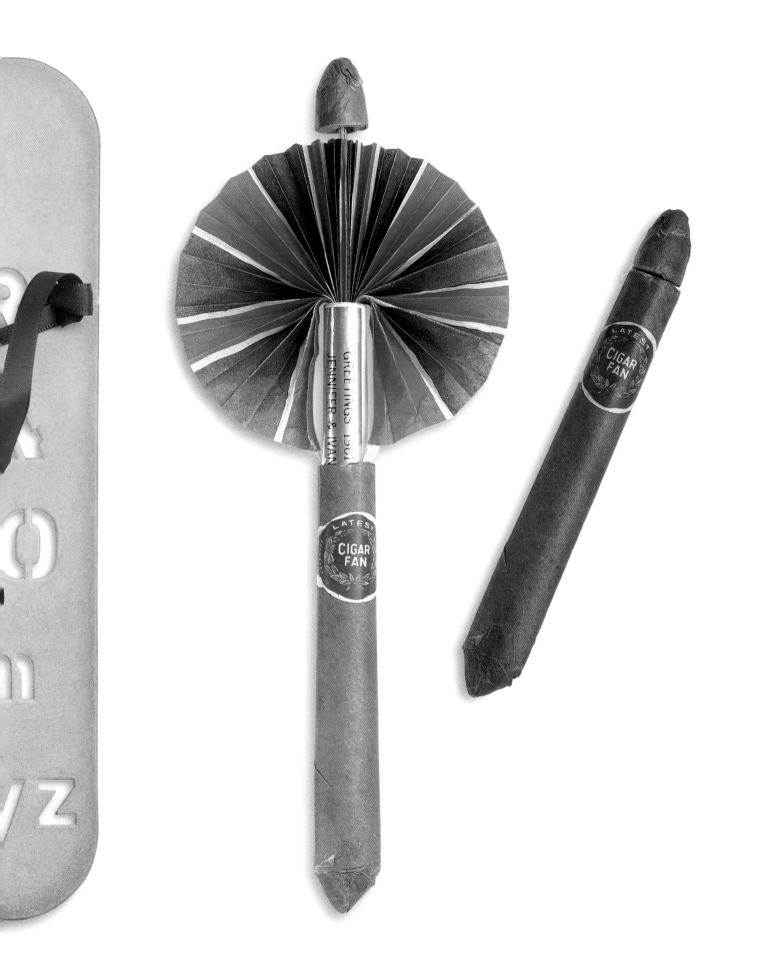

DESIGN
CHECKLAND KINDLEYSIDES
LOCATION
LEICESTER, UK
CREATIVE DIRECTOR
RICHARD WHITMORE
CREATIVE TEAM
STEVE FARRAR

"We produce a Christmas card every year to send to our clients. Away from the norm, the agency seeks to amuse and pose questions to the recipient (are you a devil... or an angel?). The design uses colours not usually associated with Christmas and a range of print finishes to create a visually interesting piece."

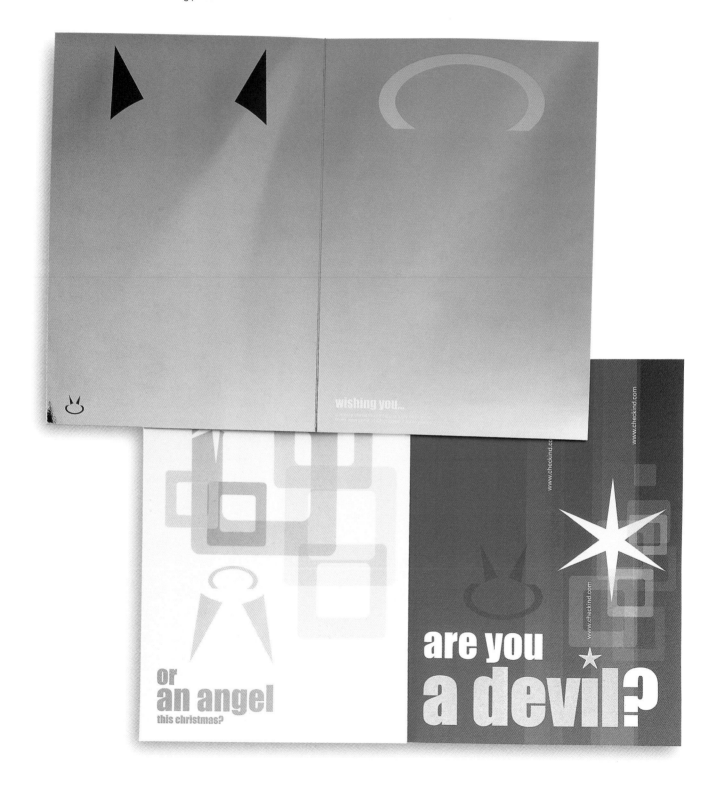

wishing you...

or an angel
this christmas?

are you a devil?

www.checkind.com

DESIGN
INTERBRAND
LOCATION
LONDON, UK
CREATIVE DIRECTOR
MARK SMITH
CREATIVE TEAM
JANE STANYON

"We needed to produce a mailer that fulfilled three objectives: firstly to communicate that Interbrand was moving to new offices in the Strand; secondly to wish our clients and contacts a Happy Christmas and New Year; and finally to inform people that 'Interbrand Newell and Sorrell' would just be called Interbrand."

DESIGN
PEMBERTON & WHITEFOORD
LOCATION
LONDON, UK
CREATIVE DIRECTOR
ADRIAN WHITEFOORD
CREATIVE TEAM
RICHARD HENNINGS,
MATT PATTINSON

Christmas is about giving and caring but above all about tolerance! For its Christmas mailers, Pemberton & Whitefoord produced this small book entitled 'White Lies'. The book pokes fun at the minor frustrations we all endure, year in, year out. It is actually more about being kind to each other than lying. The bold illustrations and witty captions sum up the 'grin and bear it' aspect of the festive season perfectly.

and it's the perfect fit, thanks nan...

easy to follow instructions...

a nice quiet Xmas at home with the relatives...

non-shedding Xmas tree...

yes, it is my favourite aftershave...

mum, your icing just melts in the mouth...

DESIGN
BROWNS
LOCATION
LONDON, UK
CREATIVE DIRECTOR
MIKE TURNER
CREATIVE TEAM
SCOTT MILLER, MIKE ABRAHAM

"To avoid the usual Christmas card,
we thought we would do a book on
religion instead."

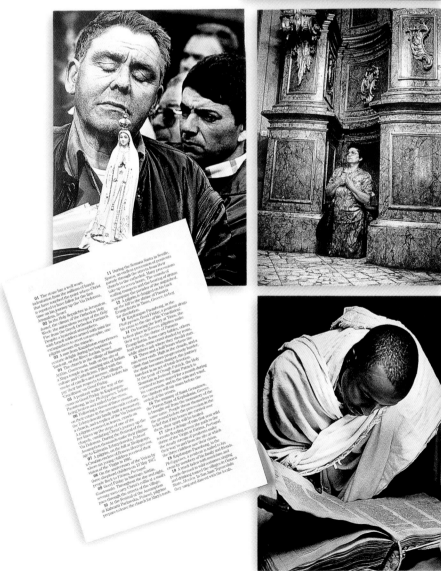

DESIGN
CACTUS
LOCATION
GLASGOW, UK
CREATIVE DIRECTOR
SIMON DEAR
CREATIVE TEAM
KEVIN LITTLE

This dual-purpose card is both a
Christmas card and a moving (new
address) card. The card carried not only
a replacement bulb but a replacement
address for Cactus as well.

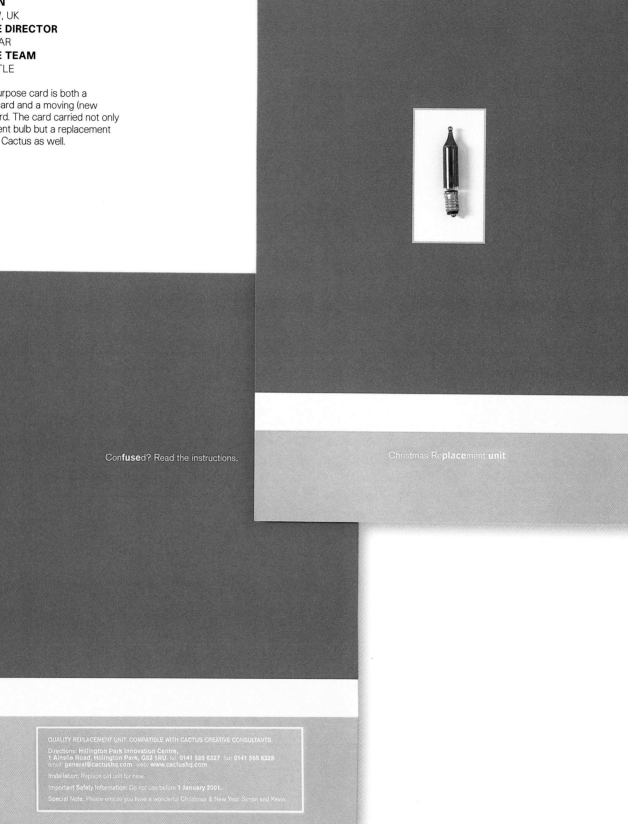

Con**fuse**d? Read the instructions.

Christmas Re**place**ment **unit**

QUALITY REPLACEMENT UNIT. COMPATIBLE WITH CACTUS CREATIVE CONSULTANTS.

Directions: Hillington Park Innovation Centre,
1 Ainslie Road, Hillington Park, G52 1RU. tel: 0141 585 6327 fax: 0141 585 6328
email: general@cactushq.com web: www.cactushq.com

Installation: Replace old unit for new.

Important Safety Information: Do not use before 1 January 2001.

Special Note: Please ensure you have a wonderful Christmas & New Year. Simon and Kevin.

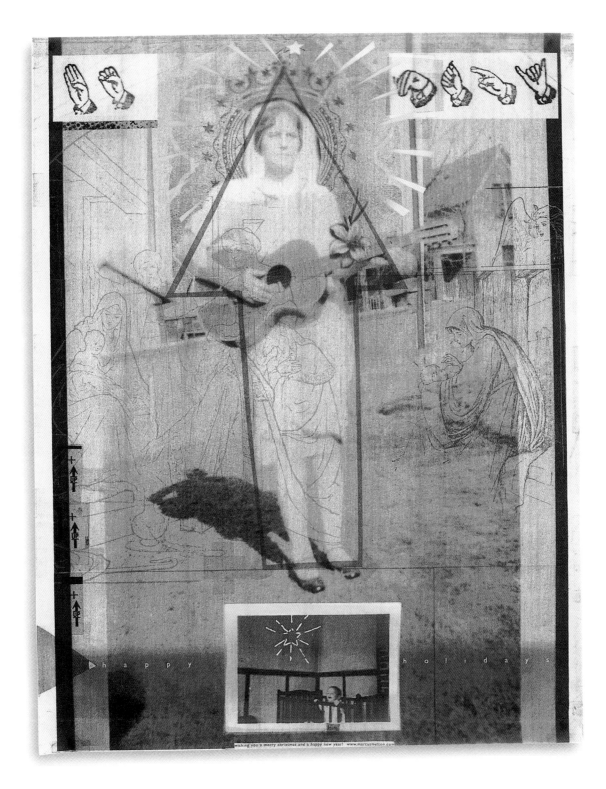

DESIGN
MARCUS MELTON DESIGN
LOCATION
FRANKLIN, USA
CREATIVE DIRECTOR
MARCUS MELTON

"This was an opportunity to explore alternative techniques, hopefully be innovative, and at the very least spread a little good cheer!"

DESIGN
HEARD DESIGN
LOCATION
LONDON, UK
CREATIVE DIRECTOR
TIM HEARD

Each team member (creative and non-creative) at Heard was given 24 hours to come up with an image that reminded them of Christmas and New Year. This allowed everyone a chance to contribute their own personal touch, thus portraying the feeling of a 'cohesive working team/environment'.

DESIGN
DE-CONSTRUCT (FORMERLY DEEP-
END)
LOCATION
LONDON, UK
CREATIVE DIRECTOR
ALEX GRIFFIN

"We really wanted to add something extra to our mailout, and in keeping with the goodwill of Christmas we supplied a set of festive transfers so people could make their own cards or just add some sparkle to their paperwork!"

DESIGN
HOWDY
LOCATION
LONDON, UK
CREATIVE DIRECTOR
NEIL SMITH
CREATIVE TEAM
SHARON CLAMPIN,
DAMIAN BROWNING,
ANKI WESSLING

"Festive mailings are a good excuse
to contact clients and lapsed clients,
friends and suppliers and to produce
a piece of work that reflects our
personality and approach. They are
also a good excuse to have a bit
of fun."

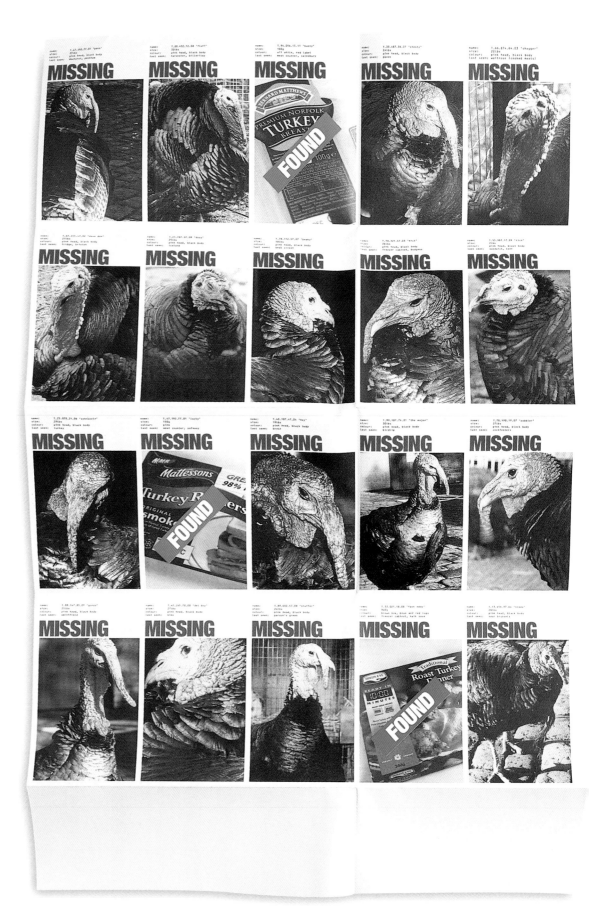

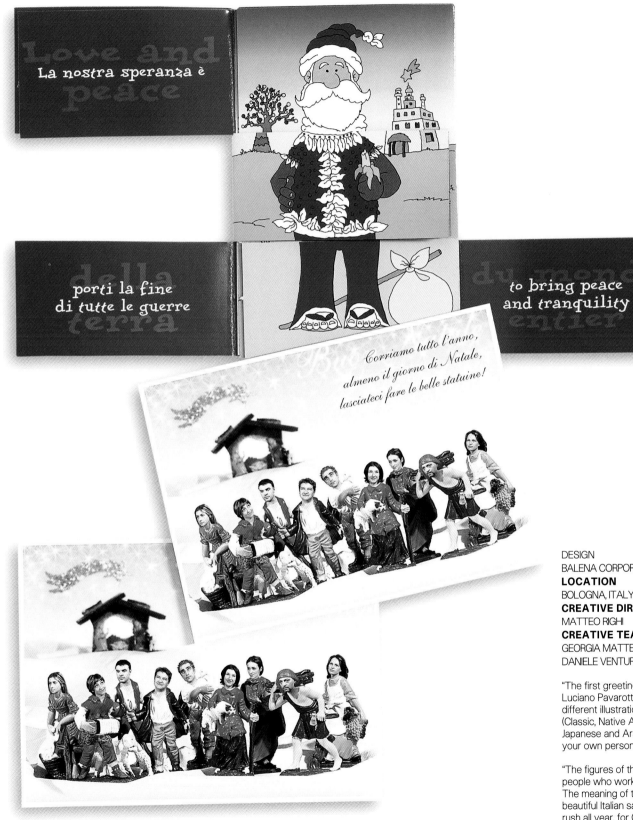

La nostra speranza è

Love and peace

porti la fine
di tutte le guerre

della terra

du monde entier

to bring peace
and tranquility

Corriamo tutto l'anno,
almeno il giorno di Natale,
lasciateci fare le belle statuine!

DESIGN
BALENA CORPORATION
LOCATION
BOLOGNA, ITALY
CREATIVE DIRECTOR
MATTEO RIGHI
CREATIVE TEAM
GEORGIA MATTEINI PALMERINI,
DANIELE VENTURELLI

"The first greeting card was created for
Luciano Pavarotti. It's a booklet with five
different illustrations of Santa Claus
(Classic, Native American, African,
Japanese and Arab). You can create
your own personal Father Christmas.

"The figures of the crib are the real
people who work for the agency.
The meaning of the phrase is a very
beautiful Italian saying that means 'We
rush all year, for Christmas let us do
beautiful statuettes'. To do a 'beautiful
statuette' means to be relaxed and take
a break from working so hard."

DESIGN
FIBRE
LOCATION
LONDON, UK
CREATIVE DIRECTOR
DAVID RAINBIRD
CREATIVE TEAM
NATHAN USMAR LAUDER

"We hate Christmas cards. We avoid
them every year. Christmas 2000 was
different. We figured that sending a
shredded card could be as festive as
sending a whole one and a good piece
of 'fibre' promotion."

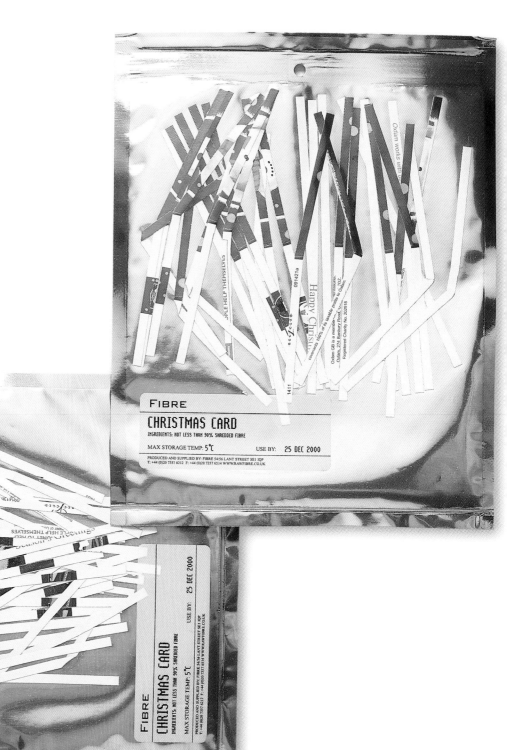

bright merry snow flake

Instant Snow
Do not open until 25th December 2000!
Open and shake for guaranteed snow on Christmas Day.

Make your own Instant Snow

Requirements

Waste paper
Hole punch
Energy
Five minutes

DESIGN
BWA DESIGN
LOCATION
LONDON, UK
CREATIVE DIRECTORS
VALERIE WORSDALE,
WEBSTER WICKHAM
CREATIVE TEAM
JIM DARKE, HELEN BURCHELL

"A sense of humour combined with creativity is usually our goal for each Christmas card! As designers we also have a strong environmental awareness; therefore, we aim to only ever use recycled materials – the snow gave us the chance to recycle many unused mock-ups!"

DESIGN
PSD: FITCH
LOCATION
LEEDS, UK
CREATIVE DIRECTOR
PSD: FITCH
CREATIVE TEAM
CARMEN HOMSY

"We wanted to create a Christmas mailer that reflects PSD: Fitch's multi-disciplinary approach and also something functional that could sit on the recipient's desk all year round.

"The mailer got a fantastic response from our clients, who kept the clips on their desks to hold their memos and photos."

Season's greetings from all at **PSD associates**

PSD
www.psd-design.co.uk

DESIGN
RED & GREEN MARKETING LTD
(FORMERLY GREENLEAF)
LOCATION
TUNBRIDGE WELLS, UK
CREATIVE DIRECTOR
ROBERT SAYELL
CREATIVE TEAM
NICK CHEESMAN

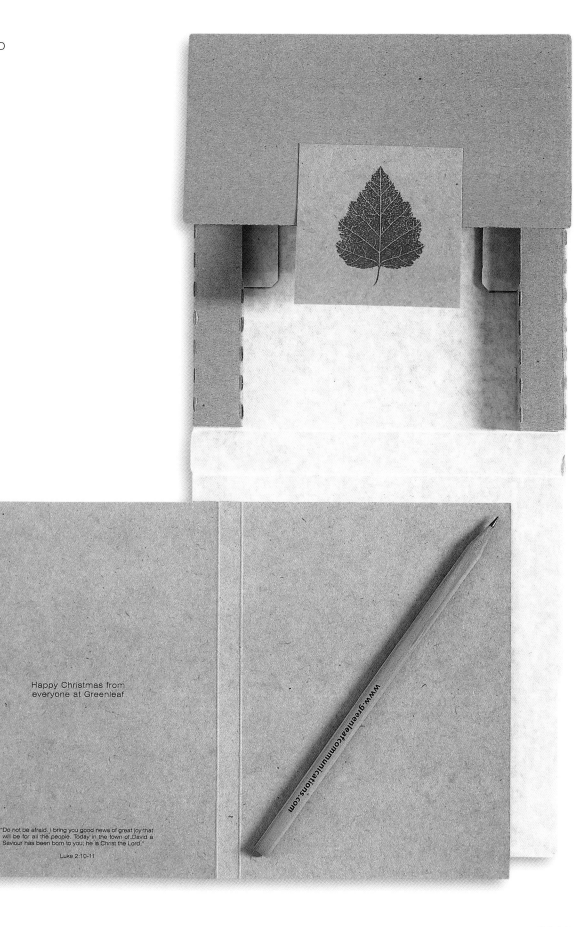

Happy Christmas from
everyone at Greenleaf

"Do not be afraid. I bring you good news of great joy that
will be for all the people. Today in the town of David a
Saviour has been born to you; he is Christ the Lord."

Luke 2:10-11

www.greenleafcommunications.com

DESIGN
NEWENGLISH
LOCATION
LEICESTER, UK
CREATIVE DIRECTOR
CARL BEBBINGTON
CREATIVE TEAM
PHIL THURLBY, WENDY LEWIS

"Every year we send out a festive mailer – this time we thought we would try and help to take the stress out of Christmas, leaving more time for eating and drinking."

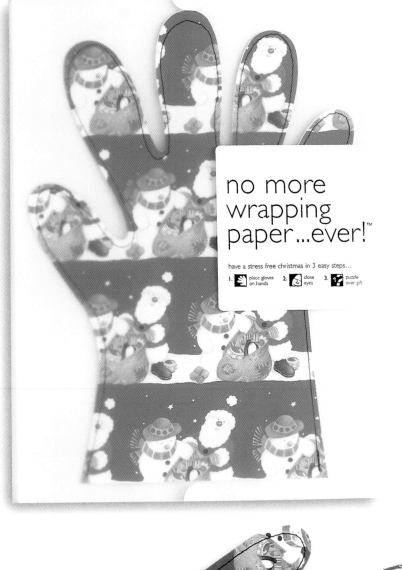

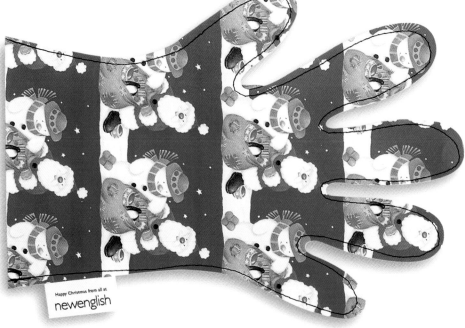

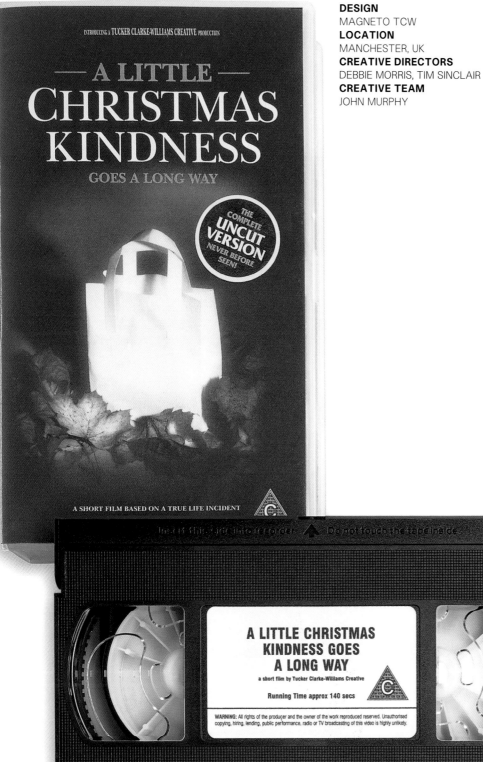

DESIGN
MAGNETO TCW
LOCATION
MANCHESTER, UK
CREATIVE DIRECTORS
DEBBIE MORRIS, TIM SINCLAIR
CREATIVE TEAM
JOHN MURPHY

"We are well known as print designers, but wanted to show clients we were capable of much more – as this was our first time making a film."

DESIGN
PROCTER & STEVENSON
LOCATION
BRISTOL, UK
CREATIVE TEAM
PROCTER & STEVENSON,
PETER THORPE, MARCUS AMMS

"Every year the designers at Procter
and Stevenson are asked to express
their creative talent in new and
innovative ways. In 2001, it was to
take everyday items found in the
office and to find new and innovative
uses. This celebration of design
talent illustrates the diversity of our
designers and their ability to think
laterally whilst having fun."

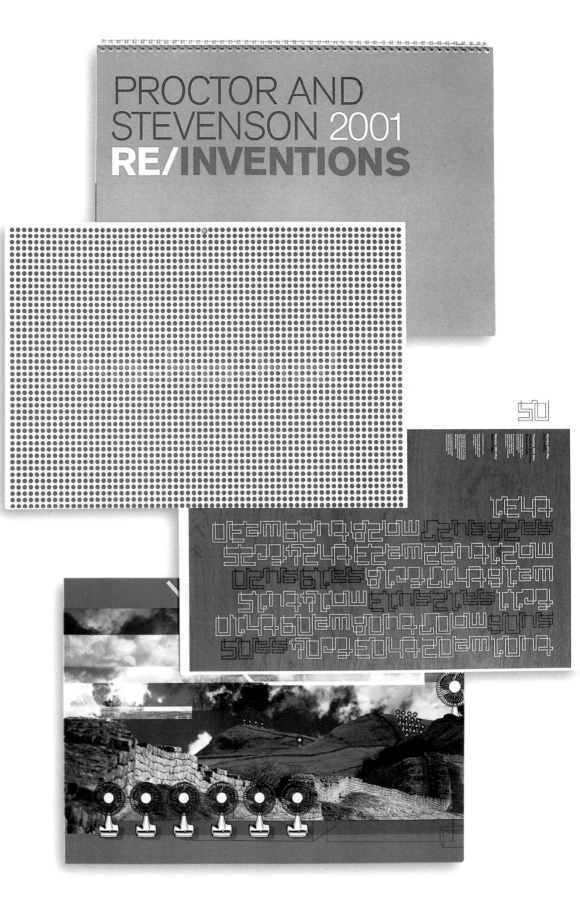

DESIGN
CITIGATE LLOYD NORTHOVER
LOCATION
LONDON, UK
CREATIVE DIRECTOR
JEREMY SHAW

"Having offices around the globe, we had to focus on the 'holiday season' rather than Christmas itself. We produced an edited book of the over-indulgences that have become a part of the festive season."

Enjoying the festive season

ed

DESIGN
IRIS ASSOCIATES
LOCATION
SHEFFIELD, UK
CREATIVE DIRECTOR
DAVID WOOD
CREATIVE TEAM
ADAM PEACH

"We saw this mailer as an opportunity to excite, stimulate and have fun joining the spirit of the festive season. As we all love to make our own decorations and Christmas messages, we felt this would give people the chance to combine both whilst having a lasting 'feel-good, creative' impression of Iris."

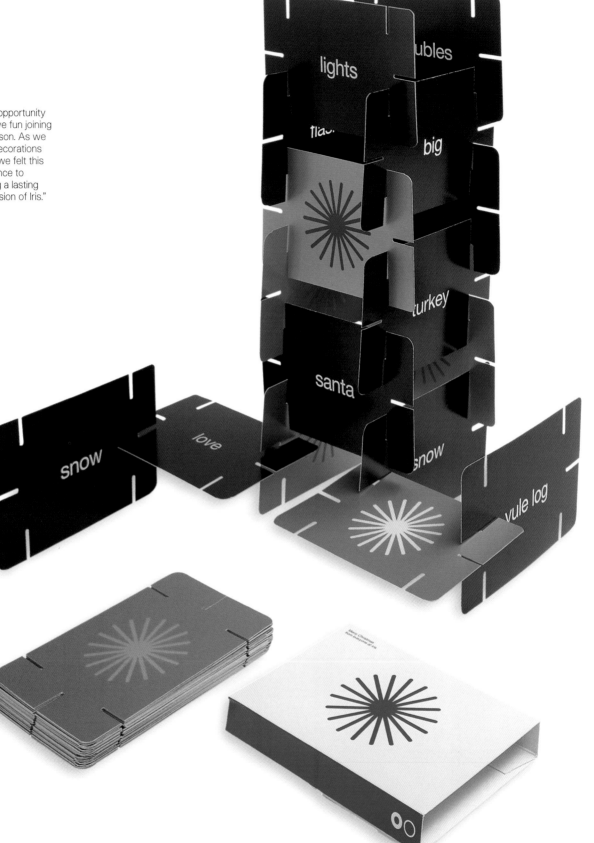

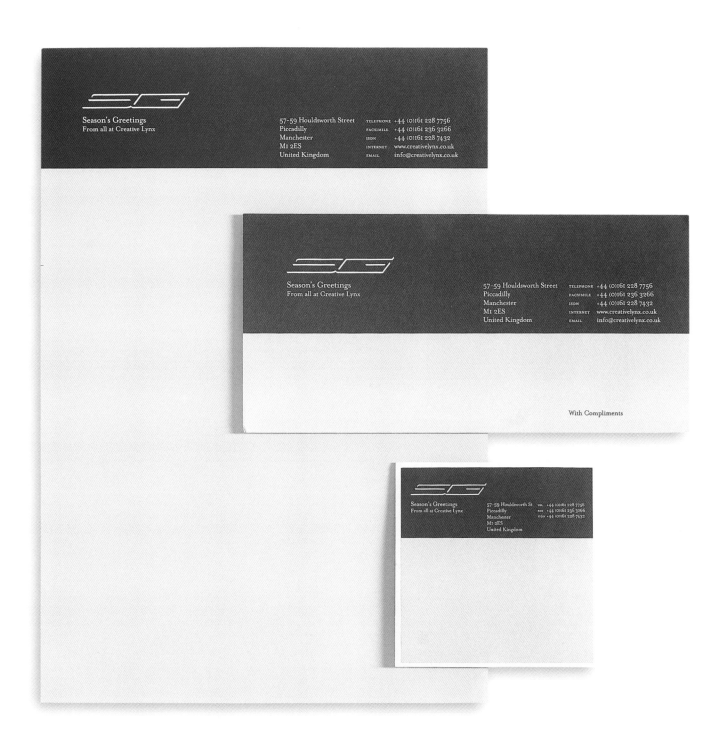

DESIGN
CREATIVE LYNX PARTNERSHIP
LOCATION
MANCHESTER, UK
CREATIVE DIRECTOR
NICK JACKSON

"A subtle change of our logo from CLP
to SG (Seasons Greetings) plus a
festive colouring makes our full range of
December stationery quite different."

DESIGN
CLEAR
LOCATION
LONDON, UK
CREATIVE DIRECTOR
IAN LETTICE

"Clear is the 'explanation agency'. We wanted to create a mailing that reminded our potential and existing clients what we do, but in a humorous way. The two-part clear acrylic Christmas tree kit, with three-step instructions, demonstrated clarity, from every aspect!"

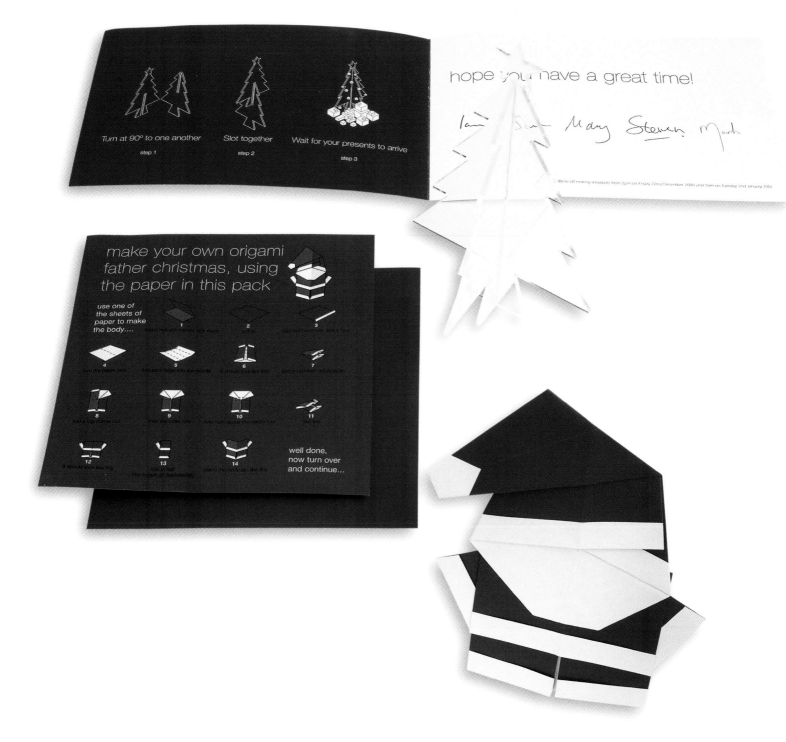

DESIGN
CAHAN & ASSOCIATES
LOCATION
SAN FRANCISCO, USA
CREATIVE DIRECTOR
BILL CAHAN
CREATIVE TEAM
GARY WILLIAMS

"We wanted to tell friends and family about our holiday party. Everyone likes to have fun at a party and reindeer games are fun."

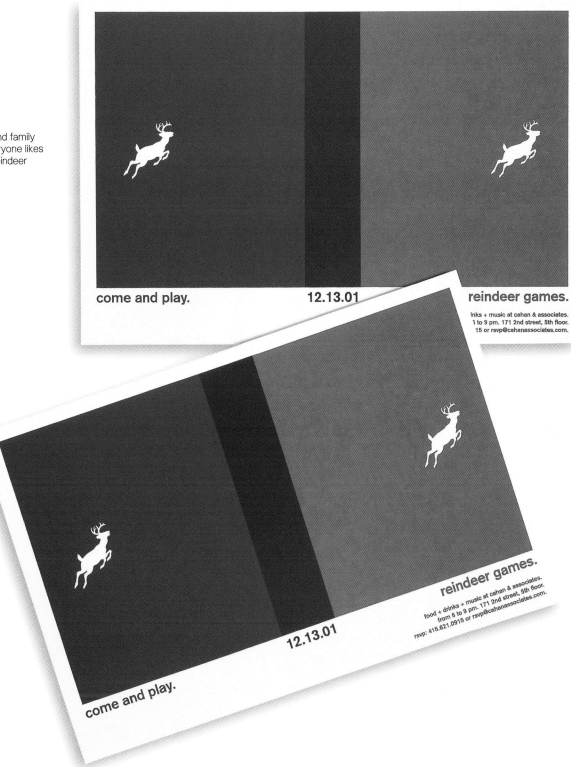

come and play. 12.13.01 reindeer games.

inks + music at cahan & associates.
3 to 9 pm. 171 2nd street, 5th floor.
15 or rsvp@cahanassociates.com.

reindeer games.

food + drinks + music at cahan & associates.
from 6 to 9 pm. 171 2nd street, 5th floor.
rsvp: 415.621.0915 or rsvp@cahanassociates.com.

12.13.01

come and play.

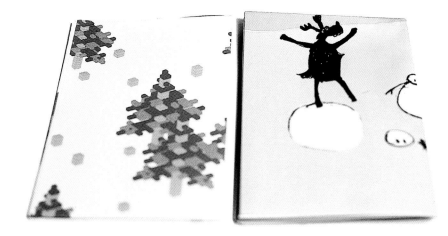

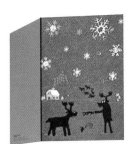
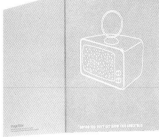

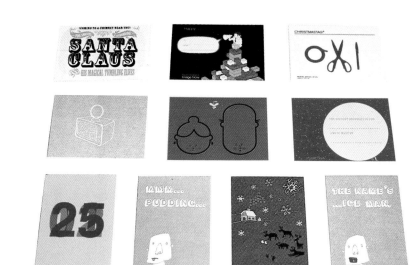

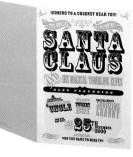

DESIGN
IMAGE NOW
LOCATION
DUBLIN, IRELAND
CREATIVE TEAM
IMAGE NOW

"If nothing else, it gives the clients' kids something to occupy themselves with if they're bored with the PS2 and there's nothing on the telly."

DESIGN
SPLASH OF PAINT
LOCATION
READING, UK
CREATIVE DIRECTOR
MALCOLM HATTON

"A designer's Yuletide log."

DESIGN
GUNTER ADVERTISING
LOCATION
MADISON, USA
CREATIVE DIRECTOR
RANDY GUNTER
CREATIVE TEAM
SARAH GRIMM, COLLIN SCHNEIDER,
JASON HENDRICKS,
BENNY SYVERSON,
VERNON MOORE

"Once again, we see the holiday card as an opportunity to try something different. The card was sent with 3D glasses, and the card and interactive website were both designed in 3D.

"'The Elves Who Hold Their Knees' included an extremely manipulated audio track recorded by agency members, a historic bibliography of the band and a website with a Flash video."

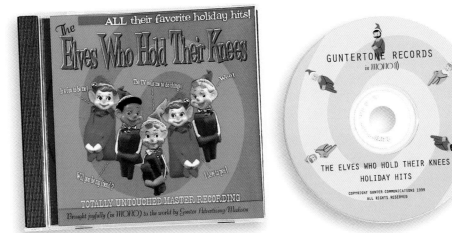

DESIGN
CPD
LOCATION
SYDNEY, AUSTRALIA
CREATIVE DIRECTORS
CHRIS PERKS, NIGEL BEECHLEY,
CHRIS TRAVERS
CREATIVE TEAM
HANS KOHLA,
AGNIESZKA ROZYCKA,
BELINDA O'CONNER

The simple yet open brief went to
CPD's designers within the Sydney and
Melbourne studios. The cards designed
for Christmas 2001 have a special
message of peace.

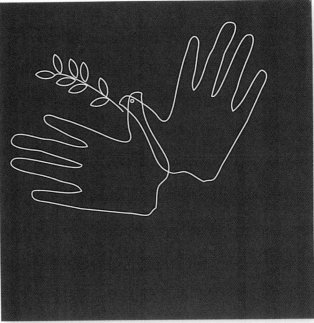

INDEX

[Below]
The Open Agency
London UK

ACKNOWLEDGEMENTS

Caroline Roberts – Features Editor, Graphics International
Katie Weeks – Assistant Editor, How Design Magazine, USA
Helen Walters – Section Editor, Creative Review
Richard Draycott – Editor, The Drum
Mark Fowlestone – Managing Director, KLP Scotland
Joe McAspurn – Managing Director, IMP Edinburgh
Ken Cassidy – Managing Director, Pointsize
Alastair Smith – Creative Photographer, Glasgow. +44 (0)7798 574 395
Paul Gray – Creative Director, BD-TANK
Gary Doherty – Senior Designer, BD-TANK
Eric Witham – Creative Director, Big Group, Bournemouth
Gary Dawson – Production Manager, BD-TANK
Xavier Young – Photographer, London. +44 (0)207 713 5502

Special thanks to
Aidan Walker, Luke Herriott, Laura Owen and all at RotoVision
Scott Campbell – Davidson Pre Press, Glasgow. +44 (0)141 248 1222
Ghill Donald – Managing Director, BD-TANK
Paul Hampton – The Picture House, Glasgow. +44 (0)141 948 0000
Scott Mackie – CMR Origination & Print Glasgow. +44 (0)1355 247773
Joan Grady – Freelance Copywriter, Glasgow. +44 (0)141 342 4020
Crown Press – Colour printers, Glasgow. +44 (0)141 221 8990

Lorna Kilpatrick – For her patience and speed typing.

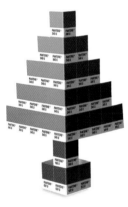

IF YOUR AGENCY WOULD LIKE TO SUBMIT HOLIDAY MAILINGS
FOR FUTURE VOLUMES OF 'FESTIVE' PLEASE SEND YOUR WORK TO:

HI RES JPEGS:
SCOTT@TRAFFIC-DESIGN.CO.UK

TRANSPARENCIES OR SLIDES:
SCOTT WITHAM. 25 CALDERWOOD ROAD, RUTHERGLEN,
GLASGOW, SCOTLAND G73 3HD, UK.

A gift to remind you of us this Christmas

Ingenious, bright, classic, innovative, tough, reliable, good value, very easy to work with...

...and totally nuts!
Another cracking good idea from
HORSEMAN COOKE